Friedrich William Vaughan

ART&IDEAS

Φ

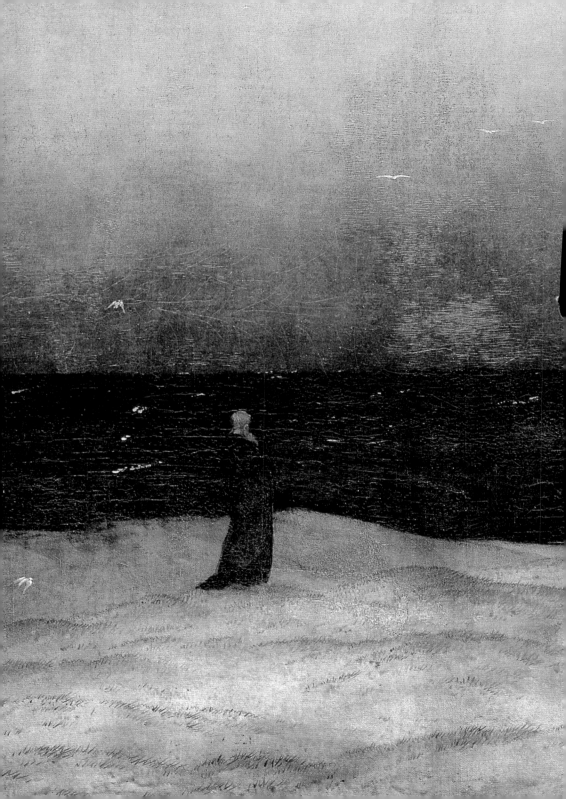

Friedrich

Opposite
*The Monk
by the Sea*
(detail of 72),
*c.*1809.
Oil on canvas;
110·4×171cm,
43⅝×67⅜in.
Nationalgalerie,
Staatliche
Museen, Berlin

Introduction

A generation ago Caspar David Friedrich (1774–1840) was little known outside his native Germany. Now he is recognized internationally as one of the leading artists of the early nineteenth century. He takes his place beside such masters as Théodore Géricault (1791–1824) and Eugène Delacroix (1798–1863) in France, Francisco Goya (1746–1828) in Spain, William Blake (1757–1827), John Constable (1776–1837) and J M W Turner (1775–1851) in Britain. Highly individual, each of these made a unique contribution to that great cultural tendency that is still (despite all attempts to dislodge the term) most usefully described by the word Romanticism.

Yet while Friedrich's importance as an artist is now established, knowledge of his work is patchy. Few of his pictures can be found outside central and eastern Europe and he is known best through widely distributed prints of a select number of his most dramatic works. He is thought of most commonly, perhaps, as a painter of Gothic weirdness, of spooky silhouettes of barren trees and ruins rising against wintry skies, as in *The Abbey in the Oakwood* (see 73).

Such pictures convey an exciting sense of the spiritual and reproduce well. Yet it should be remembered that Friedrich was also an artist of great subtlety, as can be seen in the charming painting of his wife in *Woman at the Window* (1). And even in his most fantastic works, he drew on observation. Both the ruin and the oak trees in *The Abbey in the Oakwood* are derived from detailed nature studies that can be found in his sketchbooks.

Friedrich's focus upon landscape painting is itself a sign of the times in which he lived. Born in 1774, he came to maturity when a new evaluation of the natural world was taking place throughout Europe. In the later eighteenth century there had been a growing

disillusionment with what seemed to be an over-materialistic society, and a new call for the spiritual. This tendency, central to Romanticism, encouraged the view of nature as a paradigm. It represented divine creation, to be set against the artifice of human civilization. As the English poet William Cowper put it in his poem *The Task* (1784): 'God made the country and man made the town.' It is telling from this point of view that Friedrich is almost the exact contemporary of Constable and Turner.

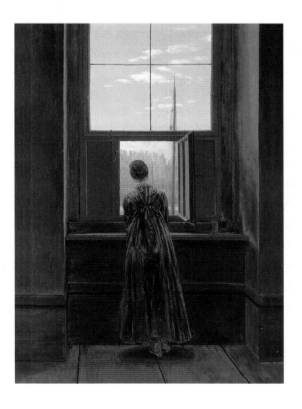

1
Woman at the Window, 1822.
Oil on canvas;
44×37cm,
17¼×14½in.
Nationalgalerie, Staatliche Museen, Berlin

Britain and Germany shared the enthusiasm for nature. In many other ways, however, their cultures were different. The distinctions between them do much to explain the differences between Friedrich's meditative form of landscape and the more vivid and 'painterly' work typical of his British contemporaries.

Germany was at that time a patchwork of small states and cities. Unification did not take place until 1871, thirty-one years after Friedrich's death. The German states of the artist's lifetime were

relatively backward economically, still suffering from the devastation of the religious wars of the seventeenth century and not yet having developed the industrial strength that was to transform Germany's economy in the later nineteenth century. However, their invasion by Napoleon in 1806 – in which even the militaristic Prussia was humiliated – spurred a resistance movement which brought together a populist nationalism with a new form of political resolve. Friedrich's *Abbey* (see 73) was one of a pair of pictures (the other being *The Monk by the Sea*; see 72) that were exhibited in Berlin in 1810 at the height of this crisis. Its intense 'Germanic' mood suggests solidarity with the resistance movement.

The sense of German identity was not just a reaction to French military invasion. It grew from the great intellectual and cultural renaissance of the later eighteenth century, which brought forth such giants as Goethe and Schiller in literature, Mozart, Beethoven and Schubert in music, and Kant and Hegel in philosophy. The image of Germany as a politically weak but intellectually strong nation was the dominant one at that time. Signs of this can be found in Friedrich's own emphasis on the spiritual in art. The philosophical and intellectual climate that surrounded him in Dresden, where he spent the majority of his working life, helped him to forge a landscape art that looked inwards as well as outwards. He understood that what you saw before you was influenced by what was inside you and always sought to bring the 'inner vision' into contact with the outer.

The meditative basis of Friedrich's work has led many to interpreting it as essentially programmatic and symbolic. An extreme example of this can be found in the writing of Helmut Börsch-Supan (see Further Reading). The leading Friedrich scholar of our age, Börsch-Supan has produced an *oeuvre* catalogue of this artist that has remained the starting point for all further studies. Yet he has also stretched credibility by insisting that Friedrich's pictures almost invariably convey specific Christian messages, with virtually every detail symbolizing aspects of the doctrines of the Protestant

faith in which the artist was reared. Others – equally improbably – have seen the artist as demonstrating the ideas of leading philosophers of the day, notably Immanuel Kant. Friedrich was deeply spiritual and believed in the potential of landscape to express the inner life. But he was far more than a mere illustrator of ideas. He himself protested that he was not what he called a 'writing painter' and suggested that those who were would do better to pen texts and pin them on the wall rather than go to the trouble of painting pictures.

Friedrich's concern that his pictures should function visually encouraged a reticence in verbal descriptions. He did not, on the whole, provide thematic titles for his works. Evocative names such as *The Wanderer* (see 94) or *The Stages of Life* (see 167) are later inventions – frequently from the twentieth century. The celebrated pair *The Monk by the Sea* and *The Abbey in the Oakwood* were simply designated by the artist, when first exhibited, as 'two landscapes'. Similarly Friedrich avoided the conventional textual means for establishing identity. He rarely signed or dated a canvas. He did date his studies, it is true; but this was so that he could recall more easily the circumstances in which he made them. The absence of dated pictures has presented particular problems for scholars in constructing a chronology of his *oeuvre*. This was only established on a firm basis in the 1960s. The two scholars who did most to achieve this were Börsch-Supan and Sigrid Hinz. Through careful formal analysis, Börsch-Supan constructed a plausible sequence for the development of Friedrich's methods of pictorial composition. At the same time Sigrid Hinz used the dated drawings to establish *termini post quem* for many key pictures which used such studies as their basis.

Friedrich was in fact more practical than intellectual. He came from a craftsman background in the Baltic harbour town of Greifswald in Pomerania, where his father was a prosperous candle-maker and soap boiler. As his enchanting painting *Greifswald in Moonlight* suggests (2), he always remembered his native town with great affection. In many ways he never quite

2
*Greifswald
in Moonlight*,
1816–17.
Oil on canvas;
22·5 × 30·5 cm,
8¼ × 12 in.
Nasjonalgalleriet,
Oslo

fitted into the cultural world of Dresden, the Saxon capital
which lay several hundred miles to the south. During the
Napoleonic occupation of Germany (1806–14) he had a brief
success with his work in Dresden and Berlin. But in later life
he became increasingly isolated, while continuing to produce
paintings of great profundity and beauty.

The importance of Friedrich's home background for his art will
be discussed later in this book. However, one indicator of it is
worth exploring here. This is the matter of his name. The artist
habitually referred to himself as 'Friderich' – sometimes shortened
to 'Fridrich' – which was the family name. It can be seen on the
bars of soap his father's firm made (3). But, with the exception
of a few occasions at the beginning of his career, he was referred
to as Friedrich by others in print. Why is this so?

The standard answer given is that 'Friderich' is an-old fashioned
way of spelling a name that was fast falling out of favour in
Germany in the early nineteenth century. All that is being done
by turning him into 'Friedrich' is to bring him up to date. This is
well and good, but it does beg some questions. The spelling of
names is idiosyncratic and usually we see it as a matter of courtesy
to adopt the form an individual prefers. The practice of calling

Friderich Friedrich – although involving small and seemingly innocuous shifts in orthography and intonation – relates in fact to the larger sphere of cultural politics. It was one of the claims behind the move towards unification that German-speaking peoples shared a culture of deep spiritual and intellectual value. Focus on the language, as the definer of that culture, was intense, and one area that was cleaned up – to bring a uniformity to the myriad dialects that were spoken – was spelling. In this context 'Friderich' seemed provincial and old-fashioned. Changing this to Friedrich was a way of making him conform to a central cultural tradition, removing him from eccentric quaintness.

Since the artist is invariably called 'Friedrich' in print, it seems that we must leave him like that, but we should not altogether forget Friderich, for this is what he remained to himself. The fact that he persisted with this spelling even when many others (including some of his own relatives back in Greifswald) abandoned it must mean something. It suggests he kept a pledge with his past. Remembering this Friderich, too, can be a helpful corrective to the over-intellectualized and programmatic readings of his work that many interpreters find so tempting. It brings us into contact with the vigorous and pithy individual that can be found in the letters the artist wrote home to his family. Friedrich was a melancholic, and he exploited this aspect of his character professionally – as can be seen in the celebrated image of him in monk-like seclusion in

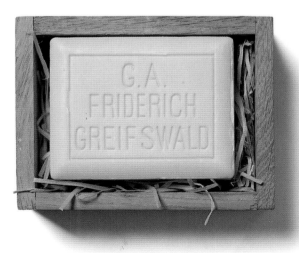

3
Bar of soap. Modern production from original mould used by the Friedrich family firm, c.1800. Pommersches Landesmuseum, Greifswald

his studio in 1812, painted by his friend Georg Friedrich Kersting (1785–1847; 4). But he was also a person of earthy tastes and broad humour and with a great fondness for children. He was a resilient individual, given to scaling mountains and braving the fiercest storms. It is his vitality and sense of the real that gives such weight to his pictures, and that allowed him to cut such an important and individual path in the art world of his own day. Without that Friderich, there would have been no Friedrich.

4
Georg Friedrich Kersting, *Friedrich in his Studio,* 1812. Oil on canvas; 51×40cm, 20×15¾in. Nationalgalerie, Staatliche Museen, Berlin

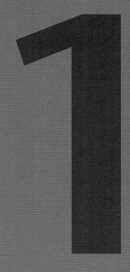

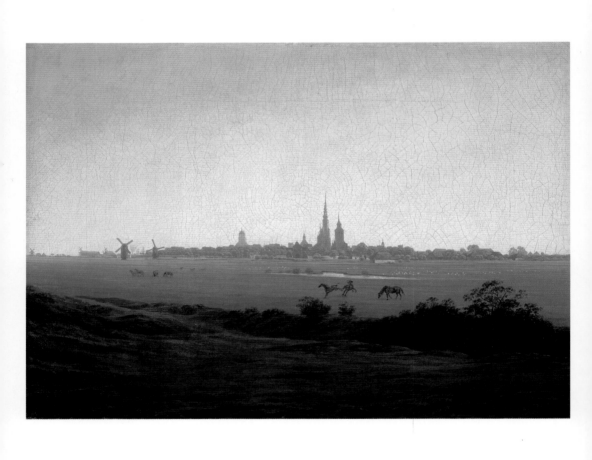

Is it simply a coincidence that so many fine landscape painters come from low-lying regions close to the sea? There are the great Dutch artists of the seventeenth century, Constable and the East Anglian painters, Claude Monet (1840–1926) in Normandy, Friedrich and Emil Nolde (1867–1956) in north Germany. Perhaps it is something to do with the light. The level land in which these artists spent their early years throws the sky into prominence, while the nearby sea reflects the sun's rays back up into the atmosphere, to produce a heightened luminosity.

5
Meadows before Greifswald, c.1820–2. Oil on canvas; 35×48·9cm, 13¼×19¼in. Kunsthalle, Hamburg

Like the great Dutch masters – who were in fact his earliest inspiration – Friedrich was surrounded by striking light effects in Greifswald. Pomeranian skies, however, are somewhat different from those of the more westerly coastal region of Holland. Perhaps because it is a colder, more northerly region – and perhaps too because the sea is landlocked – the atmospherics here seem sharper, the clouds less billowy. Yet there is no mistaking the pervasive quality of the light – evident in the early-evening view of the artist's home town, *Meadows before Greifswald* (5). It is similar to that found in the work of many Scandinavian artists who worked on other shores of the Baltic.

Friedrich did not develop fully as an artist until he had left his native coastlands to settle further south in Dresden. However, the intense northerly light in his work is unmistakable, even when he is depicting other regions. Equally important, it would seem, was that sense of the elemental that is so striking in low-lying coastal areas, where sky, sea and land seem so vast and separate, often intersecting in clear straight lines. Such qualities emerge in his work like ingrained childhood memories; ones that he kept fresh, in the first half of his career at least, through repeated journeys back to his homeland.

Greifswald, where Friedrich was born in 1774, is a small harbour town. At the time that he lived there it had a population of about 5,000 and was relatively impoverished. It could look back, however, to more prosperous times. In the Middle Ages it had been part of the Hanseatic League, that great trading network that had dominated commerce in northern Europe until outpaced by the Atlantic trade routes of the sixteenth century. Greifswald's initial development as a port owed much to the stimulus to business provided by the thirteenth-century Cistercian abbey of Eldena (6) that lay to the east along the coast. By Friedrich's time this had long since been a ruin – and it figures as such in many of

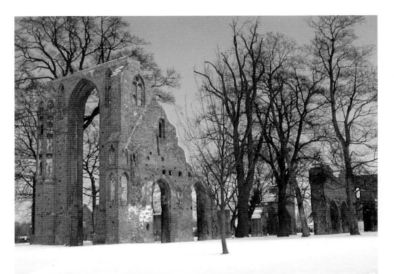

6
Abbey of Eldena,
near Greifswald

his key works, such as *The Abbey in the Oakwood* (see 73). He would often have walked the 4 km (2½ miles) downstream along the river to reach it from his childhood home in Lange Strasse in the centre of town.

Like the rest of Pomerania, Greifswald had suffered greatly in the seventeenth century as a result of the Thirty Years War (1618–48). This major religious conflict had torn Germany apart: the German saying 'Pommern ist abgebrannt' (Pomerania is burnt down) originated from that time. It was as a consequence of this

war that the part of Pomerania in which Greifswald was situated had become a possession of the Swedish Crown. Although this ownership had led to Greifswald suffering further attacks – from Brandenburg and Prussia – the people were on the whole content with their overlords who took care of them, granting many trade concessions. Like the majority of Pomeranians, Friedrich retained a feeling of loyalty towards the Swedish monarchy even after the territory had been ceded to Prussia in 1815.

Friedrich's father, Adolf Gottlieb Friderich, and his mother, Sophie Dorothea née Breckly, had come to Greifswald from Neubrandenburg in the neighbouring state of Mecklenburg in 1761. If anything, Mecklenburg was even more backward than Pomerania. Bismarck, the Chancellor and architect of Imperial Germany after 1870, was to joke that when the world came to an end, it would happen in Mecklenburg a hundred years later. Moving to Greifswald was a modest but significant step towards an area of greater commercial activity. The port itself provided Adolf Gottlieb with the fish products from which he could make his soap and candles.

By all accounts, Adolf Gottlieb was a stalwart and somewhat formidable character. In the accomplished portrait drawing of him by his son – made as an adult on a return visit to Greifswald in 1801/2 (7) – the father eyes us shrewdly, as though calculating whether we would be a good business proposition. His substantial form is covered in a thick winter coat and topped by a fine fur hat. He is very much the self-made man; his manufactory was to remain active until the early twentieth century. There were ten children in the family (Caspar David was the sixth). Many of them did well, three brothers becoming substantial tradesmen in the town and one daughter marrying a local pastor. When Friedrich himself married in 1818, he proudly brought his wife to meet them. It was around this time that he painted a celebratory view of his home town, in a matter-of-fact manner far removed from his 'mystical' style, *Greifswald Marketplace with the Friedrich Family* (8).

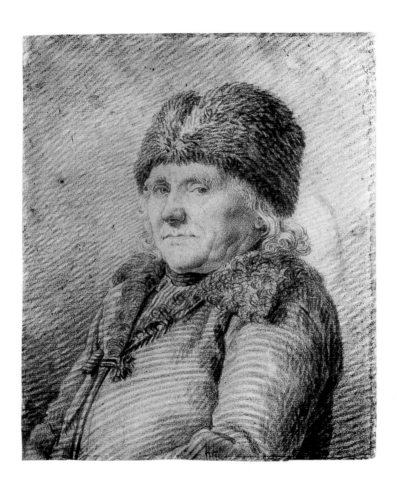

In childhood, however, there had been tragedies. Friedrich's mother died in 1781, when he was seven. After this the children were brought up by a nurse, 'Mutter Heide'. Two of Friedrich's sisters also died: Elisabeth in 1782 and Maria in 1791. Such deaths were not unusual at the time.

But there was a death in the family that touched Friedrich even more directly. On 8 December 1787, when he was just thirteen, he witnessed the drowning of his brother Johann Christoffer in a skating accident. The incident was made all the more traumatic for him, we are told by early commentators, since this brother had previously saved him from a similar fate. It is a mark of the importance of this event that it was mentioned in one of the earliest reviews of Friedrich's art in 1804 as an explanation of the melancholy to be found in his works. The story was frequently repeated, notably by Carl Gustav Carus (1789–1869), a close friend of the artist, in an account written shortly after the latter's death.

Adolf Gottlieb was a devout Lutheran and religion played a strong part in Friedrich's upbringing, something that must have been emphasized by the fact that he grew up in the shadow of the towering spire of the great Nikolaikirche, the cathedral church of Greifswald that dominates in the artist's view of the town (see 5). This would certainly have impressed him with a sense of the

9
Anonymous,
In Pace Dormiam,
1703.
Panel of chapel screen.
Nikolaikirche,
Greifswald

10
Christian Friedrich after Caspar David Friedrich,
Boy Sleeping on a Grave,
1804.
Wood engraving;
7·7 × 11·3cm,
3 × 4⅜in.
Kupferstich-kabinett,
Staatliche Museen, Berlin

11
'Wer nicht gehorchen lernt',
sample of writing by Friedrich,
1789.
Pen, sepia and wash;
20 × 32·2cm,
7⅞ × 12¾in.
Kunsthalle,
Hamburg

grandeur of the departed medieval world. The church might also have provided a source for his particular use of landscape imagery for religious purposes in his mature art. While altarpieces and other devotional images were frowned upon by Protestants, religious motifs continued to appear both in books and in places of worship. In the Nikolaikirche there is a particularly striking example of such symbolic art on the screen fronting a chapel reserved for the Corswanten family. This contains five large panels with landscape views adorned with emblems and Latin texts from the Bible. One, entitled 'Ego Semper Tecum' (I am always with you), shows a sunflower – symbol of the Deity – rising protectively over the town of Greifswald. The last in the cycle, 'In Pace Dormiam' (Let me sleep in peace), depicts a coffin at night with a skull and lamp resting on it (9). Dated 1703, these are crude provincial versions of a baroque form of symbolic landscape common in Protestant communities throughout northern Europe. However, they must surely have had a particular significance for Friedrich, who would have seen them every time he went to church as a child and young man. He did himself produce emblematic designs near the beginning of his career, to be cut in wood by his brother Christian (10). It is perhaps significant, too, that he returned to this art form in the final years of his life, a fine example being *Landscape with Grave, Coffin and Owl* (see 171).

Given this background, it seems appropriate that Friedrich's earliest surviving works – made in 1789 – should be decorated devotional and moralizing texts (11). These were to be replaced by more conventional artistic activities when, in 1790, he enrolled as a private student of the university drawing master Johann Gottfried Quistorp (1755–1835). The fact that he was sixteen by the time this training began suggests that there may have been some uncertainty in the family concerning his choice of career. Once this had been resolved, the selection of Quistorp as an instructor must have been almost inevitable. Virtually every aspiring artist of the day in Greifswald seems to have passed through this master's hands. Quistorp's own artistic ability was limited, as can be seen by the characterful portraits of local dignitaries by him that have survived, such as *Portrait of Burgermeister Siegfried Joachim Meyer* (12). However, he was a man of considerable learning and culture.

The son of a pastor, Quistorp had studied natural sciences as well as art when a student in Dresden. He later became a competent architect, designing among other things the building in which the Greifswald Museum is now housed. He also taught mathematics and engineering at the University of Greifswald, where his brother was professor of natural sciences. He may have given Friedrich some instruction in architecture as well, since the latter was to make designs for architectural installations in the years following the Napoleonic Wars (see Chapter 5). According to a letter Quistorp was later to write to the visionary landscapist Philipp Otto Runge (1777–1810), he believed strongly in allowing his students to develop their own particular gifts. However, he also put them through the conventional academic paces of the day, strengthening their ability through the copying of standard images from such drawing manuals as Johann Daniel Preissler's *Die durch Theorie erfundene Practic* (Practice Devised through

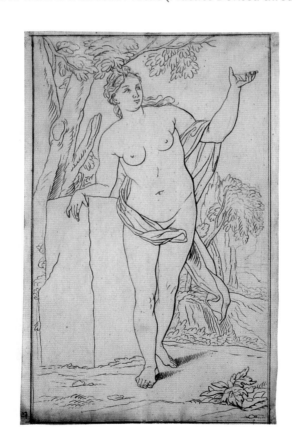

12
J G Quistorp,
Portrait of Burgermeister Siegfried Joachim Meyer,
1798/1836.
Oil on canvas;
70·6×56·2cm,
27¾×21⅞in.
Pommersches Landesmuseum, Greifswald

13
Female Nude,
outline copy
from
J D Preissler,
Die durch Theorie erfundene Practic,
c.1790–4.
Pencil;
32·1×20·1cm,
12½×7⅞in.
Pommersches Landesmuseum, Greifswald

Theory, 1728–31;13). These works are in 'outline', then regarded as the starting point for artistic competence and enjoying a vogue through the neoclassical taste for succinctness. Outline was to remain vital to Friedrich's art throughout his career.

Quistorp was also important to Friedrich for providing access to works of the great masters of the past. The Greifswald drawing master possessed a formidable collection of fifty paintings and 1400 drawings and engravings, including ones by such masters as Hans Holbein the Younger (1497–1543), Adam Elsheimer (1578–1610), Anthony Van Dyck (1599–1641) and Jakob Philipp Hackert (1737–1807). Despite such contact, however, there is little evidence that Friedrich acquired much skill in painting at this time. As was then common, Quistorp focused in his instruction on drawing as the fundamental skill necessary for all forms of art. He also gave Friedrich some instruction in printmaking – particularly etching, which the latter experimented with both then and in his early years in Dresden (see 29). Doubtless it was felt that such a skill was a highly practical one for an artist to acquire, particularly someone who appeared not yet to have shown any signs of exceptional accomplishment in any particular direction.

Quistorp – as befits a man of his learning – was probably as strong an influence on Friedrich's intellectual as on his artistic development. He had a keen interest in literature and was a close friend of the poet Ludwig Theobul Kosegarten. A younger contemporary of Goethe, Kosegarten's name is not one to conjure with today. At the time, however, he was a prominent exponent of that emotive approach to nature made fashionable by the literary Sturm und Drang (Storm and Stress) movement of the 1770s – the decade in which he himself began to publish. His poems, set in the wild north of Germany, are full of storms, ruins and blasted oaks. Like so many other nature poets of the day, Kosegarten was a pastor. In Friedrich's early days he became pastor of Altenkirchen on Rügen, the large island that lay just off the coast of Pomerania. A disciple of the celebrated poet Friedrich Gottlieb Klopstock, Kosegarten shared his mentor's belief that the Divine could be

perceived directly in nature (which he once referred to as 'Christ's Bible') and he considered it a duty to celebrate this not only in his impassioned verse, but also in his sermons and pastoral activities.

While in Rügen Kosegarten constructed a special shore chapel at the hamlet of Vitte, and would hold services on the beach for eight Sundays during September and October – the time of the herring catch – in which he would exhort his fishing parishioners to appreciate the divine beauty of nature as well as informing them of the latest discoveries in the natural sciences. 'One must', he said, speaking of his congregation, 'give them what one has to give in a clear and simple manner … in pictures and parables … in examples and stories …' Such was his conviction of the power of pictures to communicate nature's beauty that he later sought to commission Friedrich to paint an altarpiece for his chapel – an event that is commonly believed to have inspired Friedrich to paint *The Cross in the Mountains* (see 46) in this form. Indeed, the central motif of this picture appears to be prefigured in Kosegarten's verse epic, *Jucunde* (1803). In this, the poet talks of the sun as 'the visualized image of the hidden Father who dwells in the light that blinds all those who approach'. In Friedrich's account of his picture, he talks of the sun as the image of God the Father that has sunk from view behind the mountain, from where its light is reflected down to us via the image of Christ on the summit.

Kosegarten seems to have had a particular respect for Friedrich and sensed an affinity of attitudes. Perhaps this was also because he was, like Friedrich, a pronounced melancholic. His earliest collection of verses, published in 1777, was entitled *Melancholien*. It had a frontispiece by Quistorp which shows a young lady wandering in modish distraction beside a wild oak. Kosegarten was deeply inspired by English nature poetry, such as the *Night Thoughts* (1742–5) of Edward Young, and particularly drawn to the tempestuous verse of *Ossian* (1762) – that confected saga of Gaelic heroes by James Macpherson that was then believed to be a genuine Celtic epic. He seems to have considered the island of

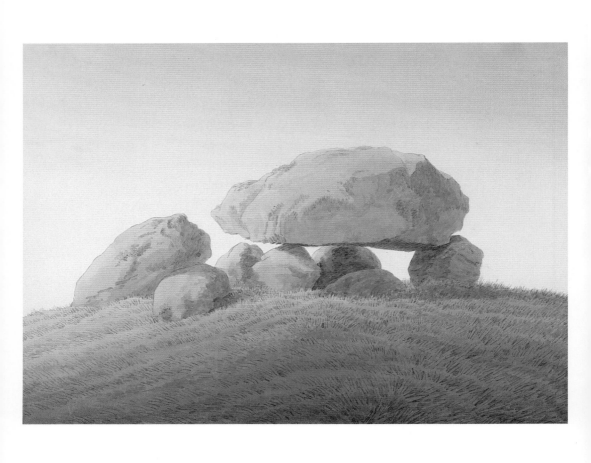

Rügen, which he 'discovered' first on a visit in 1777, to have a similar elemental wildness to that of northern Britain. He was one of those who encouraged the exploration of Rügen's myths and prehistoric remains – notably the *Hünengräber* (dolmens), the large stones marking burial sites that were reputedly the resting place of a lost tribe of heroic giants and the inspiration for works by Friedrich such as *Dolmen near Gützkow* (14).

Friedrich's pictures were frequently associated with Kosegarten's yearnings. When reviewing his *Monk by the Sea* (see 72), the playwright Heinrich von Kleist talked of its 'ossianic or Kosegarten-like effect'. Despite this, however, it is only when Friedrich moved away from the emotionalism of Kosegarten to a more intro-spective manner that he really can be said to have found his way as an artist.

14
Dolmen near Gützkow,
c.1837.
Sepia;
23×30·8cm,
9×11¾in.
HM
Dronningens
Håndbibliotek,
Copenhagen

Friedrich travelled to the island of Rügen many times. The earliest record of such a visit is in 1801, though in all probability he had made trips before, when a student of Quistorp. By this time Rügen had already become a celebrated place for the poetic traveller in search of the picturesque, not only through Kosegarten's advocacy, but also through the drawings of artists such as Jakob Philipp Hackert, and a growing number of guidebooks. This taste for the 'Picturesque' was an importation from Britain. The term had been made popular there in the later eighteenth century by the Reverend William Gilpin, who had used it in a number of guidebooks to scenic parts of the country. Literally meaning 'like a picture', the term drew attention to aspects of the countryside that were particularly likely to stimulate visual pleasure. While full of ambiguities, the term became increasingly popular throughout Europe during the Romantic period and certainly stimulated the interest in the variety of beauty in the natural world.

In 1794 Friedrich left Greifswald to study at the Danish Royal Academy in Copenhagen. This was probably on Quistorp's recommendation, though the Academy was a natural choice for students from the north of Germany. Among the other celebrated artists who studied there were the heroic classicist Asmus Jacob

Carstens (1754–1798), Philipp Otto Runge and Friedrich's friend Georg Friedrich Kersting, a fellow Pomeranian from Güstrow. Copenhagen was by far the largest and most important city of the region (it had 102,000 inhabitants in 1801) and there were strong economic links between it and the German Baltic coastlands. At that time Denmark was enjoying a period of peace and prosperity. A number of liberal reforms – particularly concerning land ownership – were introduced. This happy state of affairs did not survive the devastating effects of the Napoleonic Wars, notably the destruction of the Danish fleet and bombardment of Copenhagen by the British under Nelson. By 1813 the government was formally declared bankrupt.

Yet these reverses in fortune did not affect the quality of the art being produced at the Academy. The early nineteenth century is commonly considered as the 'golden age' of Danish art, when such masters as Christoffer Wilhelm Eckersberg (1783–1853) and Christen Købke (1810–48) flourished. This was after Friedrich's time in Copenhagen, but like those artists he benefited from the high quality of teaching and artistic activity already to be found in the Danish capital. Established in 1754, the Academy had expanded rapidly and, by the 1790s, was generally agreed to be one of the finest in Europe; it was certainly at least the equal of the major German academies of Dresden, Vienna and Berlin. Since 1771, foreign students had been allowed to study there free as well as native Danes. Foreigners could also compete for gold medals and other prizes. An added attraction was the fine collection of works – particularly Dutch of the seventeenth century – in the Royal Picture Gallery, to which all Academy students had access.

The instruction at the Academy was strict and based on the French model. It was a progressive course, starting with elementary copying and freehand drawing. Once this was mastered, students were admitted to the antique class in which they made copies of the Academy's famous collection of casts from antique sculptures. After this came drawing from the life, and finally composition.

Anatomy and ornament were taught as well as geometry and perspective. There were also lectures on mythology and history of art. As was common in this period, no painting was taught at the Academy, though students could negotiate independently with teachers for private instruction. Since Friedrich was not well off at this time he may well have been unable to afford such additional training. The strict emphasis on copying and classical prototype led to complaints and protests. Carstens had argued for a more imaginative approach to the understanding of form. Runge regretted being forced to work only from the antique and looked wistfully to the 'reformed' academy of Jacques-Louis David (1748–1825) in Paris where students had access to the living model from the start of their instruction. There are no recorded comments by Friedrich. His own progress appears to have been steady, if rather slow. He began by continuing the copying he had done with Quistorp – though to a higher level of precision. In October 1796 he transferred to the antique class, in which he worked for more than a year before being finally admitted to the life class (15).

Whatever Friedrich thought of Copenhagen, he certainly learned to draw there – as this confident life study shows. The model, standing with lifted arms and twisting to the left in a classic pose, is drawn with a firm line and solidly modelled with a form of cross-hatching that Friedrich was soon to apply to his portraits, such as that of his father in a fur hat (see 7). By the time he left the Academy in May 1798 his work had acquired an assurance and exactness quite unlike the loose and uncertain work he had done in Greifswald. This was doubtless the fruit of the rigorous regime and also the excellence of the teachers, many of whom were among the most famous northern European artists of their day.

The dominating figure at the Copenhagen Academy – and in Danish art at the time – was the history painter Nicolai Abraham Abildgaard (1743–1809). When a student in Rome in the 1770s, Abildgaard had been part of a circle of painters and sculptors from northern Europe which included the Swiss artist Henry Fuseli

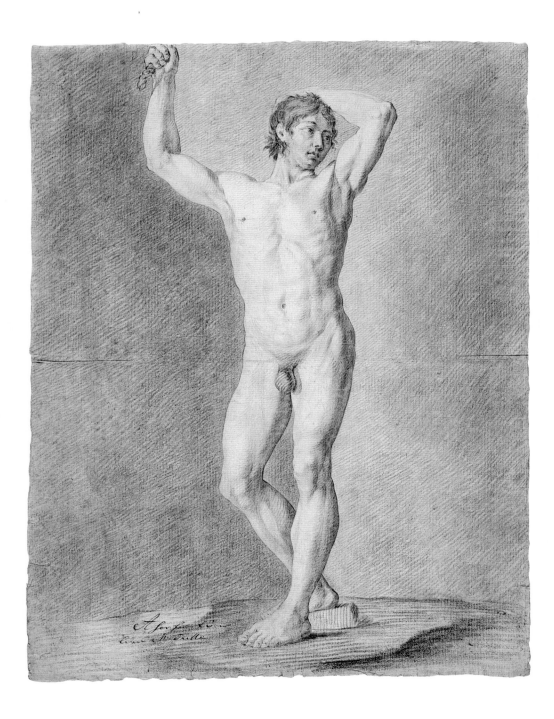

(1741–1825). Inspired by the Sturm und Drang movement, these artists sought to bring a new dramatic intensity to their work. While retaining an admiration for classical form, they would use this in a highly expressive manner, elongating or contorting forms and heightening the mood of their work through the use of strong contrasts of light. Deeply interested in myth, they pioneered the use of those from the north, such as the Icelandic *Edda* and *Ossian* (16). Abildgaard had been employed painting vast dramatic scenes from Nordic legends in the Royal Palace in Copenhagen in the 1780s, but sadly this scheme was now in abeyance and many of the works were soon to be destroyed by

15
*Study of
Nude Youth,*
1798.
Chalk
and pencil;
65×46·3cm,
25⅝×18¼in.
Kunst-
akademiets
Bibliotek,
Copenhagen

16
**Nicolai
Abildgaard,**
*Malvina
Mourning the
Dead Oscar,*
c.1790.
Oil on canvas;
62×78cm,
24⅜×30¾in.
National-
museum,
Stockholm

fire. He would have taught Friedrich in the life class, as also would the classical sculptors Andreas Weidenhaupt (1738–1805) and Johannes Wiedewelt (1731–1802). It may well be that Friedrich's attempts at dramatic scenes from such Sturm und Drang works as Schiller's play *Die Räuber* (*The Robbers*, 1781) were inspired by Abildgaard. Friedrich's continued ambition as a painter of dramatic scenes is demonstrated by the fact that he exhibited one of the *Räuber* series at the Dresden Academy as late as 1801. At that time Friedrich was still experimenting with studies of figures in histrionic poses in landscapes, such as his *Seated*

Woman (see 30), using an outline-and-wash technique similar to that employed by Abildgaard in his own figure studies.

Important though Abildgaard may have been for Friedrich while he was a student in Copenhagen, it would seem that it was the landscape painting he encountered there that had the most lasting influence. Landscape painting was not taught at the Academy, yet the genre was flourishing in the Danish capital, as it was in other major cities in northern Europe. The work of the recently deceased Erik Pauelsen (1749–90) was much in demand, as was that of his follower Christian August Lorentzen (1749–1828). While concentrating on northern scenes, both artists were strongly influenced by the most internationally famous landscapist of the day, the French painter Claude-Joseph Vernet (1714–89). As with Abildgaard – and indeed the poetry of Kosegarten – the emphasis in such work was on dramatic effects, particularly violent weather. Some early pictures by Friedrich (now lost) depicted similar storms – though this is a form of drama that he gave up in his mature work.

Friedrich had direct contact with Lorentzen through the latter's teaching at the Academy. He also knew Pauelsen's work well through exhibition. A further acquaintance with the work of both artists came through the engraver Georg Haas (1756–1817), for whom Friedrich – by now short of funds – did jobbing work, hand-colouring engravings after the work of the masters.

However it was another landscapist, Jens Juel (1748–1802), who seems to have been the most important for Friedrich's development. When he became his student in the 1790s, Juel was the leading portrait painter in Copenhagen. After training in Hamburg and at the Copenhagen Academy, Juel had travelled to Rome and worked for a time in Geneva. He was adept at painting both elegant portraits for the court and more down-to-earth renderings for wealthy burghers. He seems to have had some knowledge of British art – probably largely through engravings, including the sentiment-laden later landscapes of Thomas Gainsborough (1727–88). There is something of a similar mood evoked in his

17
Jens Juel,
Landscape with Northern Lights,
c.1790.
Oil on canvas;
31·1×39·5cm,
12¼×15½in.
Ny Carlsberg Glyptotek,
Copenhagen

30 Friedrich

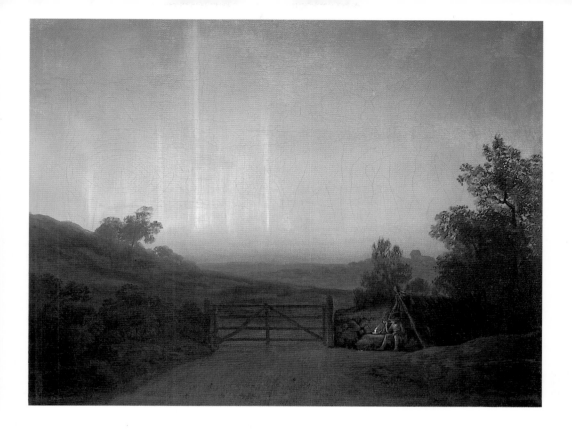

own scenes, usually through careful attention to atmospheric effect. It is this kind of *Stimmungslandschaft*, or 'mood landscape', for which Juel is most prized today.

Unlike Gainsborough, Juel focused on actual views – portraits of places. Yet he gave them a strong sense of mood through his observation of striking light effects. Like other proponents of northern landscape, Juel was particularly impressed by Dutch seventeenth-century art, making a special study of that master of nocturnal effects, Aert van der Neer (*c*.1603–77). The fruit of such work can be found in such pictures as *Landscape with Northern Lights* (17), in which a meditative mood is evoked. This picture, with its pronounced symmetry, seems also prescient of the later work of Friedrich.

Friedrich appears to have been impressed by Juel's insistence on the value of making studies directly from nature. This was a habit

that he mastered in Copenhagen, and which was to lead to a marvellous adaptation of the 'outline' technique he had absorbed for studying classical form. In the year after he left the Academy he was using this method to record the varying shapes of leaves, how they turned and grew, with rare elegance and exactitude (see 41). There is an almost Oriental refinement about some of these plant studies, such as his intricate drawings of reeds (18). Given Copenhagen's position as a centre for international trade, it is not impossible that Friedrich had seen some examples of Chinese painting by this time.

Friedrich may not have decided definitely to specialize in landscape while he was at Copenhagen, although the views he painted there are the best work he had done to date. He made one or two pictures in oil, but did not specialize in this medium until c.1805, when he was established at Dresden. He did,

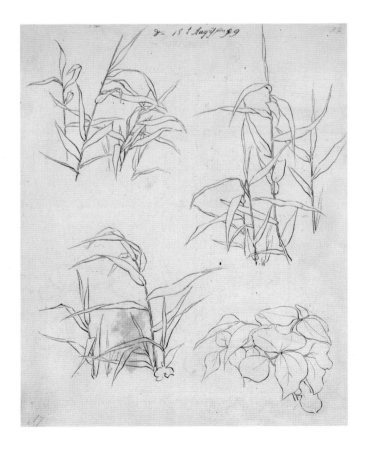

18
Plant Studies,
1799.
Pen;
24×19cm,
9½×7½in.
Kupferstich-
kabinett,
Nationalgalerie,
Staatliche
Museen, Berlin

19
*Landscape
with Pavilion*,
c.1797.
Pen and
watercolour;
16·5×22cm,
6½×8⅝in.
Kunsthalle,
Hamburg

however, paint in watercolour. The choice is an interesting one since watercolour was in such vogue in England at the time. The types of subjects he favoured were 'park landscapes' in which the impact of contemporary picturesque taste is evident. One such is *Emilias Kilde* (1797, Kunsthalle, Hamburg), which shows a monument erected to a recently dead wife by her bereft husband. Others explore such scenery from unusual angles. One of the most interesting is *Landscape with Pavilion* (19). This records the belvedere, or viewing platform, at Klampenborg, a site north of Copenhagen which offers a fine view over a nearby stretch of water, Öresund. Perhaps Friedrich's democratic tendencies were already well to the fore when he painted this picture – there seems to be something almost subversive about the way he has shown us the pavilion but not the view it affords. We are not among those privileged to enjoy the upper-class pleasure of

surveying territory. The pavilion lies on the other side of a bridge. We are barred from this by a gate on a muddy road and all we have access to is a lowly tumbledown hut that leans against a dying tree. Be that as it may, the work shows a competent mastery of effects that was to serve him well as a view painter when he began to build a career for himself in Dresden.

Friedrich's departure from Copenhagen in May 1798 seems somewhat precipitate. Although he had spent the best part of four years in the Danish capital, he had hardly completed his course of study, having been in the life class for no more than a matter of months when he left. Perhaps he was running too short of funds to continue living as a student. Or perhaps he realized that he needed a new artistic direction. In any case his next choice of move – to Dresden – was not altogether surprising. He had contacts there through his old Greifswald master Quistorp, who had studied under the fashionable portrait painter Anton Graff (1736–1813), and the city certainly constituted the most celebrated artistic centre in the Protestant part of Germany. Friedrich had, moreover, developed sufficiently well both as a portraitist and as a painter of landscapes – a genre that was rapidly gaining in popularity – to have some hopes of employment in Dresden.

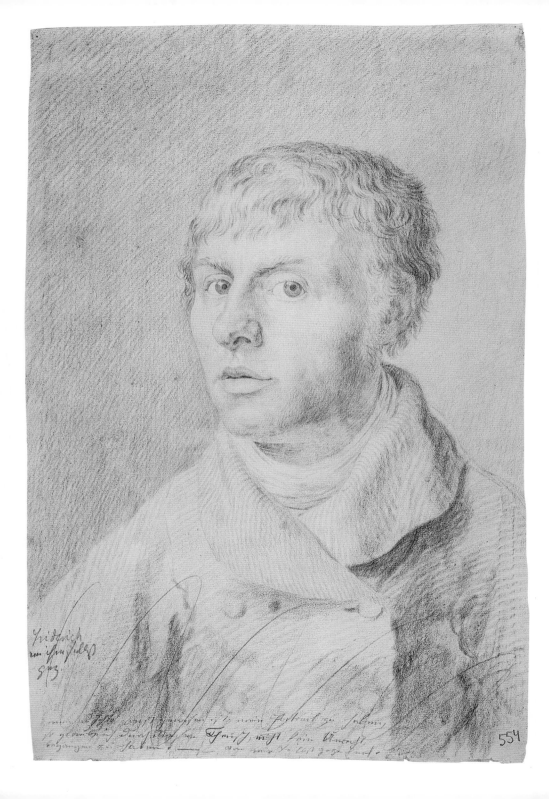

Friedrich
von Greifswald
893

um [...] nicht aussehen [...] zu [...]
so [...] durch [...] ich [...] dich [...] Schrift, nicht sein [...]
[...] zu sehen [...] von mir [...]

554

Friedrich arrived in Dresden in the autumn of 1798, after spending
the summer in Greifswald, and stopping for some time in Berlin
on the way south.

He was to remain in Dresden, with intermittent visits to Greifswald,
for the rest of his life. It was the place where his career developed,
and where he found his mature style as an artist. This was due in
part to chance. Friedrich happened to arrive in the city at a time
when a fashionable new group of writers and critics were estab-
lishing themselves there – the coterie surrounding the brothers
August Wilhelm and Friedrich Schlegel that rapidly became known
as the Dresden Romantics. Although Friedrich was never an
intimate of that circle, he certainly responded – either directly or
at second hand – to their ideas. His early success was due to the
association of his art with them. It was also, in the end, to become
his undoing. For when the Romantics fell out of favour, Friedrich
himself came to be regarded as a relic from a bygone age.

20
Self-Portrait,
1800.
Chalk;
42×27·6cm,
13×10⅞in.
Statens
Museum for
Kunst,
Copenhagen

Friedrich may have been influenced initially in his choice of
Dresden as a place to continue his career by Johann Quistorp,
but there were many other reasons why the city was attractive.
During the eighteenth century Dresden had been systematically
developed as an art centre by the Saxon rulers Augustus I
(r.1694–1733) and Augustus II (r.1733–63). Augustus I (also
known as Augustus the Strong) had exploited the European
discovery of porcelain in 1707 by one of his subjects, Johann
Friedrich Böttger, establishing the famous porcelain factory,
first at Dresden and later in nearby Meissen. The success of this
venture provided the keystone for a general scheme of cultural
aggrandizement. The rulers commissioned splendid baroque and
Rococo buildings that made the city one of the most beautiful in
Europe until sadly devastated by British and American bombers

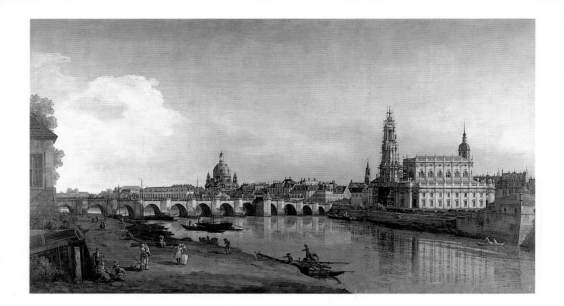

at the end of World War II. At the time that Friedrich arrived, the city looked much as it did when recorded by the Italian view painter Bernardo Bellotto (1720–80) around 1750 (21), the pleasant riverfront dominated by the domes and spires of recently erected churches and palaces.

Dresden was by this time already widely known as the Elbflorenz (Florence on the Elbe). As the poet Johann Gottfried Herder put it in 1802:

Flourish, German Florence, with your celebrated world of art! Dresden is assuredly our Olympia.

The city was treasured as much for its art collections as for its architecture. The Saxon Electors had gathered together both a substantial number of antique sculptures and, most triumphantly of all, a magnificent group of Renaissance and baroque paintings. Raphael's *Sistine Madonna* (often known subsequently as the *Dresden Madonna*), acquired in 1754, was and is the crown of the city's art gallery, the Gemäldegalerie (22).

While the gallery contained many fine works by northern masters – particularly Dutch seventeenth-century painters such as Jacob

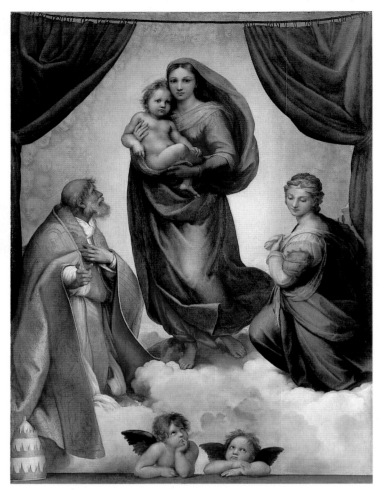

van Ruisdael (1628–82) whose *Jewish Cemetery near Ouderkerk*
is illustrated here (23) – it was the classical sculptures and Italian
pictures that established its pre-eminence. These were particularly
important in a German context, where such works were rare.
The *Sistine Madonna*, for example, was the only work by Raphael
to be found at that time on German soil. The collection fitted in
with the growing taste for the classical during the later eighteenth
century. The Italianate bias also reflected the cultural orientation
of the Saxon Electors. In 1697 Augustus I had been elected King
of Poland and, in order to retain this crown, the Saxon Electors
had converted to Catholicism. There was a strong emphasis on
southern Catholic culture at the court, something that added a

particular charm to Dresden, set as it was in a Protestant country. It was a combination that gave it a particular allure for the Romantics.

Artists throughout Germany were drawn to Dresden's art collection as a place of study. The tendency was strengthened by the establishment of an Academy of Art in 1764. This was ably managed by Christian Ludwig Hagedorn (1713–80) who had ensured that artists of high reputation taught there from the start. He managed to persuade the celebrated topographer Bernardo Bellotto to teach perspective in the 1760s, and imported Anton

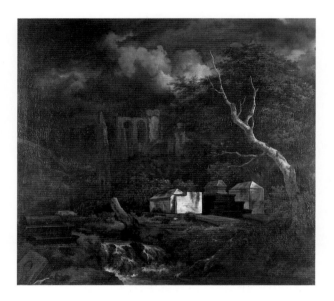

23
Jacob van Ruisdael, *Jewish Cemetery near Ouderkerk*, after 1670. Oil on canvas; 84×94cm, 33⅛×37in. Gemäldegalerie Alte Meister, Dresden

Graff (24) – one of the most accomplished portrait painters of the age – from Switzerland. He also secured two fine landscape painters – Adrian Zingg (1734–1816; see 26), also from Switzerland, and Johann Christian Klengel (1751–1824).

Friedrich enrolled at the Academy soon after he arrived in Dresden. He certainly benefited from the presence of the distinguished landscapists there, making studies of works by Zingg. He also copied the tree drawings of another teacher, Johann Philipp Veit (1768–1837), ironically the person who was to misrepresent his late masterpiece *The Large Enclosure* in an

engraving after it more than thirty years later (see 162, 163). Friedrich turned to Zingg in particular because of the latter's accomplished use of sepia. This medium, a form of wash drawing using a brown ink, enjoyed a particular vogue in Dresden and Friedrich's mastery of it was to be the basis of his early success. The current neoclassical taste for form and line might help to explain why this somewhat subdued monochrome method was

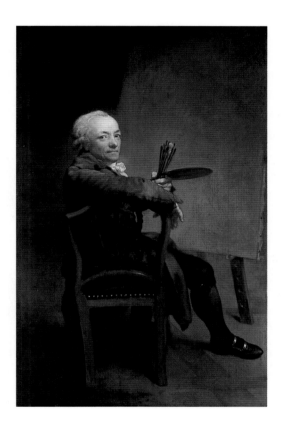

24
Anton Graff,
Self-Portrait
Aged 58,
1796.
Oil on canvas;
168×105cm,
66¼×41¼in.
Gemäldegalerie
Alte Meister,
Dresden

so admired. It also had the advantage of being cheaper to produce than oil painting. Friedrich had experimented a little with oils during his time at Copenhagen. However, it was not until he had begun to make a reputation as an artist, around 1805, that he started using the medium widely.

Despite its celebrated treasures, Dresden was not a particularly prosperous place at this time. Saxony was traditionally an industrious country endowed with the raw materials that would

enable it to play its part in the growing industrialization of Germany in the nineteenth century. The move by the Saxon rulers to become Kings of Poland might have seemed a propitious one. In effect, however, it undermined Saxony's economy – as well as bringing chaos and tragedy to Poland. There was considerable relief when, in 1763, on the death of Augustus II, the association was discontinued. But by then Saxony had suffered defeat at the hands of Prussia in the Seven Years War. This had led to territorial gains by its northern rival, a pattern that was to be repeated in the years to come. Saxony tended to favour the south, first of all siding with Austria against Prussia and then, in the Napoleonic Wars, disastrously aligning its interests with the French. All this put a brake on economic growth and art patronage. The financial position of fine artists in Dresden around 1800 was therefore not an easy one. Nevertheless the newly established Academy, with its annual exhibition, did provide a focus and reputations made there could spread throughout Germany and beyond. Dresden continued to attract art lovers who often made good the defects of local patronage. Friedrich was to sell his work largely to people visiting Dresden from elsewhere.

It may well be that Friedrich's initial reason for moving to Dresden was quite mundane. Coming from the plains of northern Germany, he had never experienced real mountains. Very soon after his arrival he applied for a permit to go to the nearby mountainous terrain known as 'Saxon Switzerland'. As a budding landscape painter, such an experience would have been critical for him. Many of his studies of this time record the remarkable sandstone formations with great clarity, using an outline-and-wash technique that brings out their form, as in *Rock Outcrop* (25). Interestingly, this was a method he normally used for blocking out studies of figures.

Saxon Switzerland was one of those areas of wild scenery that, like Rügen in the north, was now being 'discovered' by artists and picturesque travellers. Its very name was a neologism, coined by the Swiss Adrian Zingg when he first encountered the terrain.

25
*Study of
Rock Outcrop
in Saxon
Switzerland*,
1799.
Pen;
24×19cm,
9½×7½in.
Kupferstich-
kabinett,
Staatliche
Museen, Berlin

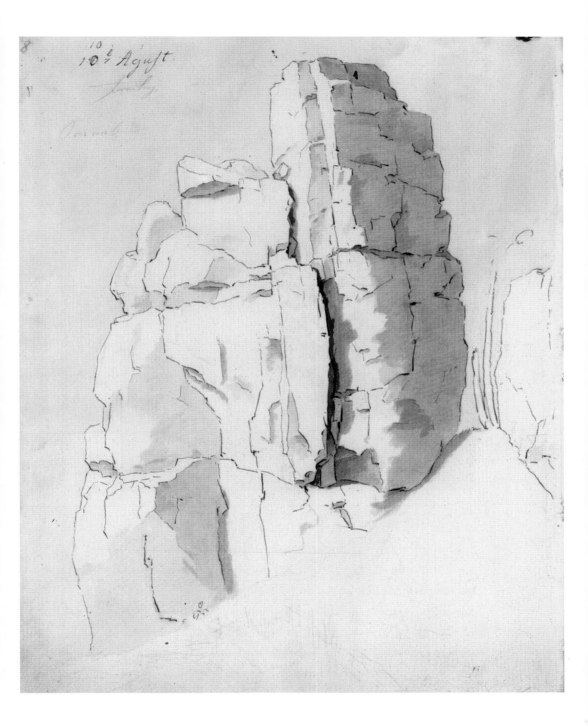

Previously the region had been little visited, being worked by a hard-living local population and having strategic value as a natural defence line between Saxony and Bohemia to the south. Artists who went there were at first treated with suspicion. Zingg, who had not had the foresight to gain a permit in advance, was arrested as a spy on his first sketching tour.

Friedrich followed Zingg in basing the mountains in his pictures on the sandstone outcrops of Saxon Switzerland. He even seems to have copied Zingg in using the wayside crosses to be found in the region as a basis for developing landscapes with religious

26
Adrian Zingg,
The Prebischkegel in Saxon Switzerland,
*c.*1800.
Sepia;
51·2×68·1cm,
20¼×26¾in.
Kupferstich-Kabinett,
Dresden

content. This is a reminder to us that there was nothing particularly unusual about the subject matter of Friedrich's work. It was his mastery of light and the way that he structured his compositions that was so original. Zingg's *Prebischkegel in Saxon Switzerland* (26) depicts a pilgrim kneeling before a wayside shrine. The dramatic light-effects in it show a control of sepia tones that Friedrich was soon to rival. Unlike Friedrich's later scenes of crosses in mountains (see 46), however, it retains a conventional landscape structure with foreground, middle ground and background. There is none of the shift towards

subjective experience in it that formed the basis of Friedrich's mature art.

Friedrich was later to supplement his knowledge of mountains through visits to nearby Bohemia, to the Harz Mountains further north and the Riesengebirge further to the east. These were to form the limits of his travelling. His terrain remained that of northern and eastern Germany.

Knowledge of mountain terrain was important for Friedrich as an aspiring landscape painter, yet it was still unclear whether this would be his ultimate destiny. While studying at the Dresden Academy he eked out a living by working for engravers and giving private tuition. He also acted as a guide for visitors to Dresden. A silent, shy man, with little knowledge as yet of the city, he cannot have been a very congenial or effective performer of this task.

It would seem that it was success at exhibition that rescued Friedrich from these chores. From 1799 he showed pictures regularly at the Dresden Academy, receiving encouraging reviews from the start. In his first exhibiting year a critic singled out a watercolour of a waterfall as 'really good', though the colour was criticized. As well as landscape views, Friedrich also showed emotionally charged figure scenes, similar to the ones he had begun to design in Copenhagen, notably *Die Räuber* series. Usually death is involved, as in the curious picture of grieving figures on a shore beside a blasted tree and wayside cross (27). Friedrich appears at this time still to have subscribed to the conventional belief that landscapes could only bear specific meaning if they encompassed human dramas. It is presumably for this reason that he made such efforts to master the figure and to explore poses that would express feeling, albeit in a somewhat theatrical manner. Even as late as 1801 he was making studies of people gesticulating, leaning or sometimes so grief-stricken as to be unable to do more than crawl along the ground, as in *Figures Kneeling and Sitting on the Ground* (28). Yet at the same time he was progressing slowly and steadily with his observation of nature, building up a repertoire of Baltic and Bohemian views.

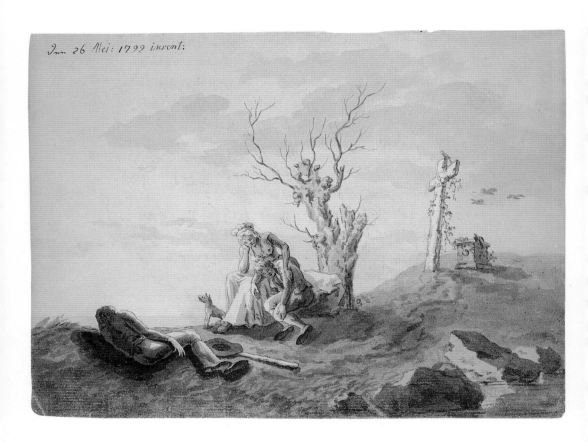

Inn 26 Mei: 1799 invent:

27
*Tragic Scene
on Shore,*
1799.
Sepia and
watercolour;
18·7×23·7cm,
7¼×9¼in.
Kunsthalle,
Mannheim

28
*Figures Kneeling
and Sitting
on the Ground,*
1801.
Pen;
18·5×12cm,
7¼×4¾in.
Kunsthalle,
Mannheim

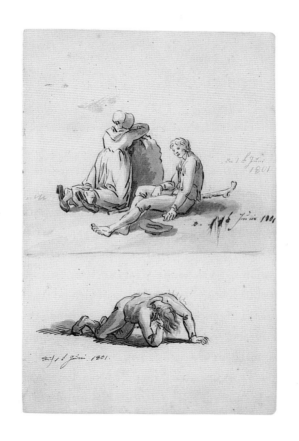

The early years in Dresden were a time when Friedrich was trying out all possibilities. For a while he returned to etching, the technique that he had learned from his Greifswald master, Quistorp. He still felt sufficiently indebted to Quistorp to dedicate one of the results to him. His main artistic debt in these works, however, would seem to be the great Dutch landscape etchings of the seventeenth century. The challenge of etching strengthened Friedrich's sense of precision. In particular it seemed to fit well with rocky terrains, in which strong lines and deep shadow could be explored, as in *Regenstein in the Harz Mountains* (29). The results were appreciated – some of his etchings even being acquired by the current ruler, Friedrich Augustus III (r.1763–1827). Yet he seems not to have found such work particularly appealing and soon abandoned it. He also tried to gain a wider audience for his figure studies (30) through prints. These were emblematic designs, which he sent to his carpenter brother Christian in Greifswald to have cut in wood. Although some – notably 'Melancholy' (31) – have subsequently ranked among his best-known works, Friedrich appears not to have been particularly satisfied with the outcome. For when Christian asked him for more designs, he wrote back suggesting other artists instead.

29
Regenstein in the Harz Mountains, 1800.
Etching;
14·5×22·6cm,
5¾×9in.
Herzog August-Bibliothek, Wolfenbüttel

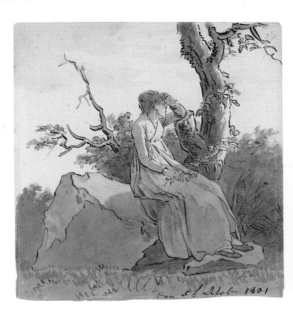
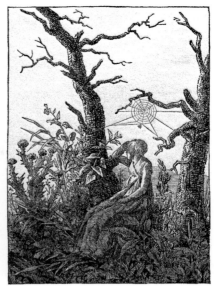

30
Study of a Seated Woman, 1801.
Pen and sepia, 18·6×12cm, 7¼×4¾in (whole page).
Kupferstich-Kabinett, Dresden

31
Christian Friedrich after Caspar David Friedrich,
'Melancholy'; The Woman with Spider's Web, 1803–4.
Wood engraving; 17×11·9cm, 6¾×4¾in

Despite distancing himself from figurative work, Friedrich was to continue for a time to produce portraits, particularly of himself. Friedrich's self-portraits may always be due to some personal circumstance. The remarkable one done in 1800 (see 20) was, as the inscription on it makes clear, a gift to the Danish painter Johann Ludwig Gebhard Lund (1777–1867), a close friend with whom he had shared lodgings in Dresden. The occasion was Lund's departure for Rome to continue his studies. Friedrich shows a pride in his work in his inscription, and well he might. Compared to the genial self-image of the leading Dresden portraitist Graff in middle age (see 24), it is almost Gothic in its angularity. Graff shows himself seated at his work. He swivels round to greet us in an engagingly frank manner. Friedrich's self-portrait is equally, if not more, self-exploratory. Yet it is curiously flat in appearance compared to Graff's work. This could be taken for ineptness, but it could equally be seen as a sign of a way of looking that Friedrich had developed. One curious feature is the position of the head. He is seen three-quarter face, a common position in head portraits which gives both a sense of the face front on and something of the profile. With self-portraiture, however, there is a difficulty about how far the artist can turn his head from the front, as he

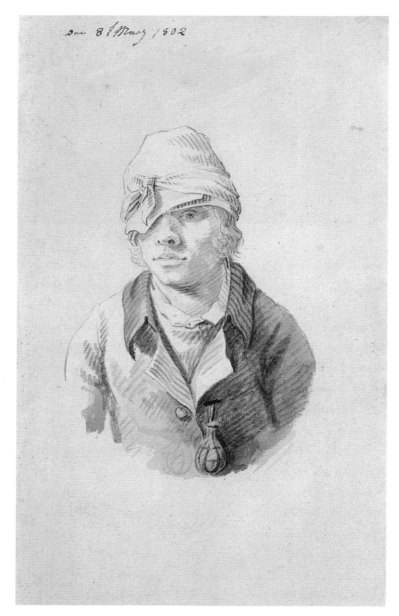

32
*Self-Portrait
with Cap
and Eyeshade,*
1802.
Pencil and
wash;
17·5×10·7cm,
6⅞×4¼in.
Kunsthalle,
Hamburg

still has to be able to observe himself in the mirror he is using to make the picture. Graff has cleverly shown himself swivelling round in his chair to provide a natural explanation for the way in which he looks at us out of the corners of his eyes.

Friedrich, on the other hand, has used no such artifice, and we get the feeling of him turning his head as far as he can to the three-quarters position while still trying to glimpse himself in the mirror. He has turned so far that only one eye can see fully. The other eye peers over the bridge of his nose. This situation may also account for the flatness of effect. For, as will be seen, Friedrich appears to have used only one eye to study himself. The intensiveness of the drawing is brought out by a curious phenomenon. When closely observed, it will be seen that the highlight in it is a reflection of the window of the room in which Friedrich is standing. Here, in the space of a few millimetres, is Friedrich's first interior view of his studio window. Considering his later concern with the 'inner eye' this seems almost prophetic. It is as though he is testing what can be found by looking. At the centre he meets the dark pupil of his eye, suggesting the limits of what can be perceived in the external world.

The single-eye vision that this portrait suggests is referred to more explicitly in the remarkable *Self-Portrait with Cap and Eyeshade* (32) that Friedrich made two years later, when out sketching in Pomerania in 1802. This shows him tying a makeshift shade over one eye so that he can see what he is painting with clear monocular vision. It is a witness to his singular method of observation. The visit to Pomerania was an extended one, lasting well over a year. It is commonly seen as the moment when he succeeded in marking out a definite path for himself as a landscape painter.

Friedrich left to go back to Greifswald, via Brandenburg, early in 1801, remaining in his homeland until mid-1802. Visiting Rügen, he used his new powers of precision to record the famous features of the coastline, such as the dramatic chalk outcrops at Stubbenkammer, in firm outlines (33). These became the basis for

a new range of sepias. Some still showed violent storms – rather in the melodramatic manner of the celebrated French landscapist Claude-Joseph Vernet. But there were also works that assumed a new contemplative force. One of the most successful of these – a composition that Friedrich was to repeat many times in the years to come (34) – was a view of Cape Arkona, then the northernmost point of Germany. Based directly on a fine outline made on the spot, *Arkona, with Rowing Boat* (35), the composition shows the influence of the picturesque, particularly in the way that the rugged foreground is set against the distant view of the main subject of the picture. Yet Friedrich is unusual even at this stage in the emphasis that he places on contrast. When sketching the scene, he must have sat low down to make the bushes on the

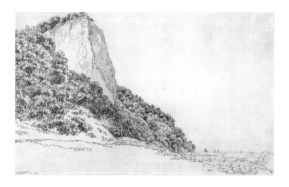

shore rear into the sky and the oar on the beached boat point, almost like an arrow, to the famous headland in the distance. Such silhouetted shapes are already beginning to take on some of the strangeness that marked his abbeys and mountain tops of a few years later.

When Friedrich exhibited his sepias in the 1803 exhibition at the Dresden Academy, following his return, they were enthusiastically received. 'They are generally applauded, and deserve to be so,' reported his fellow Pomeranian, the artist Philipp Otto Runge, to his brother Daniel on 6 April 1803. Despite being himself impoverished, Runge bought two such views – one for himself and one for Daniel.

33
Stubben-kammer, Rügen, 1801.
Pen;
23·6×36·6cm,
9¼×14⅜in.
Museum der bildenden Künste, Leipzig

34
Cape Arkona, 1805–6.
Pencil and sepia;
60·9×100cm,
24×39⅜in.
Graphische Sammlung Albertina, Vienna

35
Arkona, with Rowing Boat, 1801.
Pen, squared up with pencil;
23·5×36·5cm,
9¼×14¼in.
Kupferstich-Kabinett, Dresden

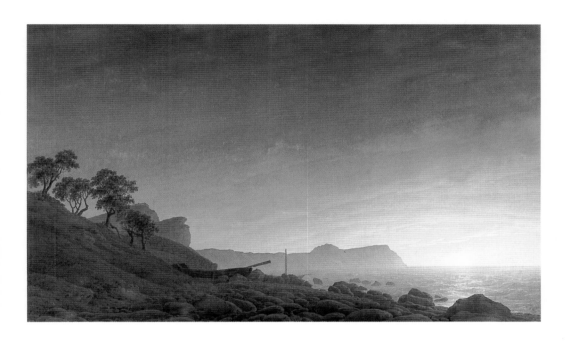

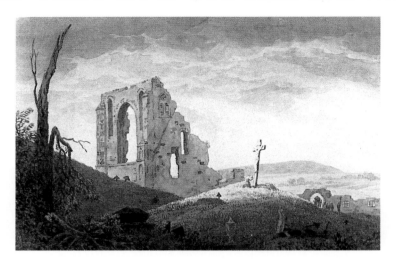

36
*Ruin of Eldena
with a Burial,*
*c.*1800.
Sepia;
15·5×21·9cm,
6⅛×8¾in.
Formerly
Kupferstich-
kabinett,
Dresden
(destroyed)

Once back in Dresden in the middle of 1802, Friedrich began to apply his mastery of sepia to increasingly adventurous subjects. While not abandoning his successful line in northern views, he supplemented this with a new kind of 'mood' landscape in which scenes and dramas are acted out. In contrast to his earlier figurative work, these contain much smaller figures. They are definitely landscapes first and foremost. Yet while the figures have shrunk, the dramas acted out are, if anything, more extreme. The ultimate here must surely be the work exhibited in 1804 entitled *My Burial.*

This sepia is now lost. According to descriptions of it, however, it shared many features with an earlier sepia of *c.*1800, *Ruin of Eldena with a Burial* (36), which shows a funeral taking place in a churchyard, a blasted tree in the foreground and the ruined abbey behind. Visually the picture owes much to Ruisdael's *Jewish Cemetery* (see 23), one of the most celebrated works in the Dresden gallery. This picture – which later became the subject of an essay by Goethe – attracted increasing attention because it seemed to suggest a new way in which landscape could convey meaning. It was widely believed to represent an allegory on the transience of life and the promise of redemption beyond – the former being shown in the ruins and graves of the foreground, the latter in the rainbow in the sky behind. Undoubtedly this

work was the starting point for a journey in Friedrich's art that was to reach fulfilment with *The Abbey in the Oakwood* (see 73).

While we can say little about Friedrich's lost representation of his own burial, we can gain a sense of the kind of response it elicited from surviving reviews. These show full recognition that a new direction in landscape is being achieved. One reviewer, in *Der Freimüthige und Ernst und Scherz*, explained the subject in terms of the artist's melancholy, telling the story of the drowning of his brother Christoffer (see Chapter 1). Another reviewer, in the prestigious *Journal des Luxus und der Moden*, recognized Friedrich's method as part of a new movement 'which is seeking to reintroduce the spiritual into art through poetry'. Part of this process was to paint pictures that are evocative, appealing to the 'imagination of the spectator'.

The new movement referred to here, with its interest in mysticism and appeal to the imagination, was that of the Romantics. By 1804 it was becoming clear to spectators that this was now the context in which Friedrich's art should be viewed.

Friedrich's first direct encounter with the writers of the Dresden Romantic circle seems to have come when Runge introduced him to Ludwig Tieck in the summer of 1803. A fellow Pomeranian, Philipp Otto Runge had also studied in Copenhagen before coming to Dresden in 1801. An artist with strong intellectual interests, he rapidly made contact with members of the Romantic circle and had developed under their influence his remarkable cycle *The Times of Day* (see 39). As will be seen, this cycle was to be highly important for Friedrich. Tieck, who had been involved with the group from the start, was the writer who did most to popularize their views. Like the others, he had always been strongly interested in the visual arts. His novel *Franz Sternbalds Wanderungen* (*Franz Sternbald's Wanderings*, 1798) was a historical fantasy about the experiences of an apprentice of the great hero of German art, Albrecht Dürer (1471–1528), in the sixteenth century. However, the art discussed in this work was more connected to the present than the past. One of Tieck's

characters is a mystically inclined landscape painter who paints works conveying ecstatic and puzzling light-effects. He could almost be Caspar David Friedrich *avant la lettre.*

By the time that Friedrich met Tieck, the headiest moments of the movement had already passed. The two most impassioned and visionary members of the group, Friedrich Wackenroder and Novalis (Friedrich von Hardenberg), had died young, while the principal theorists of the movement – the Schlegel brothers – were beginning to embrace more orthodox positions. Yet despite this, there was no doubting their impact and continuing influence. This was partly a matter of semantics. It had been Friedrich Schlegel who had first defined Romantic poetry as 'progressive universal poetry' in an essay of 1798 published in *Athenaeum*, the journal he edited with his brother August Wilhelm.

Romanticism is such a complex and diffuse phenomenon that it can hardly be discussed in any detail here. However, it would be helpful to gain an idea of how the Schlegels viewed the term and why they selected it, as their usage (as opposed to any wider cultural definitions) was of direct significance to Friedrich and other artists working in Dresden. The word was chosen, in the first place, in reference to the fantasy of the medieval Romance. It was 'modern' in the sense that it indicated the general temper of the Christian, post-classical world, rather than specifically that of the 1790s. Yet the reason for drawing attention to the quality in the 1790s was very much to do with contemporary circumstances. Its usage was a protest against what the Schegels saw as the soulless intellectualism of the eighteenth century. The rationalists of recent times, they argued, had made a fatal separation between the mind and the body. They had tried to understand the world through reason alone. Worse still, they had promoted practices that had led to the undermining of society. Their key witness here was the French Revolution, in which an attempt to organize society on rational grounds had led to the outbreak of barbaric mob rule. Equally they saw the rampant commercialism of the time – aided by technological advance that was causing mechanization of

production – as splitting society apart, leading to the misery of sweated labour. Man is not just a thinking animal, they argued. Man is a complex psychological being for whom feeling and the imagination are as important as thought. The use of the word 'Romantic' was an attempt to focus attention on these aspects of humanity that seemed to be all too easily neglected in the contemporary world.

Later, this way of looking at things led to the promotion of medieval revivalism, a desire simply to turn the clock back to how life had been in some imagined caring and spiritual community of the Middle Ages. Friedrich Schlegel, who converted to Catholicism in 1808, was a leading promoter of this tendency which, in the visual arts, led to the founding (also in 1808) of the Brotherhood of St Luke – later known as the Nazarenes: that group of German artists who sought to return to the painting style of the fifteenth century. In 1798, however, this was not the road that was being proposed. For Friedrich Schlegel at this point accepted – as did his brother August Wilhelm – that the past could never be recovered. It could only be held up as a paradigm. We might yearn for it, and seek to raise consciousness about it. But our position was that of one who has left the Garden of Eden. It was this recognition that encouraged Friedrich Schlegel to develop the concept of 'romantic irony', in which there was an understanding that what you were yearning for was on one level fruitless and your efforts doomed to failure. Yet it was also a recognition that gave a particular and new importance to the creative individual, particularly the artist, in the fallen contemporary world. For it was believed that the 'imagined' world of artistic activity was the one in which the lost harmony could be reinvoked. It is this that caused Novalis to write: 'The world must be romanticized, so that the original meaning can be rediscovered.'

This recovery, then, was an imaginative one, but that did not make it any the less real. The Romantics drew strength from the philosophy of Immanuel Kant, who had established the existence of innate categories of the mind. In contradistinction to the

rationalists – who held that the human mind was a *tabula rasa*, a thinking machine that organized material in it according to the 'evidence' of the sense data it received from the outside world – Kant asserted that the mind had innate categories which shaped experience. This was used by the Romantics to postulate the notion of a primal inner self, which predated experience and remained intact within each of us. Even in a fallen world such as ours, the argument went, the lost paradise could still be glimpsed by looking inward and reconstructing it in the mind. It was, in effect, this process of attempted recovery – the yearning, the sense of the distance between the contemporary individual in his fallen world and the desired or dreamed-of ideal – that was seen as 'romantic'. Such an idea was not, of course, new. It was essentially what formed the basis of Platonic philosophy. But Kant's philosophy gave it a new relevance, vindicated it in modern terms.

It was partly because of the philosophy of Kant and his followers that the formulation of Romantic theory came from Germany. It remains a matter of debate as to whether similar developments that were taking place in the cultures of other countries – in particular Britain and France – could be described in similar terms. While the yearning for nature and the Middle Ages and the heroicization of the creative individual were shared phenomena, there was not a similar understanding of the philosophical position.

German Romanticism was also different in its attitude to national culture. In its original formulation, Romanticism had been seen as international and universal in its approach. This had been the view of Wackenroder and Novalis, who had argued in different ways for tolerance between cultures and who had seen European culture as being a single entity in the Middle Ages – the vision conjured up by Novalis in *Christenheit oder Europa* (*Christianity or Europe*, 1799). However, the emphasis on the innate also led to the view of nations as natural and organic – a concept that was to nurture, in the twentieth century, the poison plant of fascism. In the early

nineteenth century it began to lead to the call for national unity. Germany was then, as mentioned, an amalgam of disparate states. Yet every German individual had the nation, so to speak, within their own psyche. There was a Germany shared by all Germans in their inner being. It was a feature of this belief that caused such an interest in folk culture, the only remaining communal expression of this identity. In their famous collection *Kinder-und Haus-Märchen* (*Fairy Tales*, 1812–22) the brothers Jacob and Wilhelm Grimm spoke of the stories they had gathered as the seeds that survived from a harvest that had been destroyed. They hoped to use them to replant a German sense of national identity. All this was to become increasingly important during the period of the Napoleonic invasions and will be discussed in Chapter 4.

One striking feature of these Romantics is their interest in the visual arts. They saw the visual as communicating at a deeper and more primal level than words, which they associated with logic. The very book that has been held to have started the movement, Wackenroder's *Herzensergeissungen eines kunst-liebenden Klosterbruders* (*Outpourings of the Heart of an Art-Loving Monk*, 1797), focuses on a monk writing about the art of the fifteenth century – thereby bringing art and religion into close association. Wackenroder's imagined monk talks of the 'two wonderful languages', nature and art. Nature is the language of God. Art is the language of man, which is specifically contrasted with 'words' for invoking the spiritual. Similarly the Romantics were obsessed with the function of the symbol – the visual image (literal or imagined) that held a meaning that transcended the rational. Novalis's key novel *Heinrich von Ofterdingen* (1802) begins with a vision of a mysterious blue flower that the hero pursues without resolution through the narrative (partly because the book itself remained unfinished). Another favoured image was the hieroglyph, the secret pictorial sign. The Romantics encouraged the view of art as a kind of magic, that enthralled and enhanced. Poetry came nearest to this in the world of words, and their approach, with their own use of words, can be called, broadly, poetic.

The Romantics also encouraged the fact that the visual arts stimulated the imagination of the beholder, thus becoming a way of encouraging the spectator to enter the lost primal world. This became evident in August Wilhelm Schlegel's essay 'Die Gemälde' (The Pictures) in *Athenaeum* (1799) which comprised a discussion between three people of works in the Dresden Gemäldegalerie. The three – an intellectual man, a woman of sensibility and an artist – all approach the pictures in different ways. Each way, Schlegel is saying, has its own validity. What is important is the stimulus. Raphael's *Sistine Madonna* (see 22) takes pride of place, unsurprisingly. It is here that the notion of art as religious experience is explored most fully. The visionary view of this picture drew on a section in Wackenroder's *Outpourings* in which, by creatively misreading a comment of Raphael's in a letter, he postulated that the artist's most inspired images of beauty (*ie* the Virgin) came to him in a dream. It is interesting to reflect in this context that the Romantics took great interest in the visual and symbolic nature of dreams, in some ways prefiguring the speculations of Sigmund Freud in this area.

Since the Romantics were so interested in the visual, it is not surprising to find that fine artists responded to the new dispensation that seemed to be offered them. Yet it must be said that this was not without its problems. The first art to be described as being 'in a romantic style' was in fact the outlines (37) to Tieck's play *Genoveva* by the brothers Franz (1786–1831) and Johannes Riepenhausen (1788–1860). Outline, as has been seen in the discussion of Friedrich's time as a student at Copenhagen, was admired by classicists as the ultimate and most succinct means of defining form. But, with brilliant insight, August Wilhelm Schlegel reinterpreted the outline as a stimulus to the imagination. In a review of the celebrated outlines to the works of Homer and Dante (1793; 38) by the British neoclassical sculptor John Flaxman (1755–1826), he had considered the process of using a single line to evoke form to work 'like magic formulae'. The outline, in his eyes, was a suggestive sketch, completed by the viewer in his or her imagination. Yet it must be confessed that the

37
Ernst Ludwig Riepenhausen after Franz and Johannes Riepenhausen, *The Madonna and Child Appearing to St Genoveva*, 1806. Etching; 24×30cm, 9½×11⅞in

38
Thomas Piroli after John Flaxman, *Compositions from the Hell, Purgatory and Paradise of Dante Alighieri; Paolo and Francesca Leaving Dante*, 1793. Engraving; 29·2×45·5cm, 11½×17⅞in

Riepenhausens' laboured lines do not work like magic formulae. These worthy brothers were the illustrators of Romantic ideas, rather than their enactors. Their position – they went on to become respectable if uninspired revivalist artists in Rome – was an indication of the dangers of a visual artist trying to carry out the ideas of a theorist.

It might seem that Runge – the visionary painter of nature most closely related to the Dresden Romantics – fell into a similar trap. Coming to Dresden in 1801, he was particularly close to Tieck, planning joint projects with him. Like the Romantics, and in the spirit of William Blake and the metaphysical poets, he saw nature as full of mystical signs of a higher state of being, similar to the secrets then supposed to be concealed in the hieroglyphs of

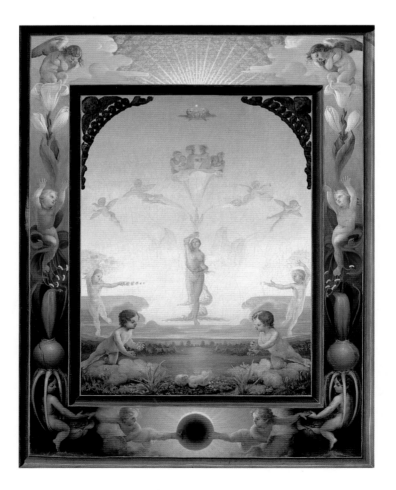

39
Philipp Otto Runge,
Morning
(small version),
1808.
Oil on canvas;
109×85·5cm,
42⅞×33¾in.
Kunsthalle,
Hamburg

ancient Egypt. His aim was, in effect, to re-mythologize art, to give it the spirituality that it had once been invested with as the servant of ancient religions. The Riepenhausens might be accused of dullness. The charge against Runge was incomprehensibility.

Runge's key work was the *Tageszeiten* (*Times of Day*), a cycle of four pictures, symbolizing morning (39), midday, evening and night. Using the Romantics' notions of affinity and association, he made this cycle stand for all religions and mythologies under the broad basis of Christianity. He envisaged the whole being carried out in large oil paintings – in which colour, of critical importance to him, would play its part. These would be set up in a special chapel-like building where they would be viewed as a backdrop to performances of poetry and music. He would thereby create a *Gesamtkunstwerk* (total work of art) that was universal and spiritual.

Runge designed his scheme as outlines and had these published as engravings. However, while outline might be effective in inspiring the imagination to complete a single form, it is a harder task to make it invoke the multifarious layers of association that Runge had in mind. The most common response to Runge at the time was bafflement. Goethe, indeed, thought the artist had gone mad. The *Tageszeiten* became used as a prime example of that typical kind of Romantic failure – the failure to communicate the inner vision that became the theme of Balzac's novella *Le Chef-d'oeuvre inconnu* (*The Unknown Masterpiece*, 1837) in his own exploration of the limits of Romanticism in the visual arts. Yet, in a way, this was tragically untrue. First, anyone who reads Runge's inspiring prose descriptions of his project – for example, in his letters to his brother Daniel – can see the real power of imagination that lay behind his designs. Armed with such knowledge, these beautifully crafted hieroglyphs can become true gateways to an enthralling vision. The slur is also untrue in another way. Runge had always intended his outlines to be no more than initial designs, ones that he would later flesh out with the more sensuous effects of paint. In paint, the power of light – that mystical power that was so

important to him – becomes evident (see 39). But by the time he came to realize his project in this form Runge had been forced to leave Dresden through lack of funds. He painted alone, in isolation, supported by Daniel, a merchant in Hamburg. He died young, in 1810, his project incomplete.

In some ways Friedrich might seem to have continued the course that Runge began – particularly in the communication of a vivid sense of the visionary through painted light. Yet while both shared an interest in the mystical in nature, there remained a

fundamental distinction between them in approach. Runge was first and foremost a man of ideas, which he sought to clothe in visual form. Friedrich is essentially an observer, who works from direct experience towards the intimation of an idea that is never fully expressed, never reaches the point of dogma or theory. One symptom of this difference can be found in the comparison of their approach to the organic forms of nature. Runge seeks literally to reshape these in geometries of his own devising. He once designed a cornflower as a perfectly spherical form, its petals

spreading out to fit the preordained shape (40). How different this is from the attention to the accidents of individual form that is the basis of Friedrich's meticulous sketches (41). The studies of both artists are masterful in their draughtsmanship, and in their exploration of the wonder of natural form. Both could be used to illustrate Novalis's saying that a leaf or a twig could create 'epochs in the soul'. Yet in one case the wonderment comes from a conception and in the other from a perception.

It might seem that the Riepenhausens had failed to realize the Romantic vision through interpreting the words of the Schlegels too literally, Runge through being carried too far by their implications. Friedrich, in this equation, might be seen as the one who related it to concrete experience. He drew inspiration from the Romantics' perception of the visual, and even more from their fundamental belief in the creative inner self. But he also knew that the vision had to be communicated, and that this was a matter of practice. The reviewer who had recognized the new mystical tendency in Friedrich's *My Burial* had warned him not to neglect the 'mechanical' side of his art 'because this is necessary for the achievement of beauty in representation'. Friedrich did not need reminding of this. However much he took from the Romantics, he was careful to ensure that it would be communicated to the spectator through the application of true visual knowledge and skill.

It is a sign of this that Friedrich should have conceived his *Jahreszeiten* (*Times of Year*, 42–45) at the time that he was encountering Runge's heady talk about his *Tageszeiten*. Superficially the works might seem to be about the same kind of claim. Both show a cycle of nature and use it to draw analogies with human life and universal verities. But whereas Runge is seeking a total visionary experience, Friedrich is more modestly telling a story. He is using the different phases of the year to stage a narrative about human life. The analogy is a traditional one, and there is no difficulty in following the associations. It is a sign of this that, while Runge's cycle was widely regarded by

40
Philipp Otto Runge,
Geometrically Constructed Cornflower,
c.1808.
Pen and ink;
25×19cm,
9⅞×7½in.
Kunsthalle, Hamburg

41
Plant Study,
1799.
Pen and wash,
23·6×18·7cm,
9¼×7¾in
(whole page).
Kupferstich-kabinett,
Staatliche
Museum, Berlin

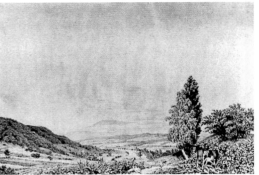

contemporaries as wilfully eccentric, Friedrich's series was praised for demonstrating the way in which the contemplation of nature could lead us to understand the deeper meaning of things. It was used explicitly for this purpose by the scientist Gotthilf Heinrich von Schubert in his book *Ansichten von der Nachtseite der Naturwissenschaft* (*Views of the Dark Side of the Natural Sciences*, 1808). Schubert first visited Friedrich's studio in 1806 and his account seems to relate particularly to an early version of the *Jahreszeiten*, now unfortunately lost. Schubert connects Friedrich's art to a cosmology in which intimations of a future higher existence can be found in lower forms of life. By extension, this means not only that human life is prefigured in that of lower creatures, but that the future human life in eternity is prefigured by signs in man's earthly existence. It is this 'History of the formation of our nature' that Schubert felt Friedrich had grasped.

In an extended description of the *Jahreszeiten*, Schubert takes us through the four scenes. In the spring with its 'clear source', all is birth, the morning-time of day and the spring of the earth. And it is peopled by children, who are looking towards the sun, still glimpsing the eternity they have just left, according to Platonic thought. This is followed by the midday and the middle of life on a rich and fertile plain. The people here are young lovers, and the landscape seems deliberately to draw upon the classical arcadian imagery of the seventeenth-century French landscape painter Claude Lorrain (*c*.1604–82). The lovers in the bower might come directly from Claude's *Acis and Galatea* (see 63) in the Dresden art

42
Spring,
1803.
Sepia;
19×27.5cm,
7¹₂×10¾in.
Formerly
Reichskammer
der bildenden
Künste
(destroyed)

43
Summer,
1803.
Sepia;
19×27.5cm,
7¹₂×10¾in.
Formerly
Reichskammer
der bildenden
Künste
(destroyed)

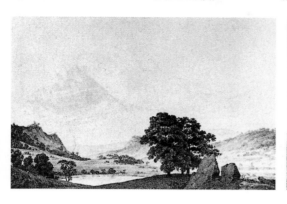

44
Autumn,
1803.
Sepia;
19×27·5cm,
7½×10¾in.
Formerly
Reichskammer
der bildenden
Künste
(destroyed)

45
Winter,
1803.
Sepia;
19×27·5cm,
7½×10¾in.
Formerly
Reichskammer
der bildenden
Künste
(destroyed)

gallery. Autumn follows, with sublime and awe-inspiring visions of mountains. Finally there comes winter, with ruin and death. The ruin is based on the abbey of Eldena (see 6) and is by the sea. This fits in with the general theme of the 'river of life' which has flowed from its spring in the first picture, through fertile country, then through the mountains, to end up running into the great sea of eternity. Schubert concludes: 'The sky reveals itself above the sea once more in its clear blueness as it did in our early childhood. There in a prophetic glimmer we get the vision of the cast of a faraway land across the sea.'

It is hard to detect a distant land in any known versions of the picture of winter (45). This raises the question of how closely Schubert's interpretation actually fits Friedrich's intentions. However the main point is that Schubert, like so many of the artist's contemporaries, felt confident that his response was a valid one, that his being stimulated to imagine an interpretation of Friedrich's pictures was a key part of their function.

This series of *The Times of Year* did in many ways show the coming together of two elements that Friedrich had developed more separately before: the landscape of meaning on the one hand and the landscape of observation on the other. In the case of the landscape of meaning, we can see here the first clear impact of the Romantic circle – mediated to some extent almost certainly through the example of Runge. From now on Friedrich's views had a 'meaning'; they had taken on a subject in the way that figurative

art had done. But this meaning was also seen as coming both through the traditions of art and, most importantly, through the artist's own observation of differing terrain. The ecstatic 'morning' or 'spring' shows a direct response to Runge in the small putti-like children looking up in ecstasy at the light. In Friedrich's scheme, however, this is but one section. Summer, as has already been said, reaches back to the classical tradition, and also shows how closely Friedrich had been studying the works in the picture gallery at Dresden. The same could be said for *Winter* – a further development of a theme indebted to Ruisdael's *Jewish Cemetery* (see 23).

Yet *Winter* is also something else. For while the imagery of ruin, dead tree and graves can be related to Ruisdael, the composition cannot. In this, it is quite different from the earlier burial sepia (see 36) in which the structure of the picture follows the staging of Ruisdael. Here it has been replaced with a more direct and awesome use of silhouetted forms in which the abbey and the dead tree come together to form a zigzag outline. They fuse into a truly enigmatic shape that has nothing to do with traditional patterns of recession – a hieroglyph, if you like, but in any case a form that has a peculiar presence and mood and power of its own. It is here that symbolism begins in Friedrich's work. He moves beyond the 'closed' system of allegory to a more mysterious and evocative form of meaning that remains open and vibrant. This is something new, so much so that certain scholars have argued that the image must be a later one. But I believe, with Börsch-Supan, that it was painted at the same time as the others and is a harbinger of the future direction of Friedrich's art. It is a truly meditative work, the imagery of death leading the artist to discover something new within himself, something that he could forge into his own particular artistic persona, as will be seen in the next chapter.

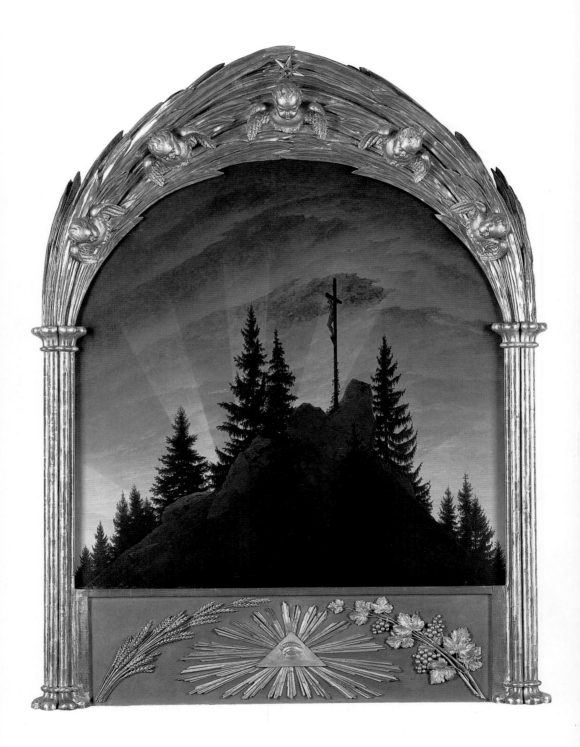

There comes a time for every successful artist when they achieve
a way of working that is uniquely their own. Traditionally this has
been seen as a process of self-realization – though nowadays there
is a preference for calling it self-invention. In Friedrich's case it
was probably a bit of both, though he himself certainly saw it
as the former. A true child of his age, he firmly believed artistic
expression to be a sincere expression of the self. As he once said:
'A picture must not be invented but felt.'

46
The Cross in
the Mountains
(Tetschen
Altar),
1808.
Oil on canvas;
115×110·5cm,
45¼×43½in.
Gemäldegalerie
Neue Meister,
Dresden

It was during the years 1805 to 1809, when Friedrich was in
his early thirties, that this process took place. He moved from
painting fine but relatively conventional sepias with fashionably
romantic themes to the production of large oils of unprecedented
appearance. He was encouraged by the attention he received to
risk effects of increasing originality and boldness. His first major
success came in August 1805 when he won half the prize in the
seventh and last of Goethe's Weimarer Kunstfreunde (Weimar
Friends of Art) competitions for two sepia works, *Summer
Landscape with Dead Oak* (see 47) and *Procession at Sunrise*
(see 48). Half a prize does not seem much, until it is remembered
that this particular award had not originally been intended for
landscape painting at all. Goethe and his collaborator, the Swiss
painter Heinrich Meyer (1760–1832), had set up the competition
in order to foster classically inspired history painting, in emulation
of the French Academy. In this case the sharer of the prize of a
hundred and twenty ducats was a Herr Hofmann from Cologne for
his scene of *Hercules Cleaning the Augean Stables*. Weimar was at
the time a leading cultural centre – not least because of Goethe's
reputation as the leading poet of the age. Goethe himself took
a keen interest in the visual arts and had established the Weimar
Art Competition in an attempt to improve standards in Germany.
A year later Friedrich began to work in oils, a development that

gave his work increasing prominence in exhibitions and culminated in the exhibition of *The Cross in the Mountains* (46) in his studio at Christmas 1808. This work was challenging both on account of its striking appearance and because it was designed to function as an altarpiece. Never before had anyone taken the step of using a landscape painting for such a specific devotional purpose. The controversy this caused made Friedrich a national celebrity. Eighteen months later, in the summer of 1810, he was to crown this success by the equally sensational exhibition at the Berlin Academy of what are perhaps his two masterpieces, *The Monk by the Sea* and *The Abbey in the Oakwood* (see 72, 73).

This change in Friedrich's work might be seen simply as a process of maturing. It is very common for dedicated and thoughtful artists to find their feet when they are in their early thirties. But there were also a number of external factors that helped the development to take place.

In the last chapter it was observed how Friedrich had engaged with the heady ideas of the Schlegels and their associates, introducing more exotic and evocative themes into his work. By 1805, however, the Schlegel circle had all but dispersed. In some ways this might have been to Friedrich's advantage. As he himself admitted, he was not particularly learned and felt somewhat out of his depth in the presence of such accomplished intellectuals. It almost seems that, once left to his own resources, the artist could develop further on his own, and find pictorial expression for so many of the concepts that had, for a time, threatened to overwhelm him.

It was at about this time that Friedrich came into contact with a number of theological and scientific writers who seemed to have a closer sympathy with the artist's central concerns. The most famous of them was Daniel Friedrich Schleiermacher, now generally recognized as one of the key figures in the development of modern Protestant theology. It had been Schleiermacher who, in a remarkable book of 1798, *Über die Religion: Reden an die Gebildeten unter ihren Verächtern* (*On Religion: Speeches Addressed*

to the Cultured among its Despisers), had sought to reassert
the relevance of religion to an increasingly agnostic intelligentsia.
Rejecting outer rituals, Schleiermacher concentrated on a
subjective response to the mysteries of divinity, thus appropriating
the secular mysticism of the Romantics and reapplying it to
conventional faith. For him, religion was 'feeling' – the sense
that God lives and works in us as finite human beings. This was,
it could be argued, exactly what Friedrich sought to achieve in
his landscapes. He was using a modern art form, based on the
fashionable taste for nature, to engage the spectator in spiritual
experience commensurate with traditional belief.

Friedrich certainly knew Schleiermacher, though he possibly
did not meet him before 1810. More immediately important
for him were a number of scholars inspired by Schleiermacher's
ideas, in particular the artist's early apologist Gotthilf Heinrich
von Schubert (see Chapter 2), Friedrich August Köthe, professor
of church history at Jena (then one of the most celebrated
universities in Germany, where Schiller and Hegel taught)
and Johannes Karl Hartwig Schultze, a particular devotee of
Schleiermacher, who taught in Weimar. There is evidence both
in reminiscences and in surviving letters that Friedrich was
particularly close to Schubert, Köthe and Schultze; indeed,
the latter helped him to prepare the defence of his *Cross in
the Mountains* when it came under public attack in 1809.

Friedrich undoubtedly saw his development as an artist at this
time in terms of spiritual struggle. It is a feeling that comes out
in a poem he wrote at that time, in which he describes his
experience of the conflict of good and evil. The first verse begins:

A being dwells within me that is constantly lifting me heavenwards …

This is contrasted in the second stanza with:

There is a will inside me that binds me firmly to the earth …

And in the final verse he concludes:

Thus I waver between good and evil like a reed blown in the wind.

This is standard confessional poetry in one sense, similar in meaning to Martin Luther's dictum 'Simul justus, simul peccator' (At the same time upright and a sinner). Friedrich, who came from a Lutheran background, would have known that saying well. However, the poem also expresses the new significance that Schleiermacher and his followers attached to inner feeling in their effort to reassert the importance of religious experience in the modern world.

Schleiermacher was criticized by many for placing too much emphasis on emotive response at the expense of the traditional doctrines of the Church. The stress on feeling also encouraged Friedrich to concentrate on devising forms of painting that did not depend primarily upon traditional allegorical conventions, but which 'worked' in terms of visual impact. He was always very clear that works of art had to be pictorially effective to succeed.

This view can be found in a letter that Friedrich wrote to Köthe in January 1811, when he was at the height of his fame following the recent success of *The Monk by the Sea* and *The Abbey in the Oakwood* in Berlin. He was writing to thank the scholar for the gift of three of his lectures. Perhaps slightly to excuse himself from having to make a detailed commentary on these, he said:

You know, dear Köthe, that I am not one of the highly learned artists of our time. It will not offend you therefore to learn that I have only partially understood your lectures. I am not one of those speaking painters of whom there are so many now, and who are capable of saying twenty-four times in one breath what art is: whereas they would not be able to show in twenty-four years what art is on one single occasion in their pictures. And so it has come about that these gentlemen express with words that which they are incapable of achieving with colours and forms.

Friedrich then anticipates that if such 'writing painters' gain the upper hand it will not be long before people will be sticking texts on walls rather than pictures:

Then we will be relieved of that great misfortune of having to spoil walls by driving huge nails into them to hang up pictures. Instead we will in future only have to stick on the wall the most beautiful and sublime thoughts expressed in words.

Friedrich's need to make this point to his intellectual friend emphasizes how important the visual remained to him. He was not a theorist like Runge, and he knew it. It also suggests that he was aware of the danger that some of his apologists might misinterpret his pictures, believing them to be more concerned with programmatic meanings than the radical new type of imagery that he had pioneered.

This tendency to misread – or perhaps one should say *over-read* – Friedrich's work was to some extent a consequence of the fashionable Romantic themes that the artist explored before he began to develop his new pictorial language. Such themes can be seen in the two works that gained him half the prize in the Weimarer Kunstfreunde competition of 1805.

It is hard to gain an idea of the original impact of these award-winning sepias because they have become badly faded. They were praised at the time for the fineness and naturalism of their effects, so one must presume that they would have exhibited that masterful control of lighting and atmosphere that can be found in Friedrich's other sepias of the period which are still in good condition, such as the view of Arkona now in Vienna (see 34).

When the two works are discussed, attention is usually concentrated on the more dramatic of the pair. Its title is given variously in the literature as *Procession at Sunrise* and *Procession at Dusk* (48) – a fact that demonstrates how uncertain the interpretation of Friedrich paintings can be. The picture shows a religious procession moving through the countryside towards a wayside cross. The relation between religion and nature is emphasized in many ways. The priest in the middle of the group is bearing a monstrance which happens to fall directly in the path of the sun. By this means the symbolic representation of Christ is

associated with the natural source of energy and light. The leading figures are just about to go under two trees whose branches lean together in imitation of a Gothic arch. This feature alludes to a myth, commonly held at the time, that the pointed shape of the Gothic arch had arisen through two branches of neighbouring trees being tied together. Even those who did not believe this saw a poetic truth in the way the story stressed the affinities between Gothic architecture and organic forms in nature. Goethe himself, when viewing this work, might have been reminded of his own early essay in praise of Strasbourg Cathedral, in which he had likened the soaring columns in the nave to the trees of a forest.

47
Summer Landscape with Dead Oak/ Autumn Landscape by a Lake, 1805. Sepia; 40.5×62cm, 16×24³⁄₈in. Staatliche Kunstsammlungen, Weimar

Yet while the striking theme in *Procession at Sunrise* has caused it to become the focus of discussions concerning Friedrich and the Weimar competition, we should not forget that the work was exhibited as one of a pair. Its pendant is far less assuming. Called variously *Summer Landscape with Dead Oak* and *Autumn Landscape by a Lake* (47), it shows an elderly couple seated beside drying fishing nets and a lowly hut. It would seem to depict life moving towards its final phase, something stressed by the barrenness of the dominating tree, which contrasts with the ripe cornfield behind it. Whatever the precise time of year, the theme of transience is unmistakeable.

48
*Procession
at Sunrise/
Procession
at Dusk,*
1805.
Sepia;
40·5×62cm,
16×24³⁄₈in.
Staatliche
Kunst-
sammlungen,
Weimar

Seen on its own, the work is not remarkable. Yet the pairing of it with the *Procession* is interesting as it heralds a tendency that Friedrich was to make his own. This was the practice of showing pictures as contrasting pairs. He had – as was seen in the last chapter – become interested in cycles of pictures a few years earlier, probably under the influence of Runge's design for his cycle *The Times of Day* of 1803. Friedrich was to continue to use the cycle on occasion, but the contrasting pendant was used by him to a far greater extent. It was, in effect, a pictorial demonstration of the comparative method that had become so popular in science in order to draw inferences about the nature of phenomena. Two contrasted objects threw up differences which seemed to mark each out to be more distinctly itself. It was this form of contrast, it should be remembered, that was used by Friedrich in his poem about the struggle of good and evil in himself. It seems, on a spiritual level, to show an acceptance of an innate dualism in the world, something that can also be found in the 'contraries' of his older British contemporary William Blake, for example in his *Songs of Innocence and Experience* (1789, 1793). Friedrich's art, as it develops, moves increasingly towards the exploration of contrasting conditions.

In the case of the Weimar sepias the contrary states highlighted are the material and the spiritual, the temporal set against the eternal. As with later contrasting pairs, it seems that Friedrich was in the habit of placing the 'material' image on the left and the 'spiritual' one on the right. Given the natural tendency in Western cultures to read images from left to right, this suggests that he intended the viewer to move from a consideration of the earthly to contemplation of the Divine.

It is hard to say how much the themes in these pictures weighed for or against them when they were being considered for the Weimar prize. When discussing the works in print, both Goethe and Meyer stressed their merits as studies of nature. As Meyer wrote of the *Procession*:

We must freely praise the painterly invention in these pieces. Indeed, even if they were views drawn directly from nature the artist would not merit any less praise for that reason. For the work is then a confirmation of his correct judgement and sense of nature. If it is not invented, then it is very well found.

Goethe firmly believed that the fine arts had to remain bound to naturalistic recording and observation and he was deeply suspicious of all art forms that appeared to address that which lay beyond the visible. Perhaps his reason for favouring Friedrich at this point was because he recognized that the artist was the only one associated with the new 'Romantic' tendency who seemed to have a genuine interest in representation and the achievement of naturalistic effects. It could be that he and Meyer were hoping to keep Friedrich among the ranks of the naturalists with a well-aimed prize.

Over the next ten years Goethe maintained an interest in Friedrich, perhaps hoping against hope that the landscape painter would remain an ally in his devotion to and exploration of nature. His interest was matched by that of several members of the Weimar court and a number of works – first of all sepias, and later oils – were sold to them. Yet as the pictures became more unusual in their form, so they aroused increasing concern. A painting of a shepherd looking at a rainbow – acquired by Duke Karl August in 1810 – passed muster because it could be seen as an illustration of a love poem by Goethe: *Schäfers Klagelied* (*The Shepherd's Complaint*; 49). However, another rainbow picture of the time provoked an unfavourable reaction from a member of the court. This one, called by some *Mountain Landscape with Rainbow* (50), shows a solitary traveller in the centre foreground looking into a dark, brooding landscape. The figure is caught up in a dramatic shaft of sunlight. The rainbow behind is a most peculiar shape, tapering at the ends in a way that rainbows do not do. Furthermore, the mountain over which it arches is placed symmetrically in the middle of the canvas. By this time Friedrich had achieved national fame for such provocatively symbolic

49
*Landscape
with Rainbow
(The Shepherd's
Complaint)*,
1810.
Oil on canvas;
59×84·5cm,
23¼×33¼in.
Formerly
Staatliche
Kunst-
sammlungen,
Weimar

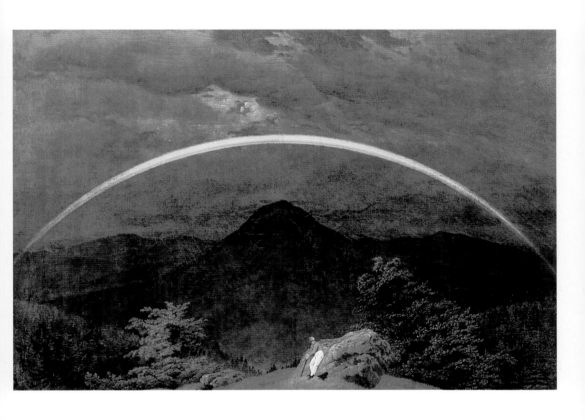

50
*Mountain
Landscape
with Rainbow*,
1810.
Oil on canvas;
70×102cm,
27⅝×40⅛in.
Staatliche
Kunst-
sammlungen,
Weimar

landscapes. Even so, on 9 October 1810 the Duke's cousin, Duke Emil August of Sachsen-Gotha-Altenburg, delivered himself of this opinion in a letter to the Dresden artist Thérèse aus dem Winckel (1779–1867):

I have seen some paintings by Friedrich which captivated and astonished me, even though I did not really find them pleasing. But I also saw some unfinished sepias, light, beautifully poetic, drawn with the utmost delicacy yet profound. These sepias greatly aroused my interest in Friedrich. But not so the paintings, those garish, harsh, contradictory affectations, those peepshows purporting to be mystical allegories – especially the rainbows which remind one of a confectioner's handiwork, and the foregrounds like mosaics and the backgrounds like maps. No, all this forced me to the conclusion that these by no means totally undeserving things are not to be taken seriously.

The Duke's exasperation at what he took to be the talented waywardness of Friedrich mirrors the more subtly expressed misgivings that Goethe felt as he saw the painter carried away with ever more extreme and dramatic works, increasingly swept up in the nationalist fervour of the times. As will be seen in the next chapter, these misgivings led eventually to an open rift with Friedrich.

Friedrich's Weimar sepias lay within the range of what was permissible in Goethe's eyes for the visual artist because he included the symbolic elements in a way that did not challenge naturalistic conventions of spatial representation. Over the next three years, however, Friedrich was to develop compositional forms that did just that. Furthermore, as he started painting his pictures in oils, this challenge became harder to avoid.

We do not have any clear account of how these changes began to take place, though it is usually assumed that the critical moment, as with Friedrich's first definitive advance, came while he was visiting his native Pomerania in the summer of 1806. Even before then it would seem that he was producing works that were exploring issues of space and representation in new ways.

Certainly around this time he was moved to paint two of his most beautiful and striking sepias which address directly the issue of perception. These are the views from his two studio windows (51, 52). They were sent to the Weimar exhibition in 1812 but are widely accepted as being works of c.1805–6, and may even have been exhibited then.

Certainly it would be unlikely that this pair were painted later than 1806, for that is the time when Friedrich moved away from sepia to produce oils and watercolours. Thematically they seem to reflect his developing interest in representing contrary states. This time the contrast rests on the different angles at which he sees the two windows he is depicting. The left-hand window is seen at an angle, the right-hand one is viewed straight on. This makes the former an informal arrangement of receding diagonals and the latter an ordered design dominated by horizontals and verticals. There could not be any more elegant demonstration of the simple yet all-important point that things look different depending on the angle from which you observe them. We can gauge the degree of shift between the two angles of vision because the distance separating the two windows is indicated by a mirror that lies between them. The left edge of this mirror can be seen in the first picture and the right edge in the second. By these means Friedrich engages us as active spectators, so that we experience in a practical and tangible way the subjectivity in experience that was stressed by the Romantics. This also makes clear that such subjectivity is not a matter of arbitrary whim: it is rooted in actual situations, in the relationship between the viewer and the viewed.

The pictures also provide an eloquent illustration of the limits of vision. They give us glimpses out of their respective windows to the Elbe, the river that flows through Dresden and which Friedrich's studio overlooked. Because of our position deep inside the studio we can only see tantalizing fragments of what lies beyond: the top of a ship's mast, half a house, sections of shoreline. There is a metaphysical point to be grasped here. The philosophically minded could hark back to Plato's illustration

of the limitations in our perception of reality, in which we are seen as people trapped in a cave trying to make sense of the world outside from shadows that are cast from objects we cannot see projected on to the outer wall of the cave. In Friedrich's case he is enclosed in his studio, trying to make sense of the world outside the window that he can perceive only partially from his position. It is a critical moment. And just in case we should doubt that this picture *is* about a particular viewpoint specifically recorded, Friedrich gives us a telling clue. In the fragment of mirror on the left-hand side of the 'spiritual' view we can see part of Friedrich's own head – his forehead and lowering eye. Now we know exactly where the artist positioned himself as he painted this picture. We can see how the view that this gave him of himself, as of the outside world, was only partial.

51
View from the Artist's Studio, Left Window, 1805/6.
Sepia;
31 × 24 cm,
12³⁄₈ × 9¹⁄₂ in.
Österreichische Galerie im Belvedere, Vienna

52
View from the Artist's Studio, Right Window, 1805/6.
Sepia;
31 × 24 cm,
12¹⁄₄ × 9³⁄₈ in.
Österreichische Galerie im Belvedere, Vienna

Although he might not have intended them to be so momentous, this pair of pictures provides a critical revision of the perception of space which had been accepted as the norm in Western art since the Renaissance. The system of linear perspective that was developed then was conceived of as a projection from the viewpoint of the spectator that orders the world around him. In a telling image, the Italian theorist and architect Leon Battista Alberti (1404–72) had likened the space created by such means to a window set into a wall, opening out on to an imagined vista. Friedrich modified this analogy by drawing attention to the position of the spectator in it. Alberti imagines an abstracted, universal observer dominating the centre of the picture and surveying all it had to present. There is no room in his comprehensive coverage for individuality in perception. There

53
Carl Ludwig
Kaaz,
*View through
an Open
Window,*
1807.
Oil on canvas;
91 × 71 cm,
35⅞ × 28 in.
Private
collection

is one reality, that discoverable by the intellectual brilliance of the scientific artist. Friedrich, by contrast, is aware of a very different position, one that was gradually being uncovered in his own time and which has since become one of the hallmarks of the modern condition. As though to stress this point, he actually viewed each window from slightly different positions in the studio – as has recently been calculated by the German art historian Werner Busch. This stresses that what is perceived is always dependent upon the situation and nature of the perceiver. As Blake put it, 'A fool sees not the same tree that a wise man sees.'

It may well be that Friedrich used this demonstration of the nature of perception to create a religious allegory. For Börsch-Supan, the left-hand picture represents the active life and the right-hand one the contemplative. He interprets the key hanging on the wall as a sign of this. Certainly the left-hand picture has a more inviting view and there is even a sense of invitation in the letter addressed to Friedrich that can be found on the window sill. The right-hand

picture, by contrast, has a restricted view, and because the light of the window is being looked at more frontally, the surround is all the more forbidding and dark. This is the picture in which the half-concealed image of Friedrich occurs in the mirror, something that suggests in itself a greater mood of introspection.

These sepias – painted with exemplary precision at the height of his skill in the medium – seemed to mark an important moment for Friedrich in his exploration of perception. Yet though he apparently exhibited them at least three times, this does not seem to have led to any recognition of their significance. The works remained unsold and were in his possession at the time of his death. Probably the novel perception he presented here was stated with too much subtlety to strike an unprepared audience. It was only when Friedrich applied his new method in a more dramatic and eye-catching way that his contemporaries began to respond to what he had achieved.

The lack of understanding of these window pictures can be seen all the more clearly by looking at a work that appeared to emulate them. In 1807, while living in Dresden, the painter Carl Ludwig Kaaz (1773–1810) painted a view through a window that bears a superficial resemblance to the right-hand window of Friedrich's pendants. This painting, an oil, has a similar rectilinear design (53). Yet in fact the interior from which this view is taken is no more than an elaborate frame for the beautiful vista outside, which is arranged like a classical landscape by Claude or Gaspard Dughet (1615–75). Kaaz produced a perfect illustration of Alberti's metaphor. The whole intention of the picture, moreover, is to celebrate the beauty of the landscape that could be seen from a villa on the outskirts of Dresden belonging to the painter Józef Grassi (1757–1838). A spyglass has been left, helpfully, on the window-ledge in case we should wish to look closer. A book is open on the sill, as though someone has been enjoying the pleasure of reading and then looking up to enjoy the idyllic scenery. Behind the window hangs a clean painter's palette, symbolizing visual art and without indicating any of the difficulties

attendant upon the pursuit of that profession. If, as is commonly supposed, Kaaz was emulating Friedrich's sepia – which he could have seen exhibited the year before at the Dresden Academy – then he could hardly have got the message more wrong.

In all probability the significant moment recorded in these sepia views took place before Friedrich made the journey back to his home town from April to August of 1806. This followed a period of illness and confinement which was, according to the artist and writer Friedrich August von Klinkowström (1778–1835) in a letter to Runge, 'brought upon himself because of his patriotic anger at events in Germany'. We can take this explanation with a pinch of salt. It would certainly seem that the crisis that Friedrich faced at this time was a psychological one, even if it had physical manifestations. Perhaps these views from the studio window, in which the partial nature of the vision to be gained from the artist's position is stressed, were stimulated by this experience of seclusion from the world where he wished to roam.

Be that as it may, there is no doubt that the French invasion of 1806 marked a significant change in Friedrich's life, as it did for most Germans at the time. This was the moment when Napoleon began tightening his grip on central Europe as part of his strike against the 'Third Coalition' that had been established by England, Russia, Austria and Sweden against France. There followed a series of French victories, the most important being that at Austerlitz against Austria and Russia in 1805, and those against the Prussians at Jena in 1806 and at Eylau in 1807. These brought in their wake the French occupation of southern Germany, the reorganization of German states abutting France into a 'Federation of the Rhine' and the abolition of the Holy Roman Empire – the political organization that had nominally governed Germany since the early Middle Ages. Never can change have seemed more dramatic and far-reaching. And, as in Spain, the French invasion created a particular dilemma for those who sympathized with the egalitarian principles that had guided the French Revolution but who revolted against imperialist occupation.

On a material level, the invasion brought widespread economic collapse. It was the immediate cause of Runge having to leave Dresden to live with his brother in Hamburg. Friedrich's removal to the north of Germany might have been made in a similar spirit of retrenchment. During his time in Pomerania Friedrich immersed himself deeply in his native landscape, as though to touch base after traumatic events. We can follow his wanderings through his surviving sketchbooks, in which tightly drawn pencil sketches tend to be given precise dates – a practice so different from his finished works which are almost never signed or dated. These sketches – used by him time and again later for the designs and details of his landscapes – must have acted as a kind of visual diary, providing moments that he could re-experience in his mind. There are portraits in profile, studies of hats and a design for a chair as well as the usual studies of landscape. There are vistas and views and some remarkable sharply observed trees (see 57). Friedrich also recorded antiquities, in particular the dolmens – those ancient memorials of a past civilization then considered to be the earliest relics of a heroic Germanic race, which lay scattered along the coast and on the island of Rügen.

In his seminal analysis of Friedrich's development at this point, Börsch-Supan points in particular to a drawing of an *Ufersenkung* (54), an opening in the sand dunes that line the Baltic shore. The artist must have thrown himself down on the ground and looked through the gap to the sea beyond. It was as though he had found a way in nature of addressing the experience he had had when painting the sepia views through his studio windows (see 51, 52). Now it is the *Ufersenkung* that has become the frame through which he peers. He has used the sides of the dunes to block off the ground immediately beyond them so that our eye travels straight to the distant shore and sea. Just as he reduced the pictorial cycle to an opposing pair, so he has now reduced the formal series of stages of recession within the landscape to a single contrast between foreground and background.

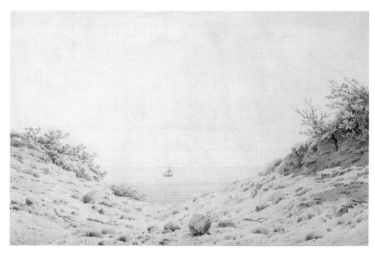

54
*View through
Hollow in Shore
to the Sea,*
1806.
Pencil;
11·7×18·3cm,
4⁵⁄₈×7¼in.
Nasjonal-
galleriet, Oslo

55
*View from the
Hollow in Shore
to the Sea,*
c.1824.
Watercolour;
24·7×36·5cm,
9¾×14³⁄₈in.
Kupferstich-
kabinett,
Staatliche
Museen, Berlin

The study is squared up – a process used by artists when taking a design from a sketch to re-use in a finished work. In this case it was used for a watercolour, *View from the Hollow in Shore to the Sea* (55). The surviving version of this dates from later – c.1824. However, it is likely that Friedrich first made a watercolour from this study around 1806, as he did with several other views from the north in this period.

From now on, painting in watercolour took on a new prominence in his practice and was soon to encourage him to start working in oil. As well as suggesting a growth in Friedrich's ambitions, these changes reflect the Romantics' interest in colour as the source not just of greater realism but also of mystical and evocative effects. Friedrich may by this time have known of the colour studies of Runge. However, as with his perception of space, he remained clear about the need to relate his use of colour to observed effects.

When he returned to Dresden in August 1806 Friedrich began to incorporate his new perceptions into images of his native landscape that were different from the ones he had produced before. Perhaps stimulated by patriotic fervour, he concentrated on images of ruin and perseverance. The dolmens that he had studied became monuments to the enduring Germanic spirit, as did the blasted oaks that frequently were shown rising about them. While remaining true to the detail of individual forms he had studied, he became more cavalier in his approach to topography. He developed the habit of reassembling features from different locations into compositions of his own fashioning. Thus in the large sepia *Dolmen by the Sea* (56), he created a group of oaks from studies of trees originally seen separately – such as the one which probably first attracted his attention because it contained a stork's nest (57). *Dolmen by the Sea* also shows the principles of Friedrich's new form of pictorial arrangement, the 'contrast' manner that he seems to have used first in his study of sand dunes and that was adumbrated in his studio window pictures. The oaks and dolmens are centrally placed and viewed

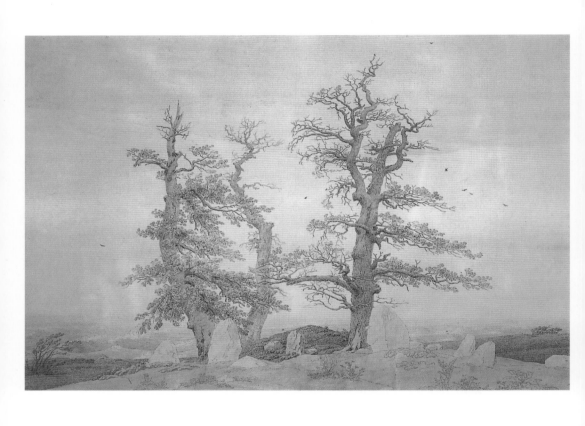

from low down, so that they throw up a striking silhouette against the sky. Friedrich may have initially depended upon direct observation of this effect, but he soon became sufficiently confident to invent the arrangement himself. Indeed, he seems to have come to see this process as invaluable for giving the image a sense of inner necessity. Later, he was famously to advise artists to see their picture first with their 'inner eye' before bringing it to the light of day. The striking, simplified yet intense images

56
*Dolmen
by the Sea,*
1806.
Sepia;
64·5×95cm,
25½×37⅜in.
Staatliche
Kunst-
sammlungen,
Weimar

57
*Study of an Oak
Tree with Stork,*
1806.
Pencil;
28·6×20·5cm,
11¼×8in.
Kunsthalle,
Hamburg

that he now created give the impression of pictures seen first in the mind. Yet they still remain responses to the outer world, for the forms with which he clothes his vision are based on minute and detailed study of the phenomena he has observed.

Something else happened to Friedrich at this time. He began to change his appearance, assuming the gaunt, monk-like guise for which he was soon to become well known, and which he was to commemorate in a startling self-portrait a few years later (58).

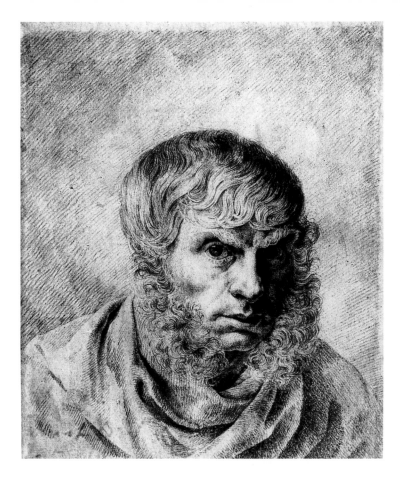

58
Self-Portrait,
c.1810.
Black chalk;
23×18·2cm,
9×7⅛in.
Kupferstich-
kabinett,
Staatliche
Museen, Berlin

Gone was the clean-shaven, close-cropped look of his early self-portraits (see 20). He began to grow a beard and let his hair sprout in voluminous locks. 'Those who want to know what Friedrich looks like,' quipped his friend the history painter Franz Gerhard von Kügelgen (1772–1820), 'had better hurry up. For he is soon going to be completely grown over.'

Kügelgen profited from the new hirsute Friedrich by having him pose for Saul in a painting of *Saul and David* (59), a work for which he enjoyed almost as much celebrity in his time as Friedrich did for *The Cross in the Mountains* (see 46). Growing a beard in the first decade of the nineteenth century was still an unusual occurrence and one of the ways in which the artistically minded could signal the distinction between themselves and both the

bourgeoisie and the rational intellectuals of the Enlightenment. It had been a ploy used by the French *Primitifs* in David's studio a few years earlier and was to become a symbol of the adherents of the medieval revivalist movement. It is worth remembering that this movement began in 1808 with the establishment of the Brotherhood of St Luke – or Nazarenes, as they came to be known – among art students in Vienna. In using a dramatic change of appearance to signal an artistic coming of age, Friedrich was very much of his time.

Friedrich's move to oils as a principal form of painting a few months after returning to Dresden, in 1807, suggests a growth in confidence and also probably an expansion in demand for his works. Oils took longer and cost more to produce, and the cautious Friedrich probably only decided to adopt the process when it was clear that the market was there. The period of the

59
Franz Gerhard von Kügelgen, *Saul and David,* 1808 (copy of picture painted in 1807). Oil on canvas; 118·5×99·5cm, 46¾×39⅛in. Gemäldegalerie Neue Meister, Dresden

60
*Fisherman
on the Shore*,
1807.
Oil on canvas;
34·5×51cm,
13¼×20in.
Österreichische
Galerie im
Belvedere,
Vienna

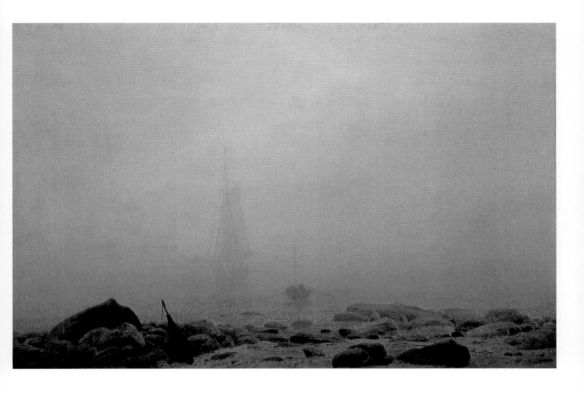

61
Mist,
1807.
Oil on canvas;
34·5 × 52cm,
13⁵⁄₈ × 20¹⁄₂ in.
Österreichische
Galerie im
Belvedere,
Vienna

Napoleonic invasions – which had brought such widespread poverty – might seem a strange moment to make such a move. On the other hand, the success he had achieved in the Weimar competition of 1805 had brought him a certain degree of fame as well as aristocratic patronage both from the court at Weimar and that at Dresden. The covert patriotism of his subject matter no doubt also helped to swell interest in his pictures during this period of occupation.

The first works in oil now known are on a modest scale. Possibly the earliest are a pair now in Vienna, *Fisherman on the Shore* (60) and *Mist* (61). Like the Weimar sepias and the studio window views, this pair seems to contrast a material and a spiritual state. Friedrich's adoption of oils has provided him with a new resource, which is used to achieve an exquisite effect. The ship is differentiated from the surrounding mist so subtly that it seems to hang on the very edge of vision. It is a breathtaking moment of imminence.

By this time there is evidence that Friedrich was attracting an audience who were responding to his works as allegories on life and death. As his friend Kügelgen wrote about this pair to Karl August Böttiger, who was chief inspector of the Antique Collection in Dresden and so a powerful figure in the art patronage system: '[*Mist*] shows a stony shore, from which people are rowing towards a ship on the horizon. So mankind steers trustfully into the veiled future, and we do not know where, when and how he will land.' There is no particular reason to think that this was an interpretation that Friedrich had given him. Even more suspicious is Kügelgen's explanation for *Fisherman on the Shore*, in which he describes how 'full of hope the fisher expects the return of his son'. Kügelgen's willingness to offer interpretations might have been driven by commercial rather than devotional considerations. As well as being a painter, he was also an agent and was successful in placing many of Friedrich's early works. It is quite probable that he may have been enhancing the saleability of these pictures by embellishing them with fanciful narratives.

The uncertainty about such readings is all the more striking when contrasted to later interpretations. Börsch-Supan, for example, explains that the fisherman is looking yearningly out to the boat at sea, not in anticipation of the return of his son, but with a sense of longing for death! This explanation is based on an equally unprovable assumption that Friedrich had a consistent and carefully worked out iconographical pattern for his images. We shall probably never be able to determine this point. Yet it remains the case that he virtually never offered interpretations of the subjects in his works and that he gave pride of place to the pictorial effects that they manifested.

Friedrich now began to make more striking contrasts in the subjects he used for pendants. He would set barren northern landscapes against the richer and more luxuriant terrain around Dresden. For Friedrich, who never travelled further south than Bohemia, Saxony was a southern land of plenty. It had already provided the summer scenery of his early sepia cycle of *The Times of Year* (see 42–45). Now the scene was extracted to create a large painting, *Summer* (62), its embracing couple in the foreground making a clear reference to the arcadian lovers in a picture Friedrich knew well from the Dresden art gallery: *Acis and Galatea* by Claude, the classical master of ideal landscape (63). This harmonious idyll was presented as a counterpart to a picture (64), based on a study of the ruined abbey of Eldena (65), which Kügelgen described unequivocally as 'Life and Death'. In this case the embracing pair in the *Summer* scene and the bent old man heading for the ruin in the *Winter* scene would support such an interpretation.

Attention then, as now, tended to focus more on the wilder and 'spiritual' scenes in these early pendants, yet there is no sign that the artist himself felt such a preference. Many of his summer landscapes are painted with a delicacy that can only really be appreciated when seen at first hand. They are as important for his artistic development as his more dramatic compositions. For it was the finesse that he perfected in them that enabled him to

62
*Summer
(Landscape
with a Pair
of Lovers),*
1807.
Oil on canvas;
71·4×103·6cm,
28⅛×40¾in.
Neue
Pinakothek,
Munich

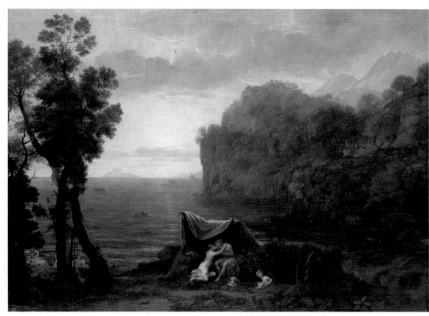

63
Claude Lorrain,
Coastal
Landscape
with Acis
and Galatea,
1657.
Oil on canvas;
102·5×136cm,
40³⁄₈×53½in.
Gemäldegalerie
Alte Meister,
Dresden

64
Winter (Monk
in the Snow),
1808.
Oil on canvas;
73×106cm,
28¼×41¾in.
Formerly Neue
Pinakothek,
Munich
(destroyed)

65
Eldena
Viewed from
the North East,
c.1806.
Watercolour;
17·8×22·9cm,
7×9in.
Museum
Georg Schäfer,
Schweinfurt

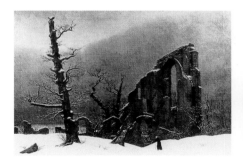

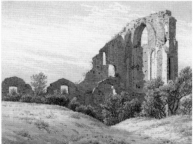

achieve the great subtleties in his later landscapes. The mixed
response to these works, however, does suggest that he was
under pressure to develop the more dramatic side of his work
at the expense of his more subtle perceptions. This was a
common dilemma experienced by artists at the time and was
a consequence of the growing practice of public exhibition.

Throughout this period Friedrich was gradually preparing the
ground for the first statement of his art on a definitive and
monumental scale – the work that became known as the *Tetschen
Altar* but is more commonly called *The Cross in the Mountains*
(see 46). This picture was acquired by Count Franz Anton von

66
*Mountain
Landscape*,
1804–5.
Sepia;
12·2×18·2cm,
4¾×7¼in.
Goethe
National-
museum,
Weimar

Thun-Hohenstein, ostensibly to be used as the altarpiece for his
private chapel at Schloss Tetschen in the north of Bohemia. At one
time it was believed that it was the Count's fiancée, Maria Theresa
Brühl, who proposed the commission. She is supposed to have
admired a sepia of a cross in the mountains exhibited in Dresden
in March 1807 (possibly similar to the *Mountain Landscape* now
in Weimar; 66) and recommended that it be tried in oils. In the
1970s, however, letters were discovered suggesting that Friedrich
originally intended the picture for Gustav IV Adolf of Sweden.
Since Sweden still owned the part of Pomerania from which the
artist came, Gustav was Friedrich's 'King'. Gustav was a staunch

anti-Jacobin and attempted to lead an alliance against the French with insufficient resources – a foolhardy move that cost him his crown in 1809.

Possibly the difficulties that Gustav was experiencing by mid-1808 caused Friedrich to abandon his plan. Perhaps it was never more than an idea, for there is no proof that Gustav himself knew anything about it. In any case the plan for painting a landscape altarpiece almost certainly reached back further than this. According to Runge's brother Daniel, Kosegarten had in 1805 drawn up plans for either Runge or Friedrich to paint an altarpiece for his fishermen's chapel on the island of Rügen. It was Runge

67
Philipp Otto Runge,
Christ and Peter on the Waters,
1806/7.
Oil on canvas;
116×157cm,
45³⁄₈×63in.
Kunsthalle,
Hamburg

who eventually took up the commission, choosing the appropriate if somewhat conventional theme of Christ walking on the waters and saving St Peter from drowning (67). In the event the altarpiece was never completed, possibly because it emerged that Kosegarten had no means of paying for it.

Whatever the details of the commission, it is clear that the *Tetschen Altar* was already occupying Friedrich's mind in the spring of 1807. In April and May of that year he toured northern Bohemia, where he made studies of rocks and fir trees (68), many of which were used for the terrain in the altarpiece itself. It is

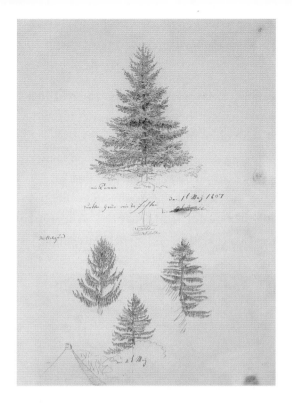

68
*Four Studies
of Spruce
and Fir,*
1807.
Pencil;
36·6×24cm,
14³⁄₈×9¹⁄₂in.
Nasjonalgalleriet,
Oslo

typical of his approach to landscape that he should wish his *Cross in the Mountains* to be based on what he had observed. Even the cross that rises up in the evening sky in his picture is no fantasy. Such crosses can be seen frequently on prominent rocks and mountain tops in the area.

While making preparations for the alterpiece Friedrich worked on a number of smaller pictures of high mountain scenes, both in watercolours and in oils. Like the *Cross* itself, these tended to have strong and simple pyramid-shaped compositions. They almost seem to be inversions of the V-shape design of his earlier *Ufersenkung* composition, *View through Hollow in Shore to the Sea* (see 54). Instead of looking through a V-shape to the distance beyond, the spectator is now looking head-on at an inverted V set against the open sky. The design could be used to convey effects of great subtlety, as in one of his most delicate oils, *Morning Mist in the Mountains* (69). Hazy atmospherics are invoked with a fine

and highly unorthodox application of small dots of paint that prefigures in some aspects the pointillist technique of the Neo-Impressionists, and that causes the whole image to shimmer. The theme of this picture is expressed in a low-key, almost clandestine manner. For it is only when the spectator gets close that it becomes clear that the mountain is surmounted by a tiny cross. It is as though Friedrich wished to try out on an intimate scale the theme that he was preparing for his grand public statement.

No one could accuse the *Tetschen Altar* (see 46) of subtlety. It is undoubtedly one of the most emphatic statements of Friedrich's career. The 'contrast' method that he had recently evolved is used to set a silhouetted mountain-top of firs and rocks against a reddening evening sky. Rays from the setting sun are thrown up against this like beams from searchlights, and one of them strikes the cross on the summit. The cross itself is turned away from us towards the source of light. The cross-bar is set at a sharp sloping angle, which makes it clear that the viewpoint of the spectator is low down, near the base of the picture where all is dark. As is appropriate, given its function, the image is dramatic and evokes a sense of religious awe. Friedrich took the picture's devotional role seriously enough to design a special frame for it full of Christian symbols, which was carved for him by his friend the sculptor Gottlieb Christian Kuhn (1780–1828). The palm fronds that meet at the top invoke the myth about the natural origins of the Gothic arch already used in the Weimar *Procession* sepia (see 48). He has embellished these with more traditional motifs – winged putti heads burst through the palm fronds – while beneath the painting, the frame contains ears of corn and bunches of grapes to represent the body and blood of Christ. These flank a triangle, symbol of the Trinity, with the Eye of God in its midst. This sign is seen frequently in Catholic churches. It is also a symbol used by freemasons. Freemasonry was certainly prevalent in Dresden and some of Friedrich's friends were members of the local Lodge. However, there is no proof that the artist himself or his patron was among their company.

69
*Morning Mist in
the Mountains*,
1808.
Oil on canvas;
71×104cm,
28×41in.
Staatliches
Museen, Schloss
Heidecksburg,
Rudolstadt

In the previous chapter, mention was made of the cycle of *The Times of Day* that Runge had been working on since 1803. In many respects this can be seen as part of the context that encouraged Friedrich to make the bold move of setting up a landscape as an altarpiece. Quite possibly Friedrich only knew these works in their 'hieroglyphic' form, as beautiful but puzzling outline engravings. He may not have known that Runge was now working to turn his symbolic pictures into evocative and inspiring oil paintings, using light and colour for dramatic effect in the same way that Friedrich himself was doing (see 39). However, the larger, painted version of *The Times of Day* remained unfinished at the time of Runge's death in 1810.

The seriousness of Friedrich's intentions is evident from the fact that he put the work on show in his studio at Christmas-time. It was displayed on a table draped like an altar in a low light. Some idea of what the effect might have been can be gained from a drawing of a picture set out in this manner (70). However, both the frame and the image of the cross in this drawing are different from that of the *Tetschen Altar*, and the work possibly relates to one of Friedrich's church installation designs in the post-Napoleonic era (see 101). If this is so, then it suggests that Friedrich persisted with his wish to paint landscape altarpieces long after the *Tetschen Altar* had been completed.

According to eyewitness accounts, the presentation of the *Tetschen Altar* was impressive. Maria von Kügelgen, the wife of Friedrich's painter friend, recorded: 'Everyone who came into the room was as moved as if they were entering a temple. Even loudmouths like Beschoren spoke seriously and in quiet tones as if they were in church.'

Despite the awe it inspired, *The Cross in the Mountains* provoked opposition. The most vehement attack came from Wilhelm Basilius von Ramdohr, a stout defender of classical values in art. His extensive critique – published in four successive numbers of the journal *Zeitung für die elegante Welt* between 17 and 21 January 1809 – was a detailed exemplification of all that traditional

connoisseurs found unacceptable in art inspired by the Romantics. That Ramdohr – who very rarely made pronouncements about the work of living artists – should have gone to such lengths is an indication of the degree of threat which Friedrich's work was felt to present. Friedrich was attacked for both the theme of his picture and for its treatment. Ramdohr claimed that the artist had transgressed the rules of the 'genres' of art, whereby only figurative painting could treat religious subjects. He said landscape had 'crept into the church and crawled onto the altar'. These suggestions of stealth were used to imply something sinister and clandestine about Friedrich's action. Yet the artist had claimed his right to treat a religious theme in the most open way possible.

It was probably the showmanship evident in Friedrich's move that annoyed Ramdohr as much as the challenge to traditional values. Both the dramatic treatment of the picture and its theatrical presentation might well have put him in mind of popular entertainments, in particular the 'peepshows' that the Herzog of Saxe-Weimar had compared to Friedrich's pictures. The simplification of the composition, which Ramdohr also saw as a crime against naturalistic representation, would have also brought it closer in appearance to such sensational displays.

But if there was a theatrical side to Friedrich, there was something far more serious underneath. Effect is not the same as sensation. The traditional form of landscape as space painting had now given way to a kind of hypnotic reworking of landscape elements so that they became symbolic forms imbued with mystical prescience. This broke a further classical rule: the insistence on the distinction between 'form' and 'meaning' in a visual work of art. Formally art was meant to convey a sense of beauty and satisfying skill in mimetic representation. 'Meaning' was to be conveyed not through the expressive nature of that form, but through the use of accepted allegorical and narrative conventions. It was a distinction that Goethe later felt moved to stress in his essay 'Ruisdael als Dichter' (Ruisdael as a Poet). Taking Ruisdael's well-known picture in the Dresden gallery, *Jewish Cemetery near*

70
*The Cross
in Front of
a Rainbow in
the Mountains
(Design for
Altarpiece),*
c.1817.
Ink and
watercolour;
27·2×20·8cm,
10⅝×8in.
Kupferstich-
kabinett,
Dresden

Ouderkerk (see 23), he claimed that this work conveyed its meaning through familiar symbols, such as the ruin to suggest transience and the rainbow to invoke hope. While the painting also made use of atmospherics to provide a suitably sombre mood for the theme it was expounding, it nevertheless remained essentially a piece of naturalistic representation. It stayed within its genre both formally and thematically.

Goethe does not mention Friedrich in this essay. However, by the time he came to write it he had already withdrawn his support for the artist. For Friedrich had moved away from the conventions whereby form and meaning could be separated out. He still had symbolic elements in his pictures, it is true, but these no longer conveyed the central meaning of the work. They were almost like the residual remains of some lost language. It is this change that has been described by Joseph Koerner in his book *Caspar David*

Friedrich and the Subject of Landscape (1991) as the 'death of Allegory'. Friedrich presented his works in a manner that made their mood the conveyer of meaning, rather than achieving this through a set narrative. As with the Protestant Divine, Schleiermacher, the new religious experience was one that depended more upon feeling than rules. And just as Schleiermacher constructed a religious faith that was universal in its address, so Friedrich seems here to be attempting to bring together the traditions of both the Catholic and the Protestant churches. He was using the Protestant enthusiasm for the intimation of the spiritual in nature to address the Catholic form of the altarpiece.

Yet while the mood of *The Cross in the Mountains* is undoubtedly its main claim to fame, Friedrich did defend it against Ramdohr's assertion that it had no clear meaning. He had a description of the picture published in the Weimar-based *Journal des Luxus und der Moden* in April 1809. This was communicated to the editor via his friend Schultze. Friedrich's choice of Weimar for its publication is revealing. He had, as has already been seen, enjoyed considerable support and patronage both from Goethe and from the court there. He probably did not realize that there were other voices now expressing misgivings.

After describing the picture, Friedrich gave the following interpretation:

Jesus Christ, nailed to the tree, is turned here towards the sinking sun, the image of the eternal life-giving father. With Jesus' teaching an old world dies – that time when God the Father moved directly on the earth. This sun sank and the earth was not able to grasp the departing light any longer …

He also pointed to the symbolic meaning of elements of the landscape:

The cross stands erected on a rock, unshakably firm like our faith in Jesus Christ. The firs stand around the evergreen, enduring through all ages, like the hopes of man in Him, the crucified.

This interpretation is so specific that it has been taken to imply that Friedrich was essentially an allegorical artist. Yet it should be remembered that this is virtually the only case where he published such an account. It was also prompted by a critical debate about the picture and seems to have been a retrospective justification.

As a narrative, moreover, it seems to present as many problems as it solves. If the sun really is God the Father, one is tempted to ask, then the fact that it is setting must surely be a cause for the profoundest pessimism. The crucifix with the metal figure of Christ might be able to reflect the rays of the sun as it sinks. But what happens when the sun sets altogether? Presumably both we and Christ will be cast into irredeemable darkness. It is only in the fleeting moment that the allegory holds good. It is a thought thrown up by an experience and does not cohere in any wider order of things.

The controversy about *The Cross in the Mountains* initiated a new phase in Friedrich's career. From now on he was a national figure. The *Cross* itself soon moved out of the limelight. It was not, however, installed in the chapel at Schloss Tetschen, but ended up in the Countess's bedroom. Friedrich appears never to have known that the picture he intended as a breakthrough in public devotional art ended up as a private domestic work. It did not re-emerge in the public arena until the twentieth century, when it was acquired by the Gemäldegalerie in Dresden.

The Cross in the Mountains may not, in the end, have changed the course of devotional painting but it did make Friedrich's reputation as a fearless and original artist, a reputation that was to be crowned two years later when he showed his *Monk* and *Abbey* triumphantly in Berlin. As has been suggested by his behaviour over the display of the *Cross*, he was now a very self-conscious artist, whose activities were deliberately planned. He had brought invention to self-realization, and formed from this combination the complex artistic persona that was to be so rich and creative in productions in the decades to come.

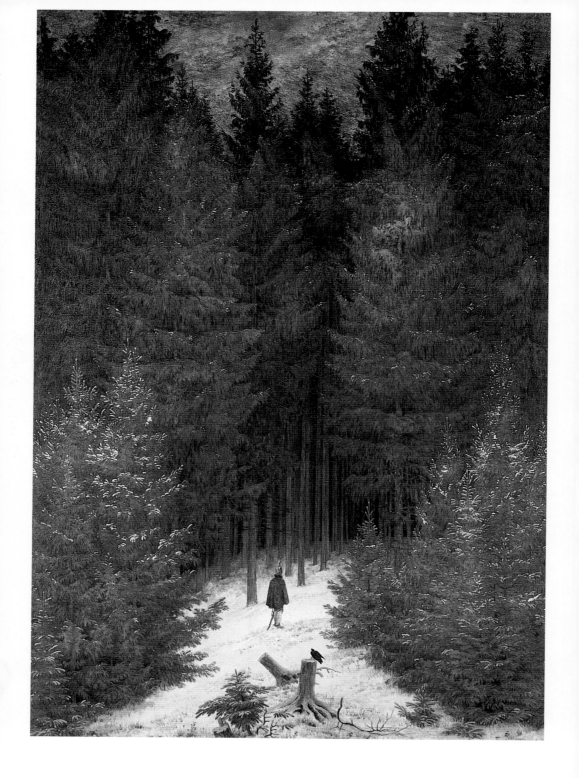

In the autumn of 1810 the gradually rising tide of success that
Friedrich had been experiencing ever since winning a prize in the
Weimar Kunstfreunde competition in 1805 reached its high point.
For it was with the showing of *The Monk by the Sea* (see 72) and
The Abbey in the Oakwood (see 73) at the Berlin Academy
exhibition that he became a truly national celebrity. The works
attracted a huge amount of attention (mostly favourable), and
were bought by the Prussian royal family. Finally, he secured a
new level of status by being elected a member of the Prussian
Academy of Arts – albeit only by the narrow margin of five votes
for and four against.

71
*The Chasseur
in the Forest,*
1814.
Oil on canvas;
65·7×46·7cm,
25⅞×18¾in.
Private
collection

Partly this success can be seen as a gradual strengthening of
Friedrich's powers. The two canvases, the largest he had ever
painted, are highly original. They represent what would nowadays
be called an artistic breakthrough. While he was to continue to
paint fine works for the rest of his life, he was never more radical
than in these two spectacular pictures. They have rightly gained
Friedrich a permanent place in the history of art. However, it does
not always happen that great works of art immediately secure
success and fame for their creators. That they did so here is due
to special circumstances. Of particular importance was the political
climate in which they emerged, which has already been alluded to.

Politics was playing an increasing role in Friedrich's life at this
time. Since October 1806, when the Prussian army had been
annihilated by the French at the battles of Jena and Auerstedt,
Germany had been an occupied country. The position was felt
particularly strongly in Dresden since the Saxon government
co-operated with Napoleon, the Elector being rewarded for his
loyalty by being elevated to a kingship. Friedrich associated at this
time with a circle of writers, artists and intellectuals in the city

who were violently opposed to the French invasion, including Heinrich von Kleist and Theodore Körner, both of whom wrote stirring patriotic works. Friedrich himself was vociferous in his patriotism. Gotthilf Heinrich von Schubert described him at the time as the man 'from whom one could most frequently hear about the political storms raging in the outside world'. So intense was Friedrich's anti-French sentiment that when in November 1808 he received a letter from his brother Christian, postmarked Lyon, the artist asked him not to write again until he had left French soil.

Friedrich had initially hoped that 'his King', Gustav IV Adolf of Sweden, would save the north against Napoleon, but after the collapse of that monarch's attempt in 1809 he had to look elsewhere. Austria, the traditional leader of the German states, had been defeated yet again by Napoleon at the Battle of Wagram in 1809. This left Prussia, the only other German state that could claim to be a major power. While defeated in 1806, and forced to pay reparations to France, Prussia had maintained a kind of independent neutrality. Furthermore, the defeats of 1806 had played into the hands of those politicians such as Karl August, Fürst von Hardenberg and Karl, Reichsher von Stein who were suing for social and administrative reform. Over the next few years sweeping changes were rushed through. The serfs were emancipated, economic restrictions were lifted and many aristocratic privileges were abolished. It seemed that what Hardenberg called a 'revolution in the good sense' was taking place. Historians have subsequently seen this change as fuelling a new kind of popularly based nationalist enthusiasm which enabled a resistance movement to develop that was to spearhead opposition to Napoleon. It was also to be the beginning of that march towards unification that culminated in the establishment of the German Reich in 1871. Even if this picture is an exaggeration (as historians such as David Blackbourn have argued), there is no doubt that the changes in Prussia were enthusiastically received by those throughout Germany who were seeking liberation from French occupation.

It is striking that Friedrich should have turned his back on the Dresden Academy at this time (he did not exhibit there in either 1809 or 1810) and looked instead towards Berlin. Doubtless he must have hoped for a better audience for his starkly Germanic canvases in the capital of Prussia, though he may not have realized quite how successful he was going to be. Nor may he have known that the Crown Prince – who was behind the purchase of his canvases – was an ardent supporter of romantic patriotism. Later, when he became King Frederick William IV, he was known as the 'romantic on the throne'. The purchase of the *Monk* and the *Abbey* for 450 thalers (approximately £4,500 or $8,000 in today's values) was only the first of a series of purchases of Friedrich's works by the Prussian royal family between that time and the end of the Napoleonic Wars.

This chapter will explore Friedrich's activities from the time of his first success in Berlin to the end of the Wars of Liberation that brought about Napoleon's expulsion from Germany in 1814. Before going further into the politics of the period, however, it is as well to look more closely at the pictures themselves. The *Monk* was the first of the two to be painted (72). The critic Christian Semler described it in Friedrich's studio in February 1809, a couple of months after *The Cross in the Mountains* (see 46) had been completed and displayed. The *Monk* outstrips that bold work in its radical approach to landscape. The picture shows a single, lonely figure, wandering on a shore of unrelieved barrenness. The horizon runs across it quite low down as an unbroken line. Friedrich had undoubtedly experienced the full powers of nature when wandering on Rügen, the island whose bleak coastline is widely presumed to have provided the basis for the picture. No other artist had dared to represent such an experience on such a scale and with such directness and simplicity. The sense of melancholy and the elemental in this work led to a renewed interest in Friedrich in the later twentieth century, when it was seen by art historians such as Robert Rosenblum to be foreshadowing abstraction (even specifically the Abstract Expressionism of Mark Rothko; 1903–70). It has similarly attracted

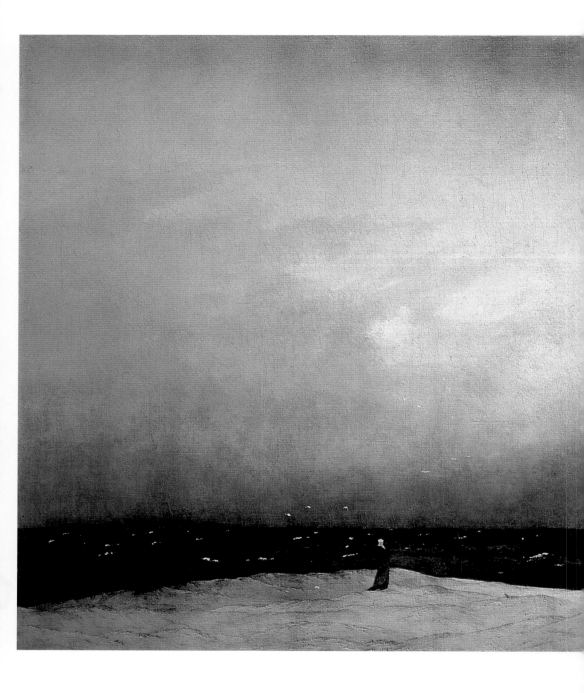

72
*The Monk
by the Sea,*
c.1809.
Oil on canvas;
110·4×171cm,
43⁵⁸×67³⁸in.
Nationalgalerie,
Staatliche
Museen, Berlin

attention among the existentialists for its unrelieved image of loneliness. It reminds us that Friedrich was one of the favourite painters of the Irish playwright Samuel Beckett. Certainly such existential aloneness can be found to have roots in the Romantic perception of subjectivity. It is certain, too, that Friedrich was responding to such influences himself when creating his bleak image. It is utterly in keeping with this vein that the monk should appear to resemble the artist. He had already exhibited a sepia envisioning his own funeral. Now he had assumed the meditative isolation of the monk – an artistic role already well known to contemporaries through Wackenroder's *Outpourings of the Heart of an Art-Loving Monk* and which Friedrich refers to explicitly in the near contemporary self-portrait drawing showing his cloak cast over his shoulder like a robe (see 58).

Friedrich was discovering as he worked. It is a sign of this that he changed the picture time and again as it developed. Originally the monk himself was looking sideways across the picture (his feet can still be seen in position for this pose; see frontispiece). The sea that he was contemplating contained two ships buffeted by the winds. Friedrich painted these out – they can still be discerned beneath the surface through infrared photographs. Figures looking out to vessels at sea occur in Friedrich's earlier works, such as *Fisherman on the Shore* in Vienna (see 60). By removing the ships, Friedrich made the composition more radical in its bleakness. He also increased the picture's introspective mood, for there is now no external image of Fate for the monk to focus on. There is only an elemental void. As well as paring down the picture's imagery, Friedrich modified the atmospheric effect several times. When Semler first described it he said the sky was grey, 'heavy with mist'. Later, shortly before sending the work for exhibition, Friedrich darkened it to a night scene, before lightening the upper parts to suggest a murky, joyless dawn. Such changes show the artist exploring deepening moods of meditative bleakness. Perhaps he was encouraged to intensify these after he had decided to paint the *Abbey* as a pendant to the work. In terms

of colour, they form a distinct contrast, the blue-grey of the *Monk* offsetting the predominantly brown tones of the *Abbey*.

While paring down the *Monk*, Friedrich took care to maintain an effective composition. It has been pointed out recently by Werner Busch that the position of the monk in the picture marks out an interval determined by means of the 'golden section', the traditional method of achieving harmony in pictorial compositions. Such harmony, however, is used to counterbalance other more unusual and unsettling intervals. The canvas shape is wider than the normal 'golden section' rectangle. The horizon is unusually low, making the sky predominate. Yet the monk is lower down still. He is literally sunk below the horizon. He does not oversee it in the way that spectators do in conventional landscape views. Similarly the distance, though shown, is flattened. We are closed in, rather than being offered an expansive vista. It is as though everything had been reduced from what would be expected for a normal, reassuring landscape.

The strangeness of the picture provoked immediate comment. All were impressed by the stark effect, though some felt this went beyond the bounds of visual gratification. 'It grasps the heart rather than the eye,' wrote Joanna Schopenhauer, the mother of the philosopher. The most remarkable tribute it received appeared in the *Berliner Abendblätter*, the journal edited by Friedrich's old acquaintance and fellow patriot Heinrich von Kleist. Kleist commissioned the Romantic poets Clemens Brentano and Achim von Arnim, who had recently completed their famous collection of German folk songs, *Des Knaben Wunderhorn* (1805–8), to review the work. Although sympathetic to the new mystical trend in painting (Brentano was an admirer of Runge), they found the picture too puzzlingly eccentric to review seriously and ended up with a rather jocular commentary which included a series of punning dialogues, supposedly based on the responses of visitors to the exhibition. Kleist, however, could see more precisely the import of the picture's challenge. He therefore radically rewrote the review, interposing sections in which he took the work in

deadly seriousness: 'There can be nothing sadder or more desolate in the world than this place: the only spark of life in the broad domain of death, the lonely centre in the lonely circle.' Referring to the bleakest of English nature poetry, he went on to comment that the picture seemed to be 'thinking Young's *Night Thoughts*'. He concluded with a striking image of the picture's starkness. 'Since it has, in its uniformity and boundlessness, no foreground but the frame, it is as if one's eyelids had been cut off.'

This searing description, invoking a tortured and involuntary opening of the eyes to bleak experience, suggests a deep resonance between Friedrich's work and Kleist's own artistic method. While both writer and painter were excited by the heady flights of fancy of the Romantics, they shared a distrust of the over-playful dilettante approach that often accompanied this. Just as Friedrich had warned that art was a 'serious game', so Kleist insisted that a stark reality lay behind the subjective. This is why such plays as *The Prince of Homburg* and novellas like *Michael Kohlhaas* remain so important and relevant. He is constantly driving situations to their logical conclusion, uncovering the truth behind apparently irrational occurrences. Often this probing leads to an uneasy recognition of the bleakness that surrounds the illusions that people use to comfort themselves. The outcome is frequently tragic, as his own life was. In 1811 he committed suicide, after helping a terminally ill woman to kill herself. Friedrich did not follow Kleist down the path of self-annihilation – probably his strong religious faith prevented him – though he is rumoured to have attempted suicide during his illness in 1806. In any case, he continued to explore the tragic in his landscapes.

After the radical nature of the *Monk*, the *Abbey* seems almost conventional (73). The imagery is familiar from Friedrich's earlier pictures of ruins and graveyards. It is essentially the same as that used in his representations of *Winter* (see 64). However, he has given the composition a greater and more imposing formality, using bilateral symmetry and a lowered viewpoint. He has used his growing prowess in oil painting to achieve more striking and

73
The Abbey in the Oakwood,
c.1809.
Oil on canvas;
110×171·5cm,
43¼×67¾in.
Nationalgalerie,
Staatliche
Museen, Berlin

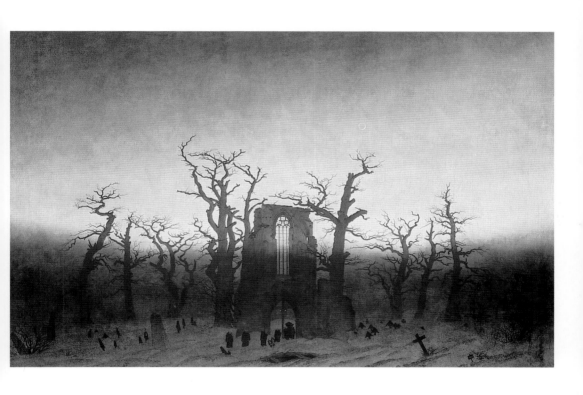

spectral atmospheric effects to set off the silhouettes of the ruins of the abbey (once more based on Eldena) and the barren oaks. The funeral added to the ghostly effect of the work, since monks would have ceased to inhabit such a ruin centuries ago. This encouraged reviewers to see the picture as a kind of dreamscape. The dream could be seen, moreover, to be hopeful. The new moon is a symbol of Christ in Marian theology, and most commentators took its presence here to be a sign of salvation and the life to come.

74
The Cross beside the Baltic, 1815.
Oil on canvas; 45×32cm, 17¾×12⅝in. Schloss Charlottenburg, Staatliche Museen, Berlin

It is significant that Kleist ignored this picture, which ameliorated, to some extent, the bleak reality of the *Monk*. Equally striking is the fact that the *Abbey* inspired a poem by another of Friedrich's Dresden associates, the patriotic poet Theodore Körner. Unlike Kleist, Körner was a hopeful patriot who celebrated heroic deeds and looked towards his nation's epiphany. His *'Friedrichs Totenlandschaft'* (*Friedrich's Landscape of Death*) begins in gothic gloom, but turns in its closing verses to the promise of salvation beyond. Körner was equally admiring of what he took to be the

emotive method of the work which, he said, inspired not 'cold admiration' but the 'feeling' in which art is perfected. In general the *Abbey* was the more appreciated of the two compositions. Friedrich's friend Carl Gustav Carus was later to call it 'perhaps the most heartfelt and poetic work of art in the whole of modern landscape painting'.

Since the pictures were intended as pendants, the question arises as to whether they hang together to tell some kind of story. Friedrich himself gave no clues about this. Delivered late, the works were listed in the addendum of the exhibition catalogue as 'Two landscapes in oil', and given a single number. As we know, Friedrich was not in the habit of interpreting his pictures or giving them titles that alluded to their symbolic content. He himself seems to have accepted that different people would read his pictures in different ways and, indeed, most of the titles that Friedrich pictures now have are retrospective designations invented by others. Of one painting, *The Cross beside the Baltic* (74), he commented that it would be 'to those that see it a consolation, to those that don't a cross'. Probably Christian Semler was nearest to the mark when he commented:

No one would seriously doubt that the immeasurableness that spreads before him in the dim spreading distance is the object of his contemplation. One feels drawn to meditate over it. Each person probably invests it with different thoughts, for every person will give a different spiritual interpretation to the great and serious subject which is determined by his individual nature. However, all these realms of thought converge in the end, and there is a point at which they all meet.

The point at which our thoughts meet is where we can experience these works as statements about existence, of endurance and wonder at the world beyond our understanding. It is this sense of endurance that could be seen as giving these pictures their political relevance at the time. Perhaps this is why the Prussian Crown Prince was so drawn to them. They celebrated a spiritualized German landscape. Their references to the Gothic

75
Karl Friedrich Schinkel,
Plan for a Mausoleum to Queen Luise,
1810.
Watercolour;
67·6×47·4cm,
26½×18⅜in.
Kupferstich-kabinett,
Staatliche
Museen, Berlin

76
Philipp Otto Runge,
Fall of the Fatherland,
1809.
Pen;
19·3×13·3cm,
7⅞×5¼in.
Kunsthalle,
Hamburg

were also timely and may have helped to recommend Friedrich's work. This quintessentially medieval style was believed to be of German origin, and had been celebrated as such as long ago as 1773 in Goethe's celebrated essay on Strasbourg Cathedral. More recently, architects had begun to return to the style for monuments with national associations. In the same exhibition in which Friedrich showed his *Monk* and *Abbey*, Karl Friedrich Schinkel (1781–1841), the leading Prussian architect, exhibited his plans for a mausoleum for Queen Luise (75), the much loved wife of the King, who had recently died. These were in the Gothic style. Schinkel was also a landscape painter and later adapted Friedrich's style to create some fantastic scenes with silhouetted Gothic buildings (see 93). However, as will be seen, these were very different in meaning to those created by Friedrich.

There might have been an advantage in the fact that nationalist sentiment is implied, rather than explicit, in Friedrich's work. Prussia was, it should be remembered, technically the ally of France at this point and direct anti-French sentiment could have been seen as subversive. The year before, when Runge had made

an obvious reference to the French invasions in his cover design for a patriotic journal, the *Vaterlandisches Museum*, this had been suppressed as subversive. The image shows a fallen hero being ploughed up by a woman and child to refertilize the land (76). The surround for the design, *Fall of the Fatherland*, is made up of lances and armour, both suggestive of war and referring back to the Middle Ages. Friedrich's pictures, by contrast, could be read purely in terms of personal religious salvation.

While the *Monk* and the *Abbey* brought a new dimension into Friedrich's art, this did not lead to an abandonment of earlier themes. They could be seen, indeed, more as a development of the practice, which had established itself over the last five years, of exploring contrary images. Initially Friedrich had contrasted summer with winter scenes, usually seeing the former as 'material' and the latter as 'spiritual'. Even in the two landscapes shown in Berlin the *Monk* is the more 'material' of the two and the *Abbey* the more 'spiritual'. The original contrasting of pairs has been related to the eighteenth-century aesthetic division between the 'beautiful' and the 'sublime'. It had been proposed first of all by

the Irish statesman Edmund Burke in his *Philosophical Inquiry into the Origin of Our Ideas of the Sublime and Beautiful* (1757) and had been a key assumption of Immanuel Kant in his *Kritik der Urteilskraft* (*Critique of Judgement*, 1790). The latter work was particularly important in Germany, and although it is highly unlikely that Friedrich, with his aversion to theory, ever read Kant, he was certainly influenced by scholars such as Gotthilf Heinrich von Schubert who had. In Chapter 7 Friedrich's own aesthetic position will be explored. Here it is enough to comment that he was aware of the common distinction of the time made between the depiction of appealing, 'beautiful' scenery and those more forbidding though also more exciting terrains that could be

77
Georg
Friedrich
Kersting,
*Kersting
and Friedrich
Wandering
in the Harz
Mountains*,
1811.
Pencil;
35·5×23·6cm,
14×9¼in.
Kupferstich-
kabinett,
Staatliche
Museen, Berlin

78
*Riesengebirge
Landscape*,
1810.
Oil on canvas;
45×58·3cm,
17¾×23in.
Pushkin
Museum,
Moscow

described as 'sublime'. While his art is more frequently associated with the latter, he continued to paint pictures in the gentler mode.

Mountains always fascinated Friedrich and in June 1810 he made a tour of the Riesengebirge with his friend Kersting, a frequent travelling companion, who recorded their later travels to the Harz in a charming outline sketch (77). The Riesengebirge or 'Giant Mountains', to the east of Dresden, inspired in Friedrich a new sense of scale and grandeur. In some sketches he contrasted the flat landscape beneath with the towering sides of the mountains (78). Others concentrated purely on the effect of the

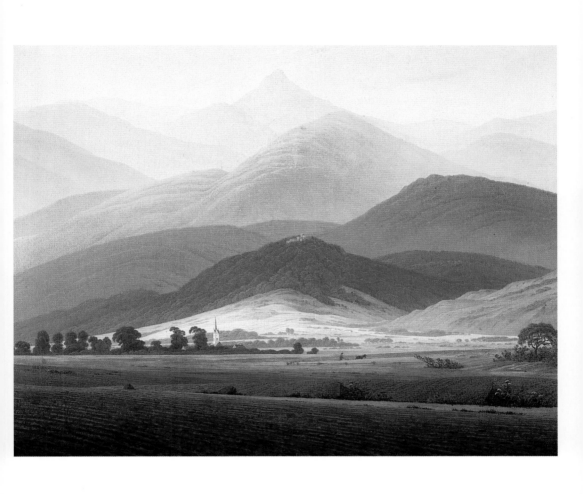

mountains themselves. He also painted a large nocturnal view – one of the canvases apparently acquired by the Duke of Saxe-Weimar in August 1810 (79). Now sadly cut down from its original shape – which would have been the same format as the *Monk* and the *Abbey* – *Moon over the Riesengebirge* shows how he was also exploring more subtle ways of representing nocturnal light, as well as succumbing increasingly to the charm of mountains.

The companionship Friedrich enjoyed on his travels to mountainous regions in these years might have encouraged him to see nature in a gentler mood. In the same year he painted some exquisite mementoes of his bohemian travels – two of which were sold to Count Thun, the purchaser of *The Cross in the Mountains*. There could hardly be a greater contrast between that dramatic sunset and these idyllic renderings of daytime light. It may well

be that we again have a religious allegory here, for one picture (*The View of the Milleschauen*, Gemäldegalerie Neue Meister, Dresden) is more 'earthly', showing the morning, and the other (80) already has the foreground more deeply shadowed – suggestive of late afternoon. The two silhouetted trees also seem to be too central and symmetrical merely to be part of a charming picturesque composition. Yet, on the other hand, they hardly have the portentous appearance of the blasted oaks in the contemporaneous *Abbey*. It would seem that Friedrich still wished us to look at landscape reflectively, even if he was displaying a simpler and more delightful type of charm. Most of all, these Bohemian pictures show Friedrich developing his considerable powers in representing differing effects of light with great finesse and subtlety.

Friedrich's experiences of the Riesengebirge formed the basis
of his major painting for 1811, *Morning in the Riesengebirge* (81).
This had its first showing at the Dresden Academy where,
according to the journal *Zeitung für die elegante Welt*, 'the whole
Dresden public began a pilgrimage' to see it. News of his success
in Berlin had made Friedrich a hero in the Saxon capital too.
The mood of this picture, however, is very different from that of
the *Monk* and the *Abbey*. There are no northern wastes, redolent
of Germanic endurance. Instead the picture seems to invoke a
picturesque tour in rapturously beautiful scenery. Friedrich has

79
*Moon over the
Riesengebirge*,
1810.
Oil on canvas,
47·5×167cm,
18⁵⁄₈×65¾in.
Staatliche
Kunst-
sammlungen,
Weimar

80
*Bohemian
Landscape*,
1810.
Oil on canvas;
70×104·5cm,
27¾×41¼in.
Staatsgalerie,
Stuttgart

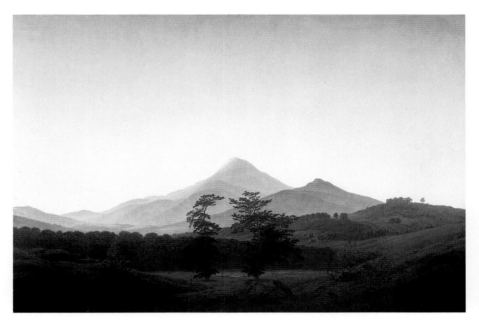

shown a hopeful time of day, the dawn, and recorded the
breathtaking effect of the sun rising above the mists in the
mountains. We look across at one of the highest peaks of the
mountain range where a woman is helping a man up to the
summit on which there is a cross that towers on the horizon.
It may well be that the woman symbolizes hope. In any case she
introduces a new note into Friedrich's work, one that recognizes
the role of woman in life and appears to envisage her as an
agent of salvation.

81
Morning in the Riesengebirge,
1810–11.
Oil on canvas;
108×170cm,
42$\frac{1}{2}$×66$\frac{7}{8}$in.
Nationalgalerie,
Staaatliche
Museen, Berlin

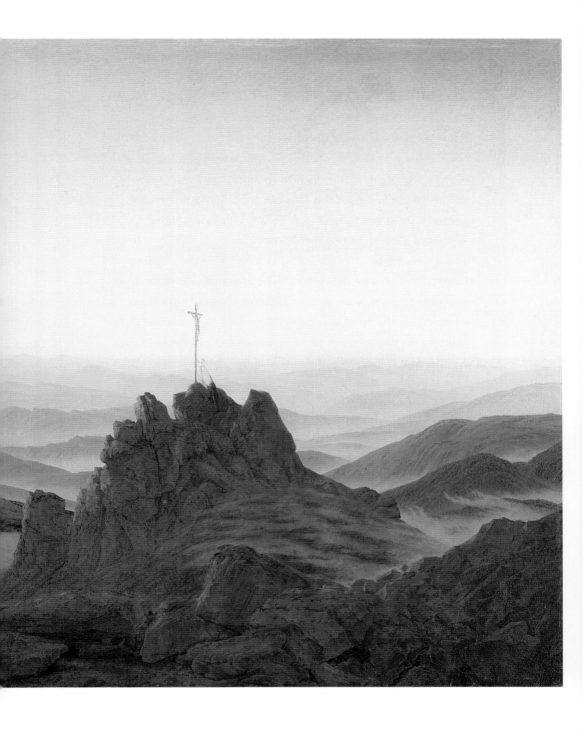

Despite the attention it attracted, *Morning in the Riesengebirge* found no buyer in Dresden. Nor did it do any better in Weimar, where it was exhibited a year later, in 1812, with a pendant (now lost) showing a gloomier evening view of the mountains with an awesome waterfall. Perhaps there was already a sign of some cooling-off in the Weimar connection. Relations with Goethe had been cordial during the previous year. The poet visited Friedrich's studio when in Dresden in September 1810. The artist returned the compliment, visiting Goethe in Jena after a tour of the Harz Mountains in June 1811 with Kuhn, the sculptor who had carved the frame for the *Tetschen Altar*. Contact after that, however, appears to have ceased. Perhaps the reservations expressed by the Duke of Saxe-Weimar's cousin in 1810 had begun to take root. Goethe himself seems to have become increasingly alarmed at what appeared to him to be Friedrich's deviation from naturalism (he is reputed to have said that it would not matter which way up the *Monk* was hung). He would also have had little sympathy for the artist's growing nationalist mood, being himself an admirer of Napoleon and sceptical about the value of a politically united Germany. A few years later such misgivings were to surface in an attack on 'Neu-Religiös-Patriotische Kunst' (New-Religious-Patriotic Art) by Goethe and his collaborator Heinrich Meyer, in which Friedrich is condemned along with medieval revivalists such as Peter Cornelius (1783–1867) for having encouraged a false direction in art.

While having failed at Dresden and Weimar, Friedrich was once again to find success in Berlin, where his *Morning in the Riesengebirge* was rapturously received, and where once more he was able to sell his work to the Prussian royal family. In addition to buying the painting they also purchased the delightful *Garden Terrace* (see 83).

As with *Morning in the Riesengebirge*, this picture gives a prominent place to a woman, whose presence seems to infuse it with a new tenderness. At this time Friedrich was a celebrity and a bachelor. He was far from insensitive to female beauty and

seems to have enjoyed the attention of young women, some of whom he wrote to in a flirtatious tone. There is an amusing story related by Wilhelmine Bardua, sister of Caroline, a painter friend who made a portrait of Friedrich at the end of his life (see 175). Returning from their tour of the Harz Mountains in 1811 Friedrich and Kuhn had also paid a visit to the two Bardua sisters, then resident with their parents at Ballenstädt. When the visitors left, the sisters accompanied them for a while through dark woodland. Hearing a voice behind her addressing her as 'schöne Minchen' (lovely Minnie) Wilhelmine was overcome with delight at the thought that the famous, tall and striking-looking Friedrich might be making advances to her. Mightily flattered, she replied 'im artigsten Tone' (in the most charming manner), only to discover that she had been addressed by the diminutive and unimportant Kuhn, a matter that caused her some anger.

Friedrich appears to have had a closer relationship with Louise Seidler, one of the young lady artists that he came into contact with through Kügelgen and his circle. She, too, was not averse to his physique and character, as the following sentence from her memoirs reveals. After having described him as being like an 'old German' with his height, blond hair and 'forceful appearance', she continued: 'Anyone who has looked but once into his pure eyes must also have tasted through the often bitter shell the sweet kernel in his deeds and pictures.'

The reference to taste here is revealing. Food seems to have played a traditional courtship role in their correspondence. On 2 May 1814, when out sketching in the Plauen'scher Grund, a favoured beauty spot near Dresden, Friedrich was so excited by a letter from Louise that he wrote an elaborate reply which included a picture of himself sketching (82):

I read your letter beside the roaring waterfall in the Plauen'scher Grund, and all the baking and roasting made me want to enjoy the splashing and plashing. If only the rocks had turned into cakes and roast meat at that moment, and the water into wine: a new cave would certainly have come into being and the raging water would

have turned into a rippling stream. Then I could have sat down before my work with a full stomach and rendered it eternal. At this very moment it is all so vivid in front of my eyes that I must try to give you a little sketch of it.

A Freudian would have a field day with the resultant image of Friedrich seated before a deep inviting cleft in the rock, dreaming of the satisfaction he would receive from Louise Seidler's provender. Certainly such letters make one aware of the playful

82
Letter to
Louise Seidler,
2 May 1814.
Ink;
19·4 × 13 cm,
7⅝ × 5⅛ in.
Kupferstich-
Kabinett,
Dresden

side of Friedrich, the mischievous and even flirtatious man he could be at times. A Freudian might also have much fun discerning erotic forms throughout Friedrich's pictures, with the tumultuous mountains and ecstatic light effects. Even without going this far, one can see that the pleasure of light could be associated by him with the feminine. He was later to explore the female as well as the male response to landscape, but here he seems to have found a new form of charm at the beauty of nature.

The *Garden Terrace* (83) would seem to be more about the erotic than about politics. However, Börsch-Supan has made us aware that it was a pendant to a more joyful garden scene – now lost – with children playing and women seated by abundant fruit trees. Picking up on the reference to this setting as a 'French' garden, he surmises that it shows the artificial to be set against the active one of the 'German' garden. There may be an implied critique of Frenchness here which would fit in with Friedrich's anti-French stance at this time. Yet, on the other hand, he could hardly have made his complaint more engagingly. Here his game of symmetries takes its cue from the formal garden. The carefully tended chestnut trees – their lower branches pollarded to make their foliage form a high, umbrella-like sunshade – divide the picture into a tripartite form. The garden wall – which runs in a dead straight line exactly a third of the way up the picture – frames a glorious sunlit view of mountains beyond. Or perhaps one should say excludes, for it is sharply cut off. The only access to it is through a gate fiercely guarded by stone lions. Another stone figure, possibly Flora, presides over the neat flowerbeds inside. The only signs of life in the garden are three or four tiny birds balancing on twigs among the broad foliage of the trees. The seated woman herself is attractive but prim, the only hint of passion being the bright red shawl, which she has taken off and discarded on her wicker basket at her feet.

There may be a political point behind all this. However, perhaps it is gender politics that is really at play. Formal 'French' gardens were associated with reading and contemplation – they are described as such in Ludwig Tieck's novel *Eine Sommerreise* (*A Summer Journey*). This picture shows an intellectual woman, who is contrasted with the 'natural' women with children in the lost pendant of the garden with fruit trees. It is noticeable that, despite the admiration of educated women such as Wilhelmine Bardua, and his flirtation with the highly cultivated Louise Seidler, Friedrich eventually married a woman with no intellectual pretensions.

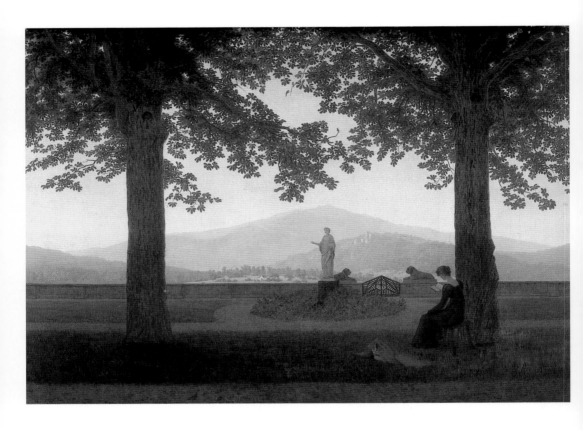

83
*The Garden
Terrace,*
1811–12.
Oil on canvas;
53·5×70cm,
21×27⅝in.
Schloss
Sanssouci,
Potsdam

The Garden Terrace is also a reminder that he continued to produce pictures on a modest scale as well as large exhibition show-stoppers. There were good practical reasons for doing so. Two hundred thalers – roughly the sum that the Prussian royal family paid for each of Friedrich's large pictures – was just sufficient, according to the playwright Friedrich Schiller, to pay for the 420 litres of wine he budgeted for in the year 1799. By that calculation it would be the equivalent of approximately £2,000 or $3,500 in today's money. Friedrich had to earn more than this, and he did so largely by painting small pictures for modest, largely bourgeois, clients. Some of these were idyllic scenes, similar to those described above, but he also provided spiritual scenes for the more restricted purse.

One such example from this period is a pendant pair of wintry scenes. In *Winter Landscape with Oak and Hunter* (84), a cripple wanders in a snowy waste amid barren trees. In *Winter Landscape with a Church* (85) he has collapsed and is praying before a wayside cross, surrounded by evergreens, the symbol of faith. The second composition is more formal than the first scene, as was Friedrich's wont. However, the symmetry evoked is more subtle than in his large exhibition pieces, the cross and fir trees being balanced by a church that rises like a vision in the background. While showing the power of faith, it should be pointed out that there is no earthly salvation offered here. Despite the fact that the cripple has thrown his crutches away, there has been no miracle cure. The church too – though definitely on the model of the new Gothic Revival churches that were being planned by Schinkel and other architects – is a vision beyond the horizon, not a graspable reality. The salvation is the realization of the life beyond this earth.

This point is worth stressing since Friedrich, even at his most intensely patriotic, distanced himself from those medieval revivalists who literally wished to turn back the clock and reconstruct a utopia in the modern world. He did, it is true, introduce visionary churches into a number of his works during this period. Some rise above fir trees, as in *The Cross in the*

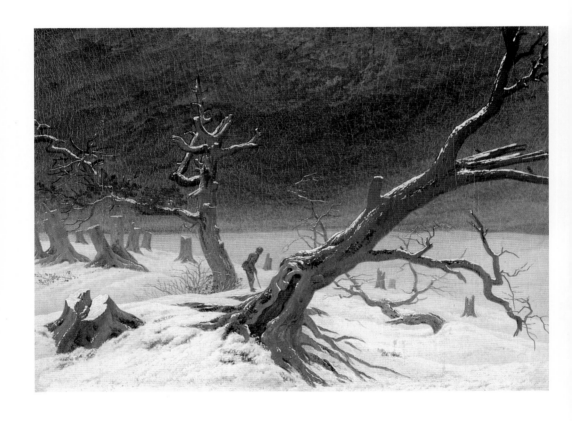

84
*Winter
Landscape
with Oak
and Hunter,*
1811.
Oil on canvas,
33×46cm,
13×18$\frac{1}{8}$in.
Staatliches
Museum,
Schwerin

85
*Winter
Landscape
with a Church*,
1811.
Oil on canvas;
33×45cm,
13×17¾in.
National
Gallery,
London

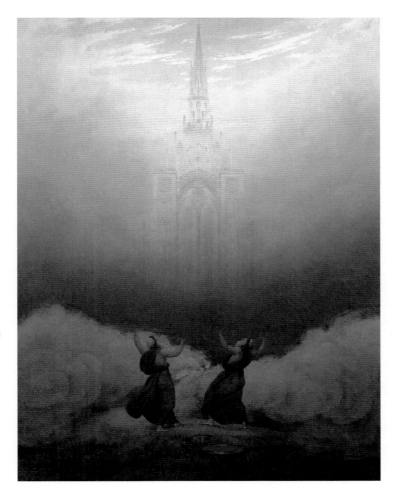

86
*The Cross in
the Mountains,*
1811–12.
Oil on canvas;
44·5×37·4cm,
17¹₂×14¾in.
Kunstmuseum,
Düsseldorf

87
*Vision of
the Christian
Church,*
1813–14.
Oil on canvas;
66·5×51·5cm,
26¼×20¼in.
Museum Georg
Schäfer,
Schweinfurt

Mountains at Düsseldorf (86). In *Vision of the Christian Church* (87) he even constructed a fantasy in which two ancient druidic figures, engaging in a ritual sacrifice, throw up their arms in amazement at the sight of a Gothic church rising before them out of the clouds. Presumably this was intended to be ancient heathendom gaining an intimation of the Christianity that was to replace it. Even here, however, the intact Gothic building remains in the 'beyond', out of reach of the foreground. It has not come down to earth.

While the Gothic remains in the clouds in these pictures, the very act of visualizing it suggests that Friedrich was moving closer than ever before to what might be called 'predictive' painting. This move seems to be a response to the growing mood of resolve at the time in Germany to mount resistance to Napoleon and hopefully bring about not just the defeat of the French, but also the achievement of a united country. The mood stiffened when, in May 1812, Napoleon gathered his *grande armée* together in Dresden in preparation for his fateful campaign against Russia. The Saxon regime, compliant as ever, provided the base for this assemblage of soldiers from all subject nations (Prussia was even coerced into supplying 20,000 men). During Napoleon's absence in the east the resolve strengthened, particularly as reports of disaster began to filter through. By the time the French Emperor returned to Dresden in May 1813 with the ragged remains of his decimated army, a full resistance movement was in force. This led to a series of battles, culminating in the decisive French defeat at the Battle of Leipzig in October 1813 which brought about the end of the Napoleonic empire east of the Rhine.

In September 1812, as Napoleon was marching towards Moscow, Friedrich exhibited the first of his explicitly political pictures, *Tombs of Ancient Heroes* (88). Significantly, in view of the Saxon government's continued support of the French Emperor, this was in Berlin rather than in Dresden. The picture shows the heroes' tombs set high in the mountains before a cleft in a rock-face. Beside them is an obelisk whose inscription 'Edler Jüngling

Vaterlandsretter' (Noble Youth, Saviour of the Fatherland) makes it clear that a patriotic hero is being commemorated. Specific reference to the invaders is made by two soldiers in French uniform who are wandering through the graves to the chasm beyond, where they will presumably be swallowed up. German nature, it would seem, is about to put paid to French artifice. The allegory is sharpened by a motif in the foreground (although hard to see in reproduction), where a snake painted in the colours of the revolutionary tricolour is spread across a broken-down tomb that has the word 'Arminius' inscribed on it. Arminius (or Hermann, to give him the German version of his name) was the chieftain who defeated a Roman army in the Teutoburg Forest in 9 AD. A fabled German hero frequently referred to in the country's history, Arminius had gained new currency during the Wars of Liberation. His famous victory had been the subject of one of Kleist's major and most patriotic plays, *Die Hermannschlacht* (*The Battle of Hermann*, 1808).

Kleist himself was already dead by this time. However, Friedrich was in contact with many of the leading agitators who were campaigning for a popular uprising against the French. Principal among these was the Dresden poet Theodore Körner and the politician and publicist Ernst Moritz Arndt. Arndt was a fellow Pomeranian who had campaigned successfully for the abolition of serfdom in his native land before becoming engaged in the current struggle. He had published a constant flow of anti-French propaganda during the occupation, living for much of the time in Sweden to avoid arrest. In 1812 he was summoned to St Petersburg to assist in the final campaign against Napoleon. Friedrich got to know him in April 1813, when he was in Dresden making preparations to counter the returning French. He was an active supporter of the Lützower Corps, the band of volunteers fighting for freedom, and designed their uniform, with its distinctive floppy hat and 'old German' coat. Friedrich's friend Georg Kersting was one of those who enlisted, and depicted himself in full attire.

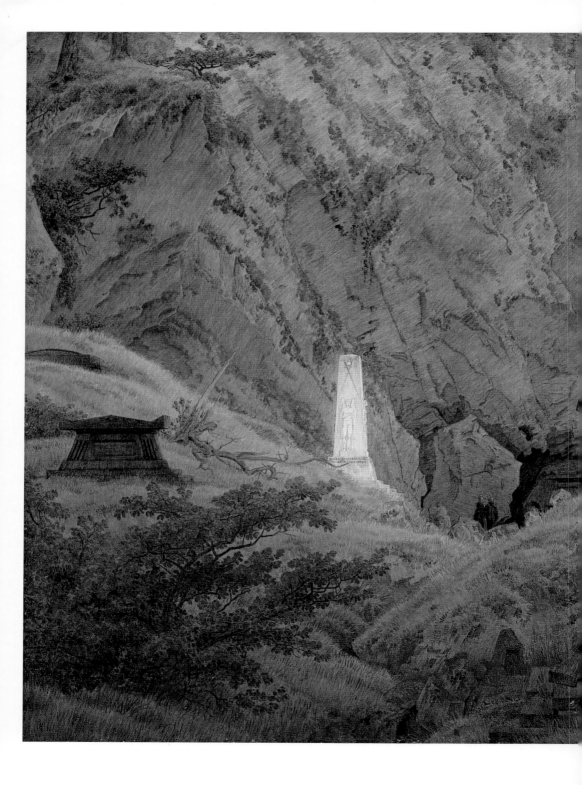

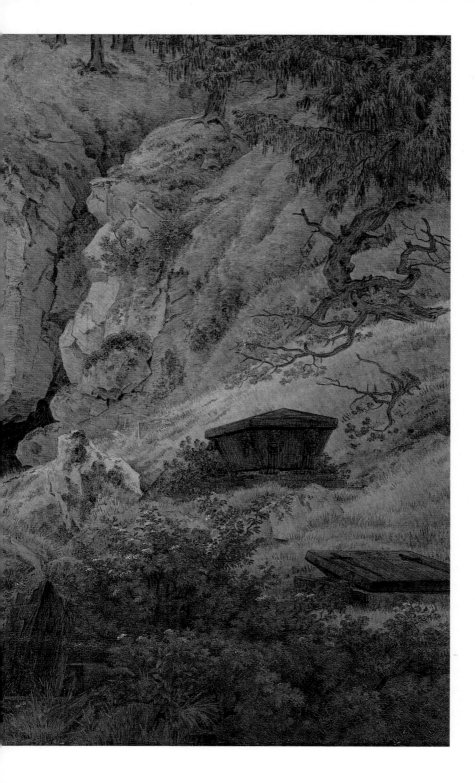

88
Tombs of Ancient Heroes,
1812.
Oil on canvas;
49·5 × 79·5 cm,
19½ × 27¾ in.
Kunsthalle,
Hamburg

89
Fallen Rocks,
1813.
Watercolour;
21×17·4cm,
8¼×7in.
Kupferstich-
kabinett,
Staatliche
Museen, Berlin

90
**Georg
Friedrich
Kersting,**
On Sentry Duty,
1815.
Oil on canvas;
46×35cm,
18×13¾in.
Nationalgalerie,
Staatliche
Museen, Berlin

91
**Georg
Friedrich
Kersting,**
*The Wreath
Maker*,
1815.
Oil on canvas;
40×32cm,
15¾×12⅝in.
Nationalgalerie,
Staatliche
Museen, Berlin

Consisting largely of untrained students and craftsmen, the Lützower Corps arguably had little impact on the final outcome of the struggle. However, they constituted a power symbol, remaining a focus for nationalist and democratic sentiment in the years to come. While openly admitting his patriotic sentiments in 1812, Friedrich's actions at the time of the conflict can hardly be called heroic. He did not enlist as Kersting had done. Like many other Dresden citizens he took to the hills when the French occupied the city in May 1813. While the battle raged he was up in the Elbsandsteingebirge sketching rocks and fir trees. Nor was Friedrich unmindful of the conflict while sketching in the mountains. Patriotic messages are written on some of his studies of fir trees. He also produced a watercolour of fallen rocks in a quarry which look as though they might be being prepared for monuments or tombstones (89). It was as if he was returning to nature to find the material for patriotic themes. The results were seen in two pictures that were shown in Dresden at the Patriotic Exhibition celebrating the defeat of the French in March 1814.

One was a further view of Arminius's tomb in the mountains. The other, *The Chasseur in the Forest* (see 71), was the most explicit of all Friedrich's anti-French images. It shows a French cavalryman who has lost his horse in battle, wandering into the darkness of a German forest of fir trees. There is even a hint of gloating revenge in the raven in the foreground which, according to one newspaper report, was singing the death song of the chasseur.

The German forest can be seen as a reference back to Arminius, who had defeated the Romans in the woods. With its deep and mysterious nature, dark, internalized, frighteningly unknown, the forest has been a powerful image in Germany throughout history. It is therefore no surprise that when Kersting came to paint his tribute to his fallen comrades, he should have shown them on sentry duty in a wooded vale (90). Friesen, Hartman and the poet Körner are shown in their freedom fighter's *altdeutsch* (old German) costume. Unlike Friedrich, who identified his Germany with Christian evergreens, Kersting goes back to a more primitive source, that of the pagan oak. In a pendant picture, *The Wreath Maker* (91), he showed a young girl winding wreaths for the three fallen heroes. Like them, she wears a costume evocative of the medieval past.

Friedrich was also active in planning to design monuments to commemorate fallen heroes (92). This might seem like an act of opportunism, since schemes were afoot to raise funds for such projects. In the event, none of his designs was ever realized, but his activities were not without consequence. On 12 March 1814 he wrote to Arndt asking him to provide an inscription for a memorial in a picture he was planning to commemorate Scharnhorst, the Prussian general most involved in the reform and democratization of the army, who had died from wounds received at the Battle of Lützen. Friedrich expressed frustration at the course which events had taken since the war. For, instead of the hoped-for introduction of democratic regimes, there had been a return to the old hierarchies. In these circumstances, he told Arndt, he was not in the least surprised to hear that there would be no monument erected which recognized either 'the great cause of the people or the brave deeds of individual Germans'. 'As long as we remain the lackey of the princes,' he concluded, nothing would come of the matter. 'Where the people have no voice, they will also not be allowed to express their feelings or to honour themselves.'

92
*Sketch for
a German War
Memorial,*
*c.*1815.
Pen;
18·9×8·9cm,
7¹₂×3¹₂in.
Kunsthalle,
Hamburg

Friedrich's pictures of this time were intended as a substitute for the lack of any proper monument to the 'real' fallen heroes. But even here there were limitations. On 2 May 1814 he wrote to Louise Seidler describing a picture he had planned, which showed a man broken on a wheel with the inscription 'Vaterlandsverräter' (Betrayer of the Fatherland). He admitted that he had abandoned the subject as it had been too distressing for him; he was more given to the inner, contemplative response.

Friedrich's critical tone contrasted with that of the Prussian architect Karl Friedrich Schinkel, creator of the Gothic design for Queen Luise's mausoleum (see 75). A great admirer of Friedrich's *Abbey*, Schinkel was moved by the Prussian victory at the end of the war to show a silhouetted Gothic cathedral looming above a busy modern town. The original picture of 1813–14 is now destroyed, but a number of copies survive, including one

by Wilhelm Ahlborn (1796–1857; 93). Schinkel's image of a reborn Germany thriving under the old order could not have been further from Friedrich's vision. While the two might have had common cause at the outbreak of the Wars of Liberation, they were on different sides now.

Friedrich was no firebrand. But his muted resistance was to bring him trouble all the same. He was not to know that, a few years later, his letter to Arndt would fall into the hands of the Prussian secret police when they were investigating the politician on suspicion of subversive political activity. By that time Friedrich had long since ceased to be patronized by the Prussian royal family and was being looked upon as an eccentric and unreliable character. The revelation of this letter did not help matters. In the end he too became a victim of the patriotic struggle.

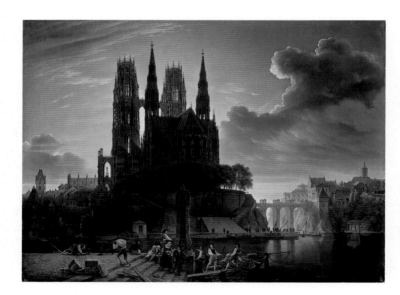

93
Wilhelm
Ahlborn after
Karl Friedrich
Schinkel,
*Gothic
Cathedral by
the Water*,
1823.
Oil on canvas;
80×106·5cm,
30¹₂×42in.
Nationalgalerie,
Staatliche
Museen, Berlin

'They are at their demagogic machinations.' That is how
Friedrich described the figures in the picture now called *Two
Men Contemplating the Moon* (95) to Peter Cornelius, a visiting
fellow artist, on 20 April 1820. It was a risky thing to do, for
'demagogue' – following an outburst against such people by
Prince Metternich, the chancellor of Austria – was the term
currently being used in the German states to describe dangerous
revolutionaries bent on inciting the populace to rebellion.

Tension over 'demagogues' had been growing ever since the
end of the Napoleonic Wars. The political settlement achieved
at the Congress of Vienna in 1815 had been one in which the
German states had been rationalized and greatly reduced in
number. However, it had not endorsed the move towards German
unification nor in any way accepted the principle of universal
franchise for Germans. Instead, Prussia and Austria had emerged
as powerful states committed to a 'Holy Alliance' with Russia to
maintain law and order throughout central and eastern Europe.
Many Germans – including Goethe (by now the cultural icon of
the age) – were prepared to accept the new political order, but
there was great unrest among those who had actively supported
the freedom fighters of 1813. To such people, the settlement
constituted an abandonment of promises made to them by the
King of Prussia and other political leaders at that time.

The most vociferous groups were those members of student
organizations, *Burschenschaften*, who continued to campaign for
the ideals of the freedom fighters. Matters came to a head in 1817
when a festival at the Wartburg Castle in Thuringia to celebrate
the 300th anniversary of the Reformation degenerated into a
student protest in which symbols of Prussian authoritarianism
were burned in imitation of Luther's historic burning of the papal

94
*The Wanderer
above the
Mists,*
1818.
Oil on canvas;
94.8×74.8cm,
37¼×29½in.
Kunsthalle,
Hamburg

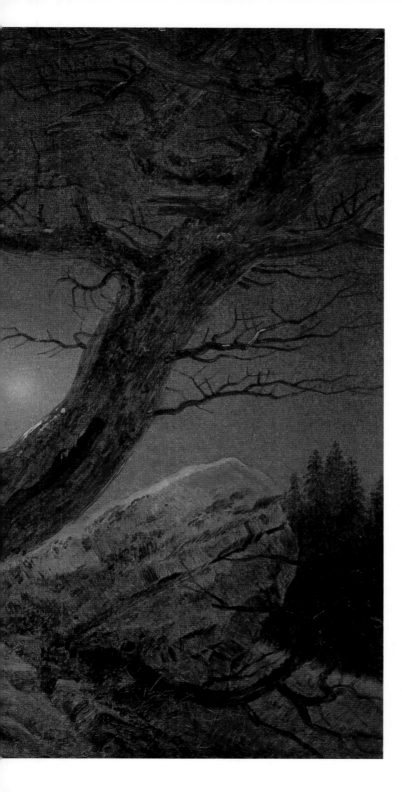

95
*Two Men
Contemplating
the Moon,*
c.1819–20.
Oil on canvas;
35×44cm,
13¼×17⅜in.
Gemäldegalerie
Neue Meister,
Dresden

bull. Two years later the murder by a student fanatic of August Friedrich Kotzebue, a right-wing popular playwright suspected of acting as a spy for the Russian Tsar, added to the sense of crisis about demagogues. After a meeting called by Prince Metternich at Karlsbad, Prussia and Austria issued a series of restrictive decrees bent on curbing subversive action. These included the suppression of the 'pernicious principle of press freedom' and of many civil liberties. There followed a period of *Demagogenverfolgung* (persecution of demagogues) similar in many ways to the McCarthyite witch-hunt for Communists in America in the 1950s. Several of Friedrich's political associates were arrested and interrogated at this time. The most prominent of these, Friedrich's friend Arndt, lost his post as a university professor as a result of such action.

It does not seem likely that Friedrich had intended his picture of two night wanderers admiring an enchanting moonlight effect to represent demagogues actually plotting insurrection. He was given to teasing visitors who came to his studio. Once he told a bemused observer that the picture he was looking at, and having trouble interpreting, was actually a view of terrain on the moon. His remark was probably intended as a joke against those who over-reacted to the freedom fighters of the recent Wars of Liberation, imagining them all to be dangerous insurgents. The costume of the figures, in particular the man with the floppy hat and the coat, makes a distinct reference to the uniform of the Lützower Corps that was still popular among students and others who felt sympathy with their views. According to his friend the Norwegian painter Johann Christian Clausen Dahl (1788–1857), who owned this picture, the older man in the cloak and floppy hat was in fact Friedrich himself, whereas the younger one leaning on him was his student August Heinrich (1794–1822).

The painter to whom Friedrich made his remark about demagogues would have been a good target for such pleasantries. He was a leading member of the Nazarene group of religious revivalist painters. During the Wars of Liberation, Cornelius had

96
Peter von Cornelius,
Faust and Mephisto on the Brocken, 1811.
Pen;
40·2×34·1cm,
15⅞×13½in.
Städelsches Kunstinstitut, Frankfurt

himself been an ardent patriot. This was the time when he made a series of highly gothic illustrations for Goethe's *Faust* (96), which played strongly on Germanic associations. Since then, he had thrown in his lot with the new regimes, who saw religious revivalist painting as according with their own emphasis on the return to traditional values. Such work fitted in with the 'right-wing' image of the Middle Ages, the *Ritterlich* (chivalric) society dominated by knights and priests. The *altdeutsch* costume worn by the figures in Friedrich's picture, by contrast, symbolized a *bürgerlich* (bourgeois) image of craftsmen and towns and was actually banned in Bavaria because of its association with civil liberties. When he visited Friedrich, Cornelius was on his way to Munich where he was about to take up his post as Principal Painter to the King of Bavaria, and start depicting large-scale frescos in public buildings stressing the values of traditionalist culture and authority.

Yet if not literally depicting a subversive act, *Two Men Contemplating the Moon* conveys a sense of the continued commitment on the part of Friedrich to his principles. For while never a revolutionary, he remained steadfast in his democratic sympathies and persisted in wearing *altdeutsch* garb throughout his life as a sign of this. Such views were, as has already been suggested, to cost him dear in the years to come. When they met, Cornelius's career was on the way up. He would soon become the most powerful authority in German art, controlling commissions and art education first in Bavaria and then in Prussia. Friedrich was heading in the opposite direction, sinking from being the most talked-of landscape painter in Germany to being isolated as an untrustworthy eccentric. He might have enjoyed making a joke about being a demagogue. Others did not share his humour.

Another remark of Friedrich's was recorded at the time of Cornelius's visit. This was of a quite different nature, made in front of his painting of *Swans in the Rushes* (97): 'The Divine is everywhere, even in a grain of sand. Here I have depicted it for once in the rushes.' Here he is alluding to the pantheism common in Romanticism which has its roots further back in Protestant mysticism. It is a reminder of the seriousness of Friedrich's religious views – and also that sincere religious faith was in no way incompatible with democratic sympathies. Yet it is also

97
Swans in the Rushes, 1820.
Oil on canvas; 35·5×44cm, 14×17¾in.
Goethemuseum, Frankfurt

probably a dig at Cornelius. The Nazarenes were bent upon reviving traditional forms of religious art. Although they had been lumped together with Friedrich by Goethe and Meyer in their attack on 'Neu-Religiös-Patriotische Kunst' in 1817, they actually represented very different approaches. The Nazarenes were as opposed as Wilhelm von Ramdohr was to landscape assuming the conventional role of figure painting in churches. Cornelius, furthermore, made it clear that he regarded landscape painting as inferior to figure painting. True to academic principles, he believed it to be a 'minor' genre and thought that the attention it was currently receiving was a sign of the distorted values of the revolution-ridden modern age. While in Munich, he was instrumental in having the post of Professor of Landscape at the Bavarian Academy abolished. As with the fears about demagogues, Cornelius was in step with the authorities in his view that landscape had got out of hand recently. This was another reason for isolating Friedrich in the post-Napoleonic 'call to order'.

Both these interpretive remarks – half jocular, half serious – made by Friedrich are a further reminder of the ambivalence that lies within his pictures. Perhaps it was the cloak of ambiguity which landscape provided that made him feel secure in sailing close to the wind in the iconography of a number of the pictures he painted during this period. For many of them bore a subversive message for those who viewed them in a receptive frame of mind. The right-wing clampdown that occurred throughout Germany in the post-Napoleonic period turned the country into a series of police states. Like many writers of the period, Friedrich responded by referring to his beliefs in an obscure and coded manner.

This situation may partly explain the predominantly nocturnal nature of so much of the work that Friedrich did at the time. He had already experimented with night scenes before – as in the *Abbey* (see 73). Now, however, they became a virtual obsession – as the three night scenes already discussed demonstrate. It is as though he deliberately wished to inhabit the world of twilight in uncertain and threatening times.

At first Friedrich's use of ambiguity seemed to work and he continued to enjoy the patronage of the Prussian royal family. In 1816 King William III bought two evening scenes as a birthday present for the Crown Prince. One of these showed a harbour (99) which is described in early inventories as Stralsund although it is based on studies that Friedrich had recently made of ships in the harbour at Greifswald (98). In either case, this view of a Baltic port would have appealed to the Prussian royal family as a representation of territory recently gained. They were looking at

98
Sailing Ship,
1815/18.
Pencil and
watercolour;
35·7×25·3cm,
14×10in.
Kunsthalle,
Mannheim

99
*Greifswald
Harbour,*
1816.
Oil on canvas;
90×71cm,
35³⁄₈×28in.
Schloss
Sanssoucci,
Potsdam

the valuable access to the sea, with all its commercial and military advantages, which they had acquired when Pomerania had been ceded to them at the Congress of Vienna the year before. At first glance it might seem that *Greifswald Harbour* expressed approval of the new order. Reviewers of the work, when it was shown in both Dresden and Berlin, interpreted it as an allegory on the peace that had recently been won. One reviewer speculated on how the boats had 'fortunately withstood the dangers of the

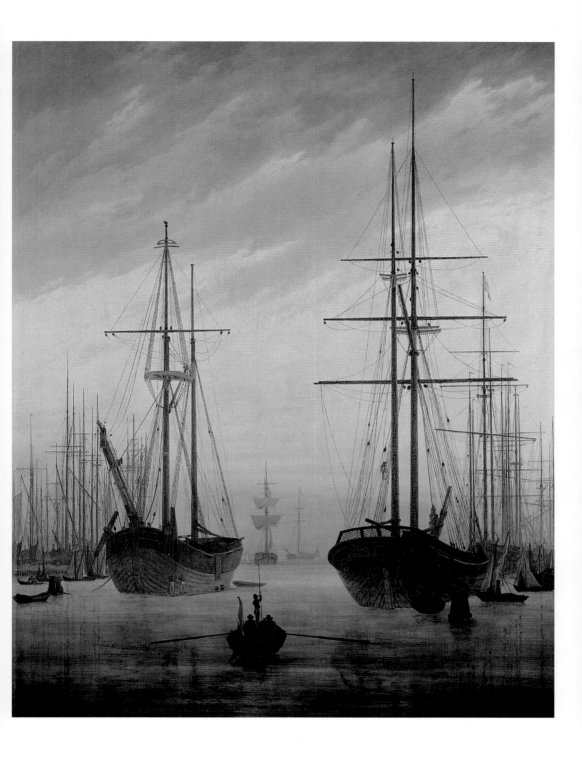

100
Sailing Ship,
c.1815.
Oil on canvas;
72·3×51cm,
28½×20in.
Kunst-
sammlungen
Chemnitz

stormy sea' and were now enjoying their sabbath beneath the
light of the silvery moon. Similar sentiments were expressed about
the other work by Friedrich purchased for the Crown Prince,
a 'fantasy' (as the catalogue put it) with a man and woman in
altdeutsch costume contemplating a cathedral in evening light.
According to a poem by Theodore Hell (Theodore Winckler),
this showed a warrior 'just come back from the holy war' who was
now to enjoy a peaceful marriage. Before the Wartburg protest
of 1817, it was still possible to see *altdeutsch* costume in a positive
light. Indeed, there seems to be a reference here to the 'Holy

Alliance' of Prussia, Austria and Russia bringing peace and order back to central and eastern Europe. At the time that this alliance was forged, Prince Metternich penned a fantasy of his own, in which he conceived of the monarchs of its three members as knights of old, fighting together on a modern crusade.

Friedrich's moonlit medievalism seemed to offer no cause for concern at this moment, although an attentive observer might have raised an eyebrow. In *Greifswald Harbour*, two of the boats have flags, one Danish, one Swedish. It would hardly be unusual to find such craft in a Baltic port. However, the picture can also be seen as a reference to the traditional allegiances of the area. Pomerania may have been annexed to Prussia in 1815, but Friedrich was typical of his generation in resenting the loss of association with Sweden. On the journey that he made back to Greifswald following the annexation – the time when he made the studies he was later to use for this harbour view – he is reported as having expressed himself vociferously on the matter. As will be seen later, he maintained his sense of allegiance to the Swedish Crown throughout his life. It may seem strange that a German patriot should do so, but it should be remembered that Friedrich was not being offered citizenship of a democratic united Germany in 1815. His country was being ceded to Prussia. This evening picture of a harbour replete with Scandinavian ships might be less a celebration of returning peace after a stormy day than an elegy for a departing era. Another favourite image that comes from this period is of a lonely, ghostly ship, wandering the high seas in half-darkness, as though with nowhere to shelter (100).

By the time his harbour view was being exhibited in Berlin, Friedrich had taken steps to distance himself from Prussian authority. On 10 June 1816 he petitioned the King of Saxony to become a Saxon citizen. The move is all the more striking because Friedrich had never been favoured at the Saxon court, which had been firmly pro-French at the time when he was making his reputation as a painter of patriotic and anti-French pictures. Fortunately for him, he had powerful supporters in the Dresden

art world, not least the head of the Saxon Academy, Graf Vitzthum von Eckstädt, who lobbied successfully in his favour. Eckstädt also managed to secure membership of the Saxon Academy for Friedrich, with a modest annual stipend of 150 thalers.

Friedrich was probably lucky to have negotiated his change of citizenship and his Academy membership in the period before the *Demagogenverfolgung* got under way. It is certainly noticeable that he received no more commissions from the Prussian royal family after the student protest of 1817. He seems, too, to have experienced some difficulties at the Berlin Academy. According to his fellow Pomeranian and patron, the Berlin publisher Georg Andreas Reimer, Friedrich resolved at this time not to exhibit again at the Berlin Academy because he had 'not been properly treated' on the last occasion. Further signs of anti-Friedrich sentiment can be found in the fact that an artist known to be a pupil and admirer of his was refused admission. Friedrich's 'mystical' tendencies had in fact always been viewed with suspicion by a leading faction in the Berlin Academy – including the great classical sculptor J G Schadow (1764–1850). Now that royal support had diminished, it seems that they felt able to express their disapproval openly.

A further sign of Prussian disapproval (perhaps spurred on by the knowledge of the artist's renouncement of Prussian citizenship) might be found in the fate of Friedrich's attempts to establish himself as an architectural designer at this time. It was a period when there was a renewed programme of building in both the new and the old territories belonging to Prussia after the Napoleonic Wars. This was partly brought about by the necessity to restore damaged buildings, and partly by the desire to imprint Prussian authority throughout the land. By far the most important project was that of the completion of Cologne Cathedral (Westphalia now also being part of Prussia after 1815), which, as it slowly progressed towards its realization in 1881, became the living symbol of Germany's move towards unification.

Schinkel, who had become chief architect in the Prussian Department of Works in 1815, was the overseer of the project, and it is hardly surprising that the buildings that went up were on the whole in a uniformly recognizable group of styles.

Friedrich had close knowledge of Schinkel's architectural work and had – as the visionary churches in various pictures show – a good command of the *Neugotik*: a style loosely based on the old *Backsteinkirche* (brick churches) that he had known from childhood in Greifswald. Together with his brother Christian – the carpenter who had made wood engravings after his designs (see 10 and 31) – he prepared meticulous plans for the refurbishment of the Marienkirche at Stralsund, which had suffered during the years of French occupation. Between 1807 and 1813 it had been used as a military magazine. After an evaluation by Quistorp it was agreed that Friedrich and Schinkel be asked to produce plans for the restoration of the church. Friedrich certainly took the project seriously (101), and it is not clear why the plans did not go ahead. Lack of funds has been suggested. Friedrich's design shows the altar with no altarpiece, but a drawing from the period suggests that he may have been planning to put one of his landscape altars into the refurbished church (see 70). This could have been enough to scare the authorities off, particularly now that Prussia was actively supporting the revival of traditional religious art being spearheaded by the Nazarenes. In any event, a more modest plan was implemented using another artist whose work was approved by Schinkel.

Perhaps to make the best of a bad job, Friedrich used the knowledge he had gleaned of the architecture of the Stralsund Marienkirche to design a further fantasy picture – a visionary cathedral floating in the sky (102). Once again, at a time when Gothic buildings were being restored throughout Prussia, his structure remains a dream. It does not touch the earth – though it may contain a hint of earthly bliss in the angel heads that hover round the cross in the foreground. For these appear to be based on Caroline Bommer, who became Friedrich's wife in 1818.

101
Design for the Marienkirche, Stralsund,
1817.
Pencil, ink and watercolour;
56·6×43·7cm,
22¼×17⅛in.
Germanisches National-museum, Nuremberg

102
The Cathedral,
c.1818.
Oil on canvas;
152·5×70·5cm,
60×27¾in.
Museum Georg Schäfer, Schweinfurt

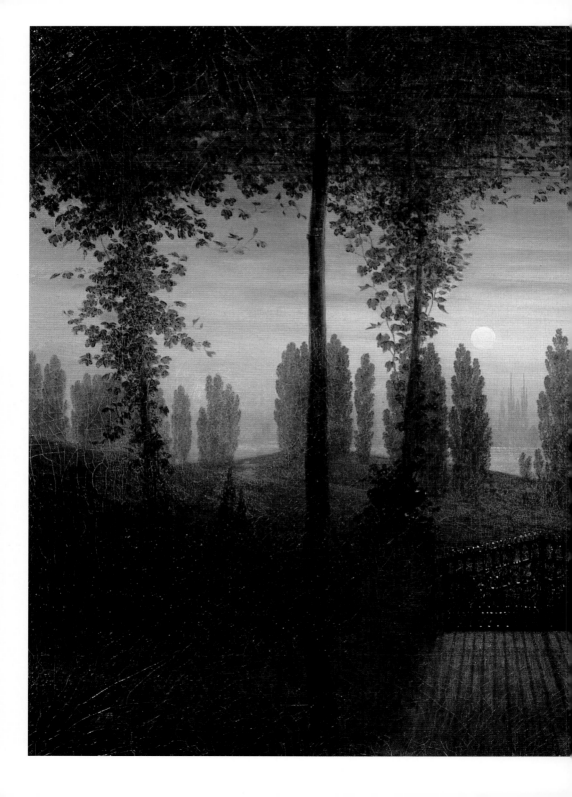

103
Picture in Remembrance of Johann Emanuel Bremer, 1817.
Oil on canvas; 43.5×57cm, 17×22½in. Schloss Charlottenburg, Staatliche Museen, Berlin

While contacts with the Prussian authorities were strained after 1817, Friedrich continued to have clients among the bourgeoisie in Berlin. Indeed, these were now forming the basis of his practice, as aristocratic and monarchical patronage receded. It is hardly surprising to find that Friedrich's clients often shared his democratic principles. A particularly moving example is the memorial picture that he painted for Dr Emanuel Bremer – or perhaps for his family (103). Bremer was a Berlin doctor noted for introducing vaccination into the capital and in particular for his work among the poor. Friedrich's beautiful nocturnal image has the doctor's name wrought into the ironwork of a gate that leads into a garden covered with trellised vines. The formal balance of the picture, which is divided into three, almost like a triptych, makes us aware that it is a spiritual work. The darkened foreground is illuminated with ethereal light – once again from the moon. There is a river or estuary in the middle ground and beyond that there are the spires of a harbour town. They glitter in the moonlight as those of Greifswald did in a near-contemporary view that Friedrich painted of his home town (see 2). Friedrich shows us here a celestialized Baltic port – something that would be appropriate in Bremer's case since he was, like Friedrich himself, a Pomeranian.

The Pomeranian connection was particularly important in the case of Friedrich's most prolific Berlin patron, Georg Andreas Reimer. Born in Greifswald in 1776, Reimer had known Friedrich from childhood, although they did not seem to have met as adults until about 1818. A link between them was the theologian Schleiermacher – so important for the development of Friedrich's ideas (as was seen in Chapter 3) – who was a house guest of Reimer for some time in Berlin. Much of what we know about Reimer's connections with Friedrich comes from correspondence confiscated when he was under arrest for his radical views in the early 1820s, and preserved in the Prussian state archives. Despite harassment by the authorities, Reimer ran a successful publishing house and was able to make significant purchases from Friedrich. At the time of his death in 1842 he possessed no fewer than thirty-

104
Monastery Graveyard in the Snow, 1817–19. Oil on canvas; 121×170cm, 47⅝×66⅞in. Formerly Nationalgalerie, Berlin (destroyed)

one works by the artist. He may well have seen *Monastery Graveyard in the Snow* (104), which was being painted at that time, but was not exhibited until 1819. This large work, sadly now destroyed, could be seen as a reworking of the *Abbey* (see 73). Formally there are great changes, which could suggest that Friedrich wished to redo this composition in a grander way, making a richer use of spatial effect and showing off his growing mastery of atmospherics. Yet it is intriguing to speculate who he thought the buyer would be, now that he no longer had hopes of the Prussian royal family, or indeed of the Dukes of Saxe-Weimar. Friedrich may have had his eye on the Saxon Maecenas Johann Gottlob von Quandt since the artist asked a mutual friend to tell him when the work was finished. Reimer seems only to have bought the picture when it had been on Friedrich's hands for some time after failing to find a purchaser at exhibition.

As well as updating the *Abbey*, the work has some significant differences. The most important of these appears to be the fact that it features the ruin of a church, rather than the monastery of Eldena. It is based to some extent on the Jacobikirche in

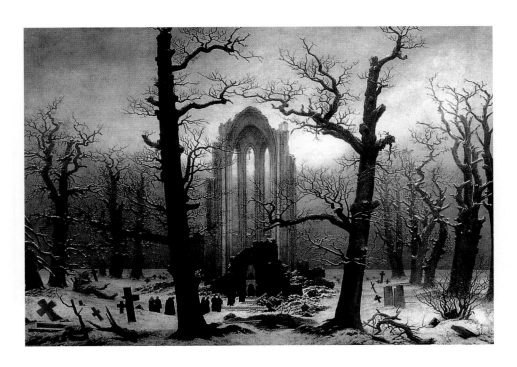

Greifswald, but is also influenced by Friedrich's failed work on the Marienkirche in Stralsund. Since a ceremony is taking place within the church, he may have been trying to indicate the present ruined state of the Church in a broader sense, once more distancing himself from the vision of Gothic rebirth that Schinkel and the Prussian government were so assiduously promoting. It is amusing to think of this great canvas residing in Berlin in the house of a modest burgher, a private critique of the larger nationalist ambitions of the *Abbey* on display in the nearby royal palace.

While he was revising his Gothic themes, Friedrich was also continuing to develop the motif of figures in *altdeutsch* costume contemplating some aspect of the national terrain. Around the same time as he exhibited the picture of the couple looking at the rising cathedral, *Vision of the Christian Church* (see 87), he painted a series of works that seem to have been inspired, like his harbour view (see 99), by his return to Greifswald in 1815. One shows Neubrandenburg (105), the town in Mecklenburg from which his parents came, being approached by two cloaked travellers. Brandenburg appears against the setting sun as a visionary town. Yet the sunset is so dramatic, with its billowing clouds, that it almost looks like an apocalyptic fire and has been read by some in eschatological terms. Maybe this is one more personal reflection on death and the world to come. Yet it could equally well be seen as a comment on German destiny.

Equally teasing from this point of view is the large canvas showing two men in *altdeutsch* costume standing on boulders in the Baltic, staring out at a moonrise (106). Here Friedrich seems to be touching on that sense of the elemental that had been conveyed so powerfully in the *Monk*. 'It is unbelievable', wrote the reviewer in the *Leipziger Kunstblatt*, 'how much such a simple picture can, by that very fact, offer the imagination, that it provides so much to think about. It is the unwritten lines that attract so magically.'

It is impossible to interpret the thoughts of these wanderers, yet their presence completely changes *Two Men by the Sea at*

105
*Neu-
brandenburg
at Sunset*,
1816–17.
Oil on canvas;
92×71·5cm,
36¼×28¼in.
Stiftung
Pommern, Kiel

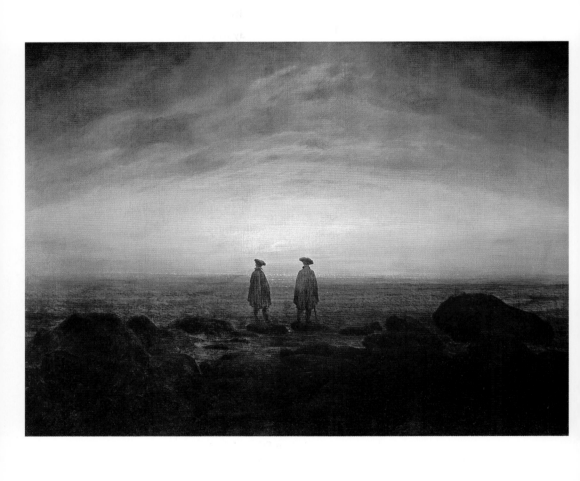

Moonrise. From a political point of view, it seems remarkable that, at a time when there was such a witch-hunt about 'demagogues', Friedrich should insistently place figures in his pictures that have unmistakable associations with the persecuted radicals. It is worth reflecting, too, that by turning their backs on us these figures become inscrutable. They are unavoidably present, yet we cannot know either who they are, or what their thoughts are.

It is striking that it is precisely at this moment that the figure viewed from the back (what the Germans call the *Rückenfigur*) takes on a new significance in Friedrich's art. The motif was used by him almost obsessively over the next decade, leading to a series of remarkable pictures that contain one of Friedrich's most recognizable characteristics. It is worth recalling, however, that Friedrich did not invent the motif. More than half a century ago the art historian Herbert von Einem drew attention to a series of engravings by the Dutch artist Jan Luyken (1649–1712) illustrating Christoph Weigel's *Ethica Naturalis* of 1700 in which *Rückenfiguren* rhetorically draw attention to a series of natural phenomena, such as *The Rainbow* (107). Since that time scholars have dug out all manner of *Rückenfiguren* both from earlier periods and among the sentimental landscapes immediately prior to Friedrich's own time. Such figures help us to focus on the fact both that Friedrich is developing a landscape convention particularly common in northern Europe, and that he is doing something entirely new

106
Two Men by the Sea at Moonrise,
1817.
Oil on canvas;
51×66cm,
20¹⁄₈×26in.
Nationalgalerie, Staatliche Museen, Berlin

107
Jan Luyken,
The Rainbow,
c.1700,
Etching;
10·3×11·9cm,
4×4¹⁄₂in

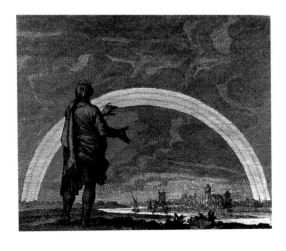

with this. The earlier *Rückenfiguren* always make clear their intentions with respect to the landscape. Some – following a practice recommended by Italian Renaissance theorists such as Alberti in the fifteenth century – introduce the subject of the picture, be it a landscape view or (as in the case of Luyken's work) a specific symbolic motif. Some demonstrate the appropriate way to look at a landscape – as does the example by the Berlin illustrator Daniel Chodowiecki (1726–1801; see 140), to be discussed in Chapter 7. Friedrich's *Rückenfiguren*, by contrast, are undemonstrative, contemplative figures; they disrupt the view, often standing right in the way of our line of sight.

Characteristically Friedrich cracked a joke about his obsessive use of *Rückenfiguren*, telling one visitor to his studio that he liked the device because 'in Life it deceives the least'. Despite such offputting remarks, sympathetic viewers saw them as constituting a new kind of *Innigkeit*, a process of contemplation seen as being typically German in its inwardness and depth. A visitor to Friedrich's studio in 1818, Kurt Waller, wrote of his *Rückenfiguren*: 'Everything is in the finest harmony and warm inner feeling – what might be called the German disposition – is predominant.'

Later commentators have tended to move away from the political implications of these figures, to consider them as a kind of philosophical breakthrough. They do indeed become this, for they introduce a new concept of spectatorship. They indicate an individualized and personal response to the landscape. But it is unclear to us whether they are surrogates for our response, or whether the real subject of the picture is us looking at them looking at the landscape. Discussion of this issue will be resumed in the next chapter. For the present, it is worth observing that it is only during the period 1817–23 – that is, the time of the *Demagogenverfolgung* – that the *Rückenfigur* is a dominating motif in Friedrich's work. It is only at this time, too (with the exception of one or two pictures painted at the end of his career, in the mid-1830s, when he was regressively reworking his earlier motifs), that the large-scale *Rückenfigur* cutting across the horizon

in the centre of the picture – thereby implicitly occupying the spectator's viewing space – occurs. Friedrich intensified the ambiguity with increasingly dominant centralized and silhouetted figures of both women (108) and men (see 94). When comparing these to the smaller *Rückenfiguren* that Friedrich introduced into earlier works – such as the Weimar *Landscape with Rainbow* (see 49) – one can see what a difference the change in scale and position has made to the motif. In that picture, Friedrich has himself looking at a natural phenomenon. But he does not get in the way of us seeing the rainbow; his presence can be viewed as a kind of stimulus for us to enter into a contemplative mood ourselves.

Woman before the Rising Sun/Woman at Sunset (108), by contrast, has the figure rising above the horizon. She dominates the centre of the picture, blocking the sunlight, which transforms her into a ghostly silhouette. Yet while disguised, she remains specific. She wears an *altdeutsch* costume, and her coiffeur is similar in style to that of the artist's new wife, Caroline. The figure sways in a delicate curve, moving slightly off-centre. In fact, although the picture is frequently described as being symmetrical, it is not. The rocks, trees and mountains form part of a subtle sequence of balances and counterbalances, all set in motion by the woman's own slightly leaning stance. She raises her hands, perhaps in surprise or admiration – some say in prayer. It could well be that she is experiencing some mystic epiphany before the beauty of nature. Some commentators say that she is watching a sunrise, others claim it is a sunset. The ecstasy of her gesture suggests the former, the depth of the tones and the way the figure has halted on a path that can go no further, the latter. Is she welcoming the dawn of a new era, or watching in dismay as an old one ends? Like her male counterparts, this *Rückenfigur* is not giving anything away.

Even if the picture did have a political or religious message, its beauty and poignancy comes from the way in which it communicates that sense of yearning that is at the heart of

108
*Woman before
the Rising Sun/
Woman
at Sunset*,
1818.
Oil on canvas;
22×30cm,
8⅝×11¾in,
Museum
Folkwang, Essen

Romanticism. As has already been mentioned, even at their most enigmatic these *Rückenfiguren* remain individual. How different in stance and mood is the solitary male scrutinizing a mountainous landscape in the painting nowadays known as *The Wanderer above the Mists* (see 94). Surmounting a rocky promontory, one foot forward, propped on a stick, there is no wavering in his position. Instead it is the landscape that seems to buckle under his gaze. As with the woman, we are aware that the scene beyond is a personal vision. This traveller is usually interpreted as a melancholic *Weltschmerz* character, supported by quotation from such nature enthusiasts of the period as Goethe, Wordsworth or Chateaubriand. Yet there might be something more specific intended here. The art historian Ludwig Grote, who discussed the work in detail in an article in 1950, interpreted the green suit as that of the Freikorps Jäger, and this, together with a tradition that the figure represents a general Brinckmann (who might have been one of the fallen Jägers of the Wars of Liberation) has led to the view that it could be a patriotic memorial picture. This would certainly fit in with the Wanderer's commanding position. It should be noted, too, that even at the height of his practice of using *Rückenfiguren* Friedrich created no other image which is as dominant and inscrutable. The prescience in the picture is so great that it has become a symbol for the destiny of Germany, as seen in its use on the front cover of the political magazine *Der Spiegel* in 1995 (see 188), when it introduced the notion of the country confronting its recent past. This is, of course, a usurpation and a 'trivialization' of an internalized image of contemplation. Yet it is hard to avoid the view that Friedrich is once again in this image exploring ambiguity and uncertainty.

109
Ulrich von Hutten's Tomb,
1823–4.
Oil on canvas;
93×73cm,
36⅝×28¾in.
Staatliche Kunstsammlungen, Weimar

The same cannot be said of *Ulrich von Hutten's Tomb* (109), a picture painted at the end of this period which abandons ambiguity for one of the clearest statements Friedrich ever made. Although innocently entitled 'Remains of an Old Chapel' when shown at the Saxon Academy exhibition of 1824, there was no doubt about its real subject. Its depiction of an imaginary monument to the sixteenth-century rebel and nationalist Ulrich

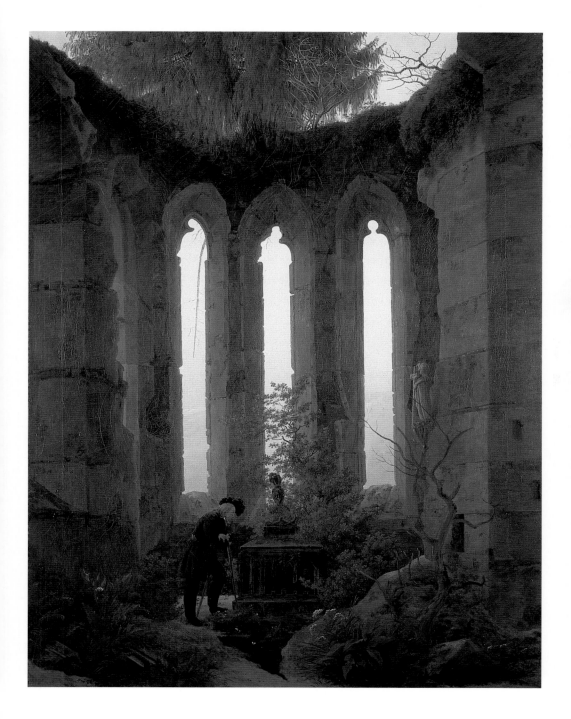

von Hutten would seem to constitute simultaneously a commemoration of the 300th anniversary of his death and the tenth anniversary of the conclusion of the Wars of Liberation or *Befreiungskrieg*. The grave is being contemplated by a man in *altdeutsch* costume. He is not concealed as a *Rückenfigur* on this occasion, but shows us his profile, through which we can see his thoughtful, sorrowing expression. And any doubts about the object of his contemplation are dispelled by the names inscribed on the base of the monument: Jahn, Arndt, Stein, Scharnhorst and Görres – all freedom fighters who had either died in the conflict, like Scharnhorst, or had been subsequently arrested, like Arndt, or who were now in exile, like Görres. Any doubts about Friedrich's view on the outcome of the *Befreiungskrieg* would have further been dispelled by the broken statue of Hope that can be seen on the wall of the ruined church – itself based on a study that Friedrich had made in 1812 of the ruin of the abbey at Oybin in Saxony.

It might be questioned why Friedrich should go so public after years of ambiguity. The anniversary was certainly a spur, but maybe it was because, by this time, he felt he had little left to lose. He would probably have learned that Arndt, when interrogated by the Prussian police, had been asked specifically about the letter that Friedrich wrote to him in 1814 in which he described himself as the 'lackey of princes'. According to the transcript of this interrogation, now preserved in the Prussian state archives, Arndt claimed that he had no knowledge of where the painter Friedrich could have got such ideas from. If Friedrich was not a marked man before that time, he certainly was afterwards. There is evidence, too, that from then on he became circumspect about what he entrusted to letters. 'I have much that I could write to you,' he said in a letter to his brother Adolf on 1 January 1824, 'but I cannot entrust it to a letter.'

Friedrich's inclusion of Arndt's name among the heroes on the monument in *Hutten's Tomb* showed that he was not trying to disguise his solidarity with the recently dismissed university

professor. An incident closer to home may have made it clear to Friedrich that his career was now being blocked too. On 17 January 1824 he had been made an 'extraordinary' professor at the Dresden Academy. This was a step up, certainly, but it also emphasized what he was not being offered. He was not made a teaching member of the Academy. Later in the year, when the professor of landscape, J C Klengel died, the post was given to J C C Dahl. Financially the difference was significant. As an extraordinary professor Friedrich received 200 thalers per annum (approximately £2,000/$3,500 in current values), whereas teaching professors could earn as much as 800 thalers per annum. From the letter written to the King by Vitzthum, the director of the Academy, it would seem that special pleading on Friedrich's behalf had been necessary even for this modest promotion. Vitzthum spoke of 'a certain eccentricity in the artist's choice of subjects' but pleaded that the merit of his handling was such that he deserved the appointment. In 1821, when the *Demagogenverfolgen* was in full swing, Vitzthum had issued an edict to the students forbidding them to wear the 'so-called Old German Costume' or anything resembling it in the Academy. Yet Friedrich had persisted in introducing figures in such dress by virtue of the pictures that he placed on the Academy walls. None could have been more explicit on the point than the character in *Hutten's Tomb*, which Friedrich sent to the Dresden Academy exhibition just months after learning that he had been denied a teaching post there. The fact that some reviewers claimed the figure to be a portrait of Friedrich himself can hardly have helped.

Not surprisingly, *Hutten's Tomb* did not find a purchaser in Dresden. Subsequently Friedrich sent it for exhibition to Hamburg and Berlin (where he had begun to exhibit again). By this time, although described in the catalogue as a view of a chapel, it was openly referred to in the press as a monument to Hutten. Opinions about the work were starkly divided, some praising it extravagantly, others advising the artist not to continue exhibiting it. Friedrich made it clear that his reasons for showing the work were ideological rather than mercenary. He stated in the catalogue

that the proceeds from the sale of the work would go to the fund for supporting the Greeks in their struggle for liberation from the Turks. This reference to the current *Befreiungskrieg* that was being officially supported in Germany, as elsewhere in western Europe, was a neat way of drawing an uncomfortable parallel with the earlier German struggle. It would seem that the Greeks did in fact receive some support from Friedrich in this manner, for in 1827 the work was bought by the Duke of Saxe-Weimar, one of the few German rulers of the period who maintained a sympathy with the ideals of the freedom fighters. At long last, it would seem, Friedrich had performed a 'demagogic machination' that had worked.

Two phrases frequently occur in the titles of pictures exhibited
by Friedrich during the early 1820s. They are *eigne Erfindung*
(own invention) and *nach der Natur* (from nature). The former
is used for large composed works, such as *Monastery Graveyard
in the Snow* (see 104), the latter for direct studies, such as *Woman
at the Window* (see 1), or paintings closely based on drawings
made on the spot, such as the view of Eldena exhibited in 1825
(111). This need to distinguish between invention (for which
Friedrich also used such terms as 'composition' and 'arrangement')
and observation was a response to changing attitudes to
landscape painting. Throughout Europe at this time there was
a discernible move towards a more direct and vivid representation
of nature. In Britain this can be found in the work of Constable,
whose *Haywain* (National Gallery, London) provided a new
standard for the representation of everyday life and scenery when
it was exhibited in 1821. In France it occurs in the fresh studies
made by Jean-Baptiste-Camille Corot (1796–1875) and (a little
later) in those of the Barbizon painters. In Austria, similar effects
can be found in the open-air studies of Ferdinand Waldmüller
(1793–1865), in Denmark in the work of Christen Købke. In
Dresden, where Friedrich worked, the main catalyst was the young
Norwegian artist J C C Dahl, who took the Saxon capital by storm
when he turned up in 1819 and painted views of local scenery
of unprecedented freshness (see 121), as well as vivid studies
of such natural phenomena as skies (112) that form an interesting
parallel with similar work then being undertaken by Constable.

The work of such painters was not, of course, entirely
unprecedented. Direct oil painting from nature (often known
by the French term, *plein-air*) had been a habitual practice among
landscapists, particularly those who visited Rome, for more than
a century. There had been, too, a gradual move since the later

110
*Morning in
the Mountains,*
1822–3.
Oil on canvas;
135×170cm,
53$\frac{1}{8}$×66$\frac{7}{8}$in.
State
Hermitage
Museum,
St Petersburg

189 Engagements with Naturalism

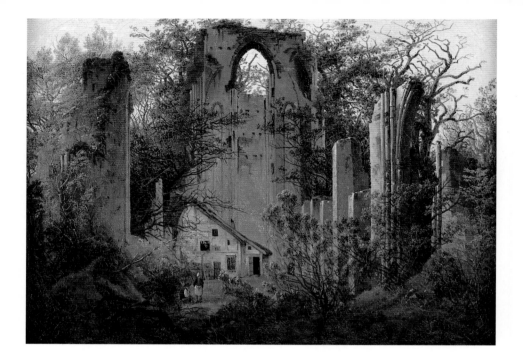

eighteenth century towards placing increasing weight on studies made out-of-doors in the construction of 'finished' pictures in the studio. Friedrich himself had been in the forefront of this tendency. Indeed, it had been the 'truthfulness' of his sepias that had caused Goethe to award him a prize in the Weimarer Kunstfreunde competition of 1805. Yet, like others of his generation, he still believed that direct study of nature had to be accommodated within a larger concept of landscape painting that involved invention and composition. It was only in the 1820s that such notions began to be challenged, and the view prevailed that serious landscape painting should be based primarily on direct transcripts of nature. Behind that assumption lay the belief that it was possible to gain an enlightened understanding of the workings of nature by these means, and that such an understanding should be the principal aim of landscape.

Although it can clearly be seen that painters throughout Europe began to espouse this creed in the 1820s, it is less easy to give an account of why this should have happened. Within the practice of

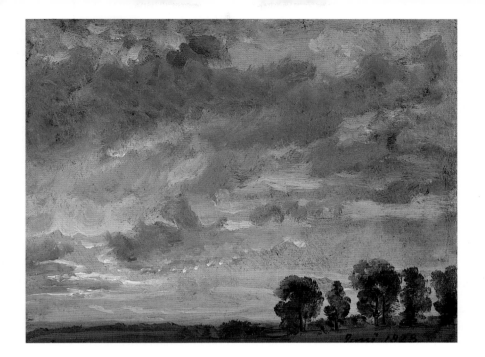

111
*The Ruin
at Eldena,*
c.1825.
Oil on canvas;
35×49cm,
13¼×19¼in.
Nationalgalerie,
Staätliche
Museen, Berlin

112
**Johan Christian
Dahl,**
*Clouds in
the Evening,*
1823.
Oil on paper;
16·5×21cm,
6½×8¼in.
Nasjonal-
galleriet, Oslo

painting there was no particular 'discovery' that precipitated it.
Plein-air painting was already a well-established practice at the
time. It was not for another twenty years, moreover, that tube
paints were invented – the technological advance that has been
held to be a key factor in enabling the development of *plein-air*
painting by the Impressionists. There do, however, appear to have
been a number of intellectual, social and political factors that made
the time favourable for the ascendance of the naturalist creed.

On the intellectual side, perception of nature was being
progressively changed through developments in the natural
sciences. The period between 1780 and 1830 is commonly seen
as one of great advancement in this area. This was the time when
the science of geology came into being, notably through the
discoveries of the German Abraham Gottlob Werner and the Scot
James Hutton. Spurred on initially by the need for a more accurate
knowledge of rocks and minerals generated by the Industrial
Revolution, this led to a widespread rethinking of the nature of
land formation and the processes of natural change. Another key

development was meteorology – important for travel and agriculture – which brought about a more accurate classification of cloud-types and atmospheric effects, particularly through the observations of the British scientist Luke Howard. Such changes did not just affect specialist groups. There can have been few families in the period unaffected by industrial changes and travel. Science itself became a popular pastime, in which amateurs – such as Goethe himself – could often play a key role. In making greater use of more direct and careful studies of natural effects, landscape painters were in a sense simply keeping up with the new knowledge of nature that was being pursued with enthusiasm by many of their most perceptive clients. They could even see themselves as participating in this growth of knowledge. Constable famously likened painting to scientific experiment.

From the philosophical point of view, one can see this as a time when there was a desire to counter the subjectivity of Romanticism with more 'objective' and structured modes of inquiry. The process developed differently in different countries, and in each it engaged with a particular political situation. In Germany, as indicated in the previous chapter, it was used to support a 'return to normality' after perilous times. While not unified, the region had been reorganized. Trade links had improved and industrial development was beginning to take off. All this, however, was to be managed by authoritarian governments, determined not to let revolutionary ideas get in the way of material advance. The term Biedermeier, originally a satirical term, named after a fictitious poet, mocking the simple, unpretentious style of the period, has traditionally been used to characterize this era, seen as lasting from the end of the Napoleonic Wars to the revolutionary uprisings of 1848. The surface image promoted was that of a cosy, domestic harmony; of decency and wellbeing. However, there was much stirring beneath the surface. The 'naturalistic' art of the time did not just celebrate a return to order. It also harboured a critique, often expressed by covert and ironic means, that became more insistent as social and political problems grew.

Friedrich's response to such changes was a measured one. He preserved the monk-like, meditative bleakness of his studio and continued to espouse painting inspired by the 'inner eye'. This is doubtless why he added 'own invention' to the descriptions in exhibition catalogues of so many of his compositions. On the other hand, he was genuinely stimulated by new forms of representation, as these emerged. Dahl habitually practised *plein-air* oil painting, particularly after a visit to Italy in 1820–1. His studies of clouds were made soon after he returned to Dresden. Friedrich, who came to know him far more closely at that time, also began to experiment in this area (113). While his art never assumed the painterly bravura of Dahl's naturalistic studies, it did begin to show a richer sense of atmospherics and colour.

Dahl himself was a firm admirer of Friedrich's work. There were many of the younger generation, however, who saw him as an outmoded subjectivist, limited in his understanding of nature by his own morbid personality. 'Friedrich chains us to an abstract idea,' complained the young Dresden painter Adrian Ludwig Richter (1802–84) in 1824. Knowledge of his eccentric adherence to the discarded political beliefs of the freedom fighters of 1813 only helped to enhance the view that the artist was distorting the 'truth' in his melancholy works. Gradually, throughout the 1820s, his popularity declined.

As well as responding to the more vivid techniques of the naturalists, Friedrich focused increasingly on everyday types of subject. Monks, ruins, burials and creatures of the night become scarce and they do not re-emerge in full force in his work until the last years of his life. There were personal as well as artistic reasons for this shift of direction. On 21 January 1818 he married Caroline Bommer, the 25-year-old daughter of a Dresden blue-dye warehouse manager. Friedrich was in his mid-forties at the time, and had seemed to most of his acquaintances to be a confirmed bachelor. It was possible that a new sense of financial security encouraged him to think of matrimony. His work was still selling well at this point and he was not to know that his fortunes were

113
Evening,
Sky Study,
1824.
Oil on board,
20 × 27·5 cm,
7⅞ × 10¼ in.
Kunsthalle,
Mannheim

soon to take a turn for the worse. Several times during this period he boasted in his letters to his brothers in Greifswald of the amount he was receiving from commissions.

Friedrich's close friend Carl Gustav Carus later recorded the surprise of the artist's friends on hearing of his marriage, even more so because he had chosen a woman of the people. He reported that Caroline was a simple woman who bore children and did not alter Friedrich's way of life. This was not how Friedrich perceived the matter. In a cheerful letter to his family announcing the news, he talks of the many changes that married life had brought to his home:

Much, and all sorts of things, have altered since I acquired a wife. My former, simple domestic arrangements can hardly be recognized any more, and I find it delightful that everything around me now looks cleaner and neater.

But despite this, his holy of holies, his studio, remained intact. 'Only in the room that I use for my business does everything remain as it was before.'

Following the birth of a daughter, Emma, in August 1819 the family moved to larger accommodation. This was an apartment in another house overlooking the river, Haus an der Elbe 33, where the couple were living by August 1820. As in the old dwelling, a room with a view of the Elbe was reserved for Friedrich's studio, and this retained its former sparseness. Caroline looks out from it in *Woman at the Window* (see 1), a painting that contrasts her lively curiosity charmingly with the formality of her surroundings.

While a direct painting, this picture is far from being unplanned. It is in fact one of the most subtle compositions that Friedrich ever made, and forms a prelude to a new sophistication in pictorial arrangement that can be found in his work as he engaged with naturalist practices. As has often been pointed out, it is a picture about looking, about the young woman peering curiously out of the window. The poignancy of the picture, in fact, rests in the way in which Friedrich juxtaposes the formal and the informal.

Many commentators have tried to put their finger on how this works. Yet the explanations offered have not been fully convincing, perhaps because they pay too little attention to spacial refinements. They tend to over-stress the picture's symmetry. Thus, in what is probably the most widely read book on Friedrich to be published in Germany over the last quarter-century there is a reference to the three lines caused by the joins in the floorboards leading to a point that falls 'exactly in the middle axis of the picture, that is indicated by the vertical bar of the window cross'.

They do not. If the lines they form are continued backwards it will be found that they meet not at the centre of the picture but at a point on the left-hand side of the window frame (114). There is a very good reason for this. For that point is the focal or 'vanishing' point of the picture. It indicates the position from which Friedrich

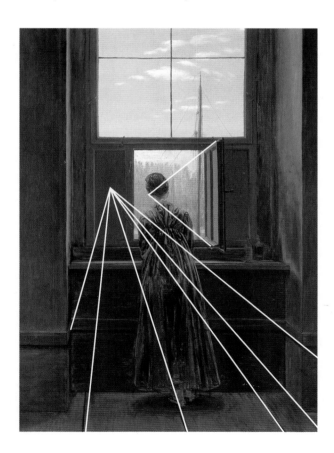

114
Woman at the Window (showing vanishing point), 1822. Oil on canvas; 44×37 cm, 17¼×14½ in. Nationalgalerie, Staatliche Museen, Berlin

would have viewed the subject while painting it. Friedrich has not placed himself facing the centre of the window and directly behind his wife, but slightly to one side. This fact is further confirmed by looking at the returns of the wall as they lead back from the window, those on the right being more exposed to view than those on the left.

Since this is such an obvious and straightforward effect, it might be asked why it has been so little noticed. The reason is because Friedrich has thrown us off the scent with an ambiguity created by the position of the hinged casement pane near his wife. This is not in parallel with the returns of the walls (as one might at first suppose), but is set at such an angle that lines from its receding top and bottom edges meet at a more central point, by the woman's head. So while we are actually looking at the picture slightly to the left, we are also made aware by the angle at which the casement is swung open of the centrally placed viewpoint of the woman. Probably Friedrich never expected us to take his picture apart in this manner. His purpose was to create a particular visual tension, which he does with unique subtlety. Ultimately the point about *Woman at the Window* is that it is not itself symmetrical. It involves looking at symmetry from an angle. By these means Friedrich separates out the spectator of the picture from the viewer in the picture, and stresses once again that 'subjectivity' is the expression of an individual viewpoint. He can see the wider dimensions of things in the everyday as well as in the dramatic and the extraordinary.

To judge by her letters, Caroline (or 'Line' as Friedrich called her) possessed that friendly cheerfulness for which the Saxons are renowned. Even before she had met her new Greifswald relatives she addressed them with warmth and intimacy. When one of Friedrich's brothers sent the couple the present of a herring, she wrote to thank him with joy, saying that he would have received a kiss from her, had he been present in person.

Friedrich returned to Greifswald to introduce his new wife to his family in the summer of 1818. Together with his brother Heinrich,

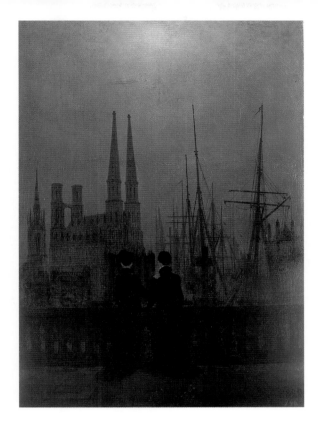

115
Sisters,
1820.
Oil on canvas;
74×52cm,
29×20½in.
State
Hermitage
Museum,
St Petersburg

he took Caroline on a tour of the principal sites of the area,
including the island of Rügen. This was the time when he painted
the topographical view of his brothers and their families in the
market square of Greifswald (see 8). But he also wove his new
domesticity into the iconography of his more spiritual work.
It seems that Caroline was one of those ladies who wore
altdeutsch dresses – perhaps at the behest of her husband. This
is how she appears in the somewhat mysterious picture entitled
Sisters (115), where she stands with one of her Greifswald sisters-
in-law in an image that symbolizes the coming together of the
families. The enchanting harbour scene that they are looking at
contains boats from the Baltic set against a Gothic church based
on that at Halle in Saxony, as though here too a union was taking
place, between north and south. Typically, however, the envisaged
union is beyond the balcony on which the ladies stand. It is a
vision rather than a reality.

Caroline appears in similar garb in the beautiful work *On the Sailing Boat* (116), where the couple sit on the prow of a boat, looking out towards one of Friedrich's visionary cities. This picture can also emphasize for us the division between 'nature' and 'invention' that Friedrich was currently insisting upon in his exhibited works. The painting took its origins from a careful pencil-and-wash study of the front of a boat made during this visit. Friedrich has copied all the detail of this exactly, down to the slight roll of the boat to the right, and the position of the ropes

116
On the Sailing Boat,
1818–19.
Oil on canvas;
71×56cm,
28×22in.
State
Hermitage
Museum,
St Petersburg

117
Study for
On the Sailing Boat,
1818.
Pencil and wash;
36×26cm,
14⅛×10¼in
(whole page).
Nasjonal-galleriet, Oslo

lying on the deck (117). The only alterations he has made have been to extend the whole slightly, vertically, and to make more space on the fo'c's'le to enable him and Caroline to be fitted in. The 'invention' comes with the insertion of the shimmering city beyond, which gives the boat a journey and a purpose. This is largely based on buildings from Greifswald and Stralsund. However, there are also visible spires from Dresden, as though he wished to include some of Caroline's home town, as well as his

own, in the goal towards which they are travelling. He has, furthermore, introduced a spatial distortion which enables him to give prominence to his speciality; the silhouette. He has raised the prow of the boat unnaturally high, so that the two rise against the sky as they look towards the celestial vision – an unusually positive gesture for Friedrich, as is the touching way in which the couple are holding hands.

Friedrich was perhaps encouraged by the presence of Caroline to see his native land more from the position of the tourist. It was a change of view very much in line with the times, and a move greatly encouraged by Pomerania's new master, Prussia. After 1815 the coast rapidly became a resort area – following the development of similar places in Britain. Among Friedrich's sketches from this period there is even one of a bathing machine.

118
The Chalk Cliffs on Rügen,
after 1818.
Oil on canvas;
90·5×71cm,
35½×28in.
Museum Oskar Reinhart am Stadtgarten, Winterthur

These changes, which mirror the new bourgeois leisure industry developing elsewhere in western Europe, are implicit in the most famous picture to come from this trip, *The Chalk Cliffs on Rügen* (118), in which Friedrich shows Caroline the awesome cliffs that he had clambered over in earlier and more adventurous times. Together with another man – probably Friedrich's brother Heinrich – Caroline peers and points downwards. Friedrich stands slightly apart from them, staring out to sea. Once again he has based his scene on a nature study, and once again he has altered its effect by a subtle spatial distortion. This time he has raised the horizon, rather than lowering it as he had done on the *Sailing Boat*, so making the infinite into which the artist is staring the boundless depths of the sea. In such a way Friedrich is suggesting different responses to nature among his *Rückenfiguren*, stressing that what you see before you is dependent upon what is within you.

Throughout the early 1820s a domestic mood can be found in many of Friedrich's paintings, and even more so in his sketches. Always fond of children, he enjoyed sketching both his own and those of neighbours as they played, along with women going about their household duties (119). Some of these sketches became the starting point for pictures, as the image of Caroline

holding a candle seems to have sparked off an intriguing corridor scene (120). Others show children looking out of windows, giving an almost kitsch-like charm to a motif formerly used by Friedrich with greater seriousness. By the time he painted these works he had two more children, another daughter, Agnes (b.1823), and a son (b.1824), named Gustav Adolf in continued veneration for the monarchs of Sweden. It seems that a visit to his friend Kersting, now overseer of painting in the china factory at Meissen, may have encouraged him to return to this genre.

Despite their domestic ambience, these works remain ones in which personal vision is stressed. This can be emphasized by contrasting the *Chalk Cliffs* with a picture of people viewing scenery painted by Dahl soon after he came to Dresden in 1819

119
Caroline with Candle and Children,
*c.*1824.
Pen;
24·3×17·5cm,
9⅝×6⅞in.
Kunsthalle, Mannheim

120
Woman with Candlestick,
1825.
Oil on canvas;
71×49cm,
28×19¼in.
Private collection

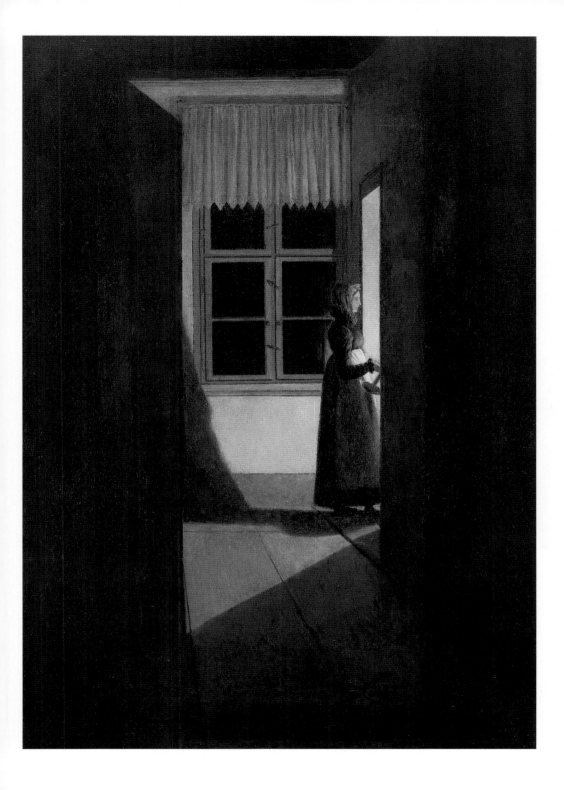

(121). It shows the Bastei, one of the spectacular features of the Saxon Switzerland terrain that Friedrich had explored many years earlier. As with Rügen, this area had now become a regular tourist site. A neatly fenced viewing post has been established for the safe enjoyment of the wonders of nature. This is what Dahl has shown his fashionably attired lady and gentlemen doing. In one sense his centrally placed figures could be a tribute to Friedrich's *Rückenfiguren*. Yet he has made sure his spectators do not get in the way of our view of the breathtaking scenery. Nor do they show any individualized response to what they are seeing.

121
Johan
Christian
Dahl,
*View of Bastei
in Saxon
Switzerland*,
1819.
Oil on canvas;
52·5×86·5cm,
20⅝×34in.
Drammens
Museum,
Drammen,
Norway

The process of viewing has become objectivized, as though the lively record of atmospherics that Dahl gives us was the one and only way of seeing. One can imagine that many visitors to the Dresden galleries would have found Friedrich's work dry and peculiar in contrast to this spirited and reassuring performance.

What is perhaps most peculiar of all, however, is that Friedrich's challenger should have been on such excellent terms with him. They seem to have hit it off together almost immediately. In 1823 Dahl (recently married, like Friedrich, to a local Dresden girl) moved into an apartment in the same house as the older artist. They both remained there, and Dahl was to be one of the few people who remained a stalwart supporter of Friedrich.

The situation was potentially fraught with problems. Exhibition reviewers constantly compared their works along the lines of a well-worn cliché. 'Our poetical Friedrich forms a contrast to Dahl, the painter of truth' is typical of the comments that occur (this one coming from a Viennese magazine in 1822). Friedrich would have been less than human had he not experienced jealousy when Dahl received the teaching post for landscape at the Dresden Academy in 1824 for which he was passed over, and there were certainly signs of tension between the two artists later in life. But in the 1820s, it would seem that their relationship remained a balanced one. Dahl, on his part, appreciated the quality of Friedrich's study of nature. He clearly absorbed much of Friedrich's imagery, too, adapting it (improving it, many contemporaries would have said) to his own naturalistic techniques. Friedrich on his part, as has already been seen, was stimulated by Dahl to make open-air studies and gain a more vivid sense of colour (see 113).

While public opinion was favouring the naturalists, Friedrich was not without his supporters. He may have lost the Prussian royal family, but in 1821, thanks to the poet Vasili Zhukovsky, one of his most enthusiastic supporters in later life, he gained that of Russia in its place. It might seem ironic that the future Tsar Nicholas I – hardly noted for liberalism – should have started patronizing Friedrich at this point. However, it should be remembered that the

artist's work would hardly have had the political resonance in Russia that it did in Germany. Zhukovsky denied that there was any

… affectation in his pictures. On the contrary, they please us by their precision, each of them awakening a memory in our mind! If you find in them more than what strikes the eye, this is due only to the fact that the painter did not look at nature as an artist seeking nothing but a model for his paintbrush, but as a man who always sees in nature a symbol of human life.

Romanticism was a growing German export throughout Europe in the 1820s and 1830s. In Russia its imaginative richness played a part in stimulating the creative upsurge that was soon to produce the great school of literature that has remained the nation's crowning glory.

122
Moonrise over the Sea, 1821.
Oil on canvas, 135×170cm, 53⅛×66⅞in.
State Hermitage Museum, St Petersburg

Friedrich must have been particularly grateful that Nicholas I (through the agency of Zhukovsky) took off his hands not only *On the Sailing Boat*, painted in 1818, but the large image of the figures looking out to sea (122). *Moonrise over the Sea* had been his major work of 1821. It could be seen as a poeticized and softened version of *Two Men Contemplating the Moon* (see 95). Contemplation of the moon has now been given a domestic slant, with two women demurely seated on the shore while the men stride out as far as they can (which is not very far) on boulders in the sea. Although there is a certain *altdeutsch* quality about their clothes, it is hardly of the strident and explicit kind to be found in Friedrich's more political paintings.

Ever since his early successes at exhibition, it had been Friedrich's aim to produce at least one major picture a year, alongside a large number of more modest productions. The strategy was clear enough. The large picture would attract exhibition-goers and hopefully receive serious critical attention as well as finding a buyer. It would also act as a flagship, encouraging modest clients to buy smaller works by him. Until the 1820s this strategy seems to have worked, but after 1819 it was a sign of Friedrich's

declining popularity that such pictures became increasingly unsaleable. From now on, big pictures become far less frequent in his repertoire.

One of the signs of a growing bourgeois market for art was the proliferation of exhibitions, and these continued to remain highly important for him. Like many other artists, Friedrich was assiduous in trying out the new venues as they emerged, showing his work in places such as Prague, Hamburg and Bremen during the 1820s, frequently packing his pictures off in the company of those by Dahl.

The opportunities offered by this opening-up of the art market is another reason why Friedrich painted an increasing number of small pictures at this time, including ones that emphasized charming atmospheric effects in 'everyday' scenery. Yet it was not clear, despite the success of painters such as Dahl, whether clients really wanted to have more naturalistic works from Friedrich himself. In 1823 he exhibited two views of Rügen with windmills and domestic buildings (123). Freshly and meticulously painted, they give a calm sense of the everyday, similar to that in Dutch seventeenth-century rural scenes. The response of one reviewer was to comment on how badly Friedrich acquitted himself when he wanted to be prosaic. Indeed, while such works are painted with great delicacy, they did not possess either the compelling qualities of his 'mystical' paintings or the attractive verve of naturalistic painting, and they do not appear to have sold.

Friedrich had greater success when he retained more of his poetic approach in these small scenes. One such is the charming cycle of lowland views painted for a doctor in Hanover, which include a ravishing depiction of early-morning mists rising above a river (124) and a mysterious evening woodland scene (125). Pendant pairs of contrasting light effects and terrain were also popular, as for example the scenes painted for the Berlin collector J H W Wagener (see 141 and 144).

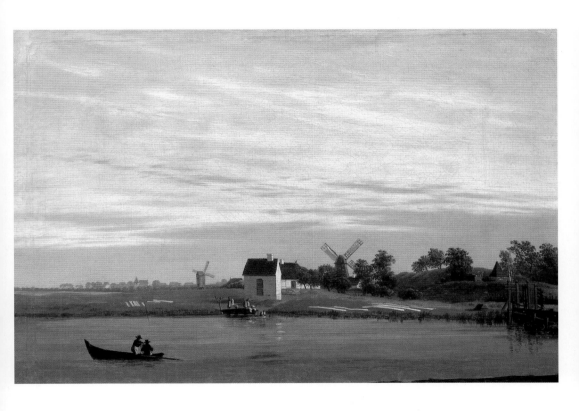

123
*View on Rügen
with Windmills,*
1822/3.
Oil on canvas;
27·7×41·1 cm,
10⅞×16¼ in.
Schloss
Charlottenburg,
Staatliche
Museen,
Berlin

124
Morning Mist,
1820–1.
Oil on canvas;
22×31cm,
8¾×12¼in.
Nieder-
sächsisches
Landesmuseum,
Hanover

125
Evening,
1820–1.
Oil on canvas;
22·3 × 30·7 cm,
8⅝ × 12 in.
Nieder-
sächsisches
Landesmuseum,
Hanover

Friedrich's large painting for 1823 also marks the change towards the naturalistic. Now called *Morning in the Mountains* (see 110), it shows a breathtaking vista of the Riesengebirge as sunlight spreads over the peaks. It is based on sketches made in 1810 on the trip that led to the earlier *Morning in the Riesengebirge* (see 81). Yet how different is the treatment here from that earlier one, with its drama of figures struggling to reach a cross. The only figures in this scene are local shepherds, who sit quietly and unostentatiously on an outcrop of rock. The vista beyond does not form a single striking contrast with the foreground, as in earlier 'visionary' works. It gradually unfolds in a sequence of lightening ridges. The effects of mist rising between these ridges are recorded with the new subtlety of tones that Friedrich was learning from his recent practice of making open-air oil studies. The hour of sunrise has never been depicted more beautifully. The picture did not sell at exhibition, however, and might have stayed on the artist's hands had not Zhukovsky recommended it to his royal master.

Morning in the Mountains formed the prelude to a series of large pictures exploring climatic extremes. These show not just a response to naturalistic painting, but also an engagement with scientific inquiry which Dahl helped to foster. As has already been mentioned, the growing status of naturalism in art had been underpinned by advances in knowledge of the natural world. Friedrich, as an attentive landscapist, could be expected to respond to this movement enthusiastically. He had early counted scientists among his supporters. One of the first and most enthusiastic of these had been Gotthilf Heinrich von Schubert, who celebrated Friedrich's art in his book *Ansichten von der Nachtseite der Naturwissenschaft*. From 1817 onwards, a more significant figure was the Dresden court physician Carl Gustav Carus.

A multi-talented individual, Carus was simultaneously courtier, scientist and artist. A leading exponent of the new discipline of comparative anatomy, he was also a gifted amateur painter.

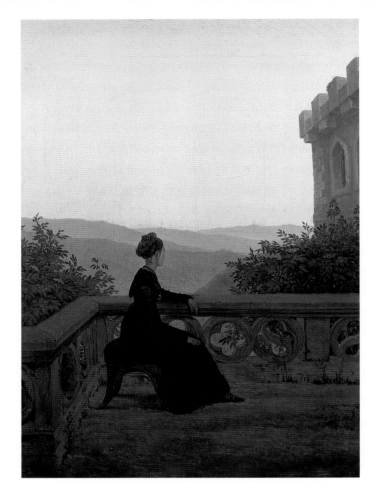

126
Carl Gustav
Carus,
*Woman on
the Terrace*,
1824.
Oil on canvas;
42×33cm,
16½×13in.
Gemäldegalerie
Neue Meister,
Dresden

He frequently emulated the poetic mood of Friedrich's smaller works with great charm, as in *Woman on the Terrace* (126). He was among those who remained faithful to the artist, and published the first lengthy appreciation of him after his death. However, although Carus often adopted Friedrich's pictorial style, it should not be assumed that their ideas about landscape were identical. Carus made his views clear in many publications, particularly his *Neun Briefe über Landschaftsmalerei* (*Nine Letters on Landscape Painting*, 1831). In the earliest of these letters, written soon after Carus first met Friedrich, he shares the artist's views on seen landscape, being principally concerned with the evocation of feeling. He believed that both science and art led to an

understanding of the workings of the Divine in nature. However, he maintained, this was achieved by different means, and had different aims. As he put it in Letter 3: 'In science one feels oneself within God; in Art one feels God within oneself.' Later, however, Carus became interested in more objective ways of exploring natural phenomena as organic mechanisms, a concern that led to him re-christening landscape painting *Erdlebenbildkunst* (earth-life painting). Such interests become manifest in the sixth of his letters on landscape painting, after which he envisages the 'earth-life' painter as one who made visible the inner workings of nature and for whom spiritual enlightenment was only a secondary matter.

Carus's change of view was inspired by his reading of a poem on clouds by Goethe. As we have seen, Goethe became increasingly suspicious of the mysticism in Friedrich's work during the period of the Wars of Liberation, but it was their different views on clouds that brought about the final rift. Goethe became greatly excited by this subject after reading a treatise by Luke Howard, in which the scientist established the classification system that has remained in place to this day. Goethe seems to have been particularly taken by the evidence this provided that seemingly fleeting and ephemeral phenomena could be proved to be as subject to the 'laws' of nature as could more enduring features such as mountains. 'He gives precision to the imprecise, confines it,' he said of Howard in his poem in the meteorologist's honour. As well as making his own sketches of cloud types, Goethe was seeking a landscape artist who could realize these with a greater level of technical skill. It was his ambition to create a 'cloud-atlas' in which all cloud-types could be specifically delineated according to the new system of classification.

On 10 July 1816 Goethe wrote to the painter Louise Seidler – a useful go-between in the past – asking her to approach Friedrich with the commission. The response was not encouraging. 'Believe me when I tell you that he immediately saw the overthrow of landscape painting in this system, and feared that in future the light, free clouds would be slavishly forced into this rigid order.'

Nothing could emphasize more clearly Friedrich's opposition to theory and abstraction than this response. A precise observer, Friedrich looked to record an individual cloud rather than construct a type. An oak he drew was a particular tree, not an example of a genus. It had its individual shape built from the specific circumstances in which it grew. It was this that he would transcribe exactly in his picture, endowing it with the emotive charge of his personal response to it.

While maintaining this critical stance against the process of scientific classification, Friedrich began to take the issues raised by it more seriously in the 1820s. When he followed Dahl in making oil studies of the sky, he may have thought again about Howard's system. According to Dahl's biographer, Andreas Aubert, the Norwegian artist was inspired by a copy of the German translation of Howard's work lent to him by Carus. On the other hand, there is nothing about Friedrich's sky studies that suggests an interest in isolating cloud-types. They seem to be more responses to the effect of a particular sky, a rapid record of an individual and unrepeatable moment in the endless immeasurable interactions of light and atmospherics. Certainly he excelled at this time in the production of small pictures that record fleeting moments. Such is his painting of a cargo ship travelling along the Elbe through lifting mists in late summer (127). So, too, is the capturing of birds settling on a darkening field, seen on an evening walk from Dresden (128).

Uncharacteristically, over the next few years Friedrich painted a series of 'inventions' in which he sought to adapt the experiences of scientific investigators and fellow artists to his own purposes. The first theme to engage his attention was that of an explorer's ship trapped in the ice of a northern sea. This was later to lead to the production of one of his most memorable works, *Arctic Shipwreck* (129). He first thought of this theme in response to a request by the wealthy Leipzig patron Johann Gottlob von Quandt, to provide a 'sublime' northern landscape to form a counterpart to a southern landscape by the Rome-based landscape

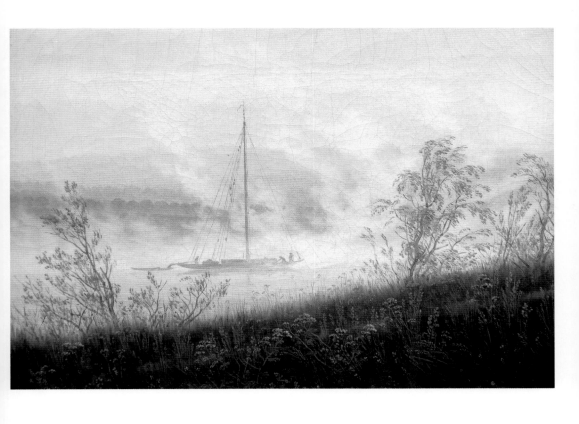

127
*Boat on
the River Elbe
in the Early
Morning Mist,*
1820–5.
Oil on canvas;
22·5×30·8cm,
8¾×12in.
Wallraf-Richartz-
Museum,
Cologne

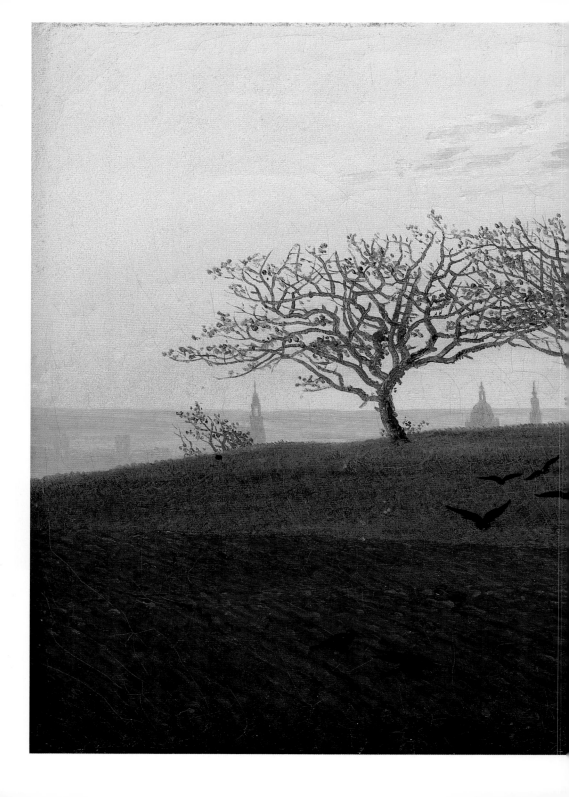

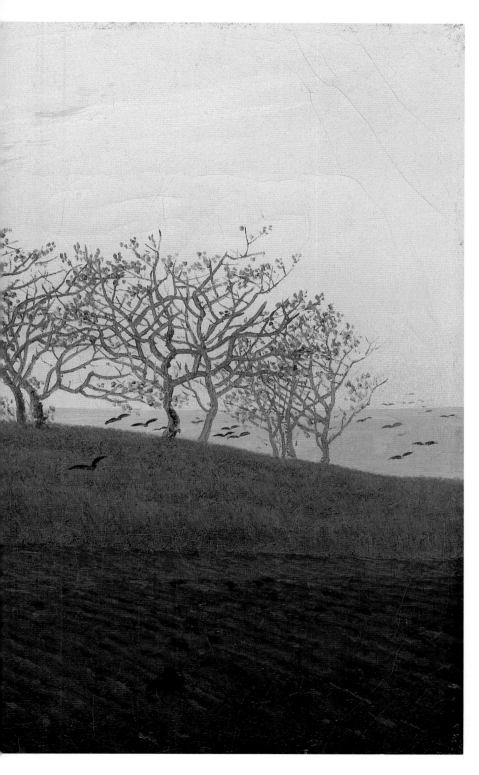

128
*Hill and
Ploughed Field
near Dresden,*
1824.
Oil on canvas,
22·2×30·5cm,
8⅝×12in.
Kunsthalle,
Hamburg

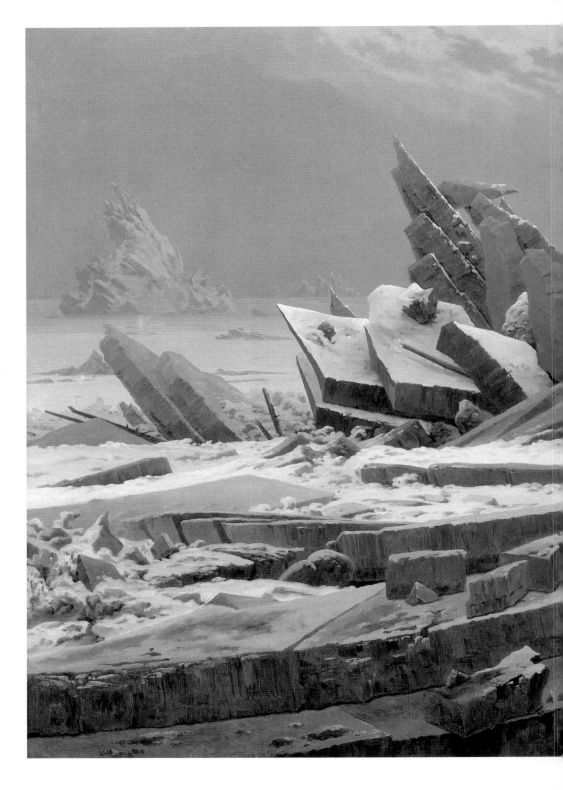

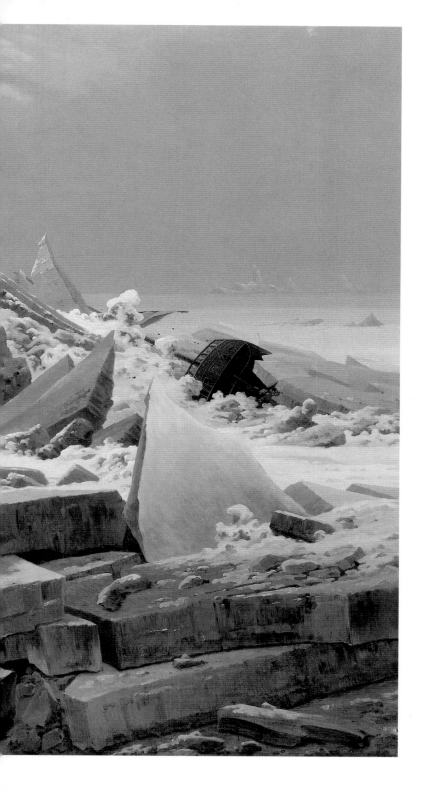

129
Arctic Shipwreck, 1823–4.
Oil on canvas; 96·7 × 126·9 cm, 38 × 50 in.
Kunsthalle, Hamburg

130
Johann Martin
von Rohden,
*Hermit offering
Hospitality
to a Pilgrim*,
1818.
Sepia;
43·5×58·2cm,
17⅛×23in.
Städelsches
Kunstinstitut,
Frankfurt

131
Blocks of Ice,
1820–1.
Oil on canvas;
15·2×20·6cm,
5⅞×8in.
Kunsthalle,
Hamburg

painter Johann Martin von Rohden (1778–1868). This work – of which the *Arctic Shipwreck* is a related version – is now lost. Rohden's picture is also lost, but an earlier sepia version of it survives (130). It shows a hermit providing for a traveller in a mountainous though verdant terrain. Hospitality here is contrasted to the inhospitality of the freezing arctic wastes.

Quandt was himself principally an admirer of the Nazarenes and southern landscape. His request also shows that he was conventional in his aesthetic tastes, favouring the well-worn distinction commonly made at the time between the 'sublime' – which was frightening and awe-inspiring – and the 'beautiful' – which represented the pleasurable. Nevertheless Friedrich had earlier had hopes of him as a patron, making sure that he knew about his fantastic snowbound ruin, the *Monastery Graveyard* of 1819 (see 104). Quandt seemed pleased with the 'wonderful and great effect' of Friedrich's resultant picture (now also lost) of a ship off Greenland destroyed in a sea of ice. Interestingly, he particularly praised the treatment of the ice: 'The transparency and sea-green colour of the ice is achieved by Friedrich astonishingly well because he was born and brought up on the Baltic and so often had opportunity to observe such natural scenes.' In fact Friedrich seems to have been relying more on the study of ice he made in the winter of 1820–1 in Dresden when the Elbe froze over (131).

In *Arctic Shipwreck* he constructed a dynamic pile of broken sheets of ice, based on this study of the frozen blocks, to give his own interpretation of one of the most persistent types of disaster pictures of the period. Shipwrecks first became popular in the later eighteenth century when the French artist Claude-Joseph Vernet made them a speciality. As well as representing a kind of disaster as real in its day as air crashes are to us, such pictures gained added resonance during revolutionary and Napoleonic times when they could provide a surrogate for the representation of current scenes of conflict and war. The image was certainly employed with great success by the English landscapist J M W Turner.

In post-Napoleonic times, however, the shipwreck had been used to characterize another kind of political disaster. It had formed the basis of the celebrated *Raft of the Medusa* (132) of 1819 by Théodore Géricault which used an account of a recent disaster to mount a critique on the incompetence of the right-wing restoration government. It would be fascinating to know if Friedrich had any knowledge of this great work, both because he would have sympathized with the French artist's view of restoration governments and because his pyramidal design appears to have a formal affinity with the mountainous mass of shipwreck survivors that forms the main part of Géricault's work. Certainly the strategy of turning a figurative design into a landscape form would fit in with Friedrich's own claim – first asserted in the pyramidal composition of *The Cross in the Mountains* (see 46) – that landscape elements could themselves be used to articulate themes once considered the prerogative of history painting. Certainly none of the seascape shipwrecks that preceded Friedrich's work was in any way similar to it in form. Another point that links Géricault and Friedrich is that they both show the horror of a situation through static rather than moving form, achieving in each case an awe-inspiring monumentality.

132
Théodore
Géricault,
*The Raft of
the Medusa*,
1819.
Oil on canvas;
491×716cm,
193¼×282in.
Musée du
Louvre, Paris

A more direct inspiration may have been provided by a popular display that took Dresden by storm in 1822. This was a panorama of a Polar expedition by the artist Johann Carl Enslen (1759–1848).

Invented in the 1790s by the Scot Robert Barker, this form of spectacular display had become a popular event throughout Europe by the 1820s. There could be a deliberate exposition of hubris in *Arctic Shipwreck* – for the ship is shown utterly destroyed. One version (now lost) was entitled *The Wreck of the Hope.* As such, it matches the bleakness of *The Monk by the Sea* (see 72), exposing earthly vanities. While engaging with the modern world, Friedrich was also offering a critique of it.

There were occasions, too, when he painted pictures that seemed to imply criticisms of the works of his contemporaries, even close associates. His major painting of 1824, the now lost *High Mountains* (133), was based on a sketch made by Carus of Mont Blanc in Switzerland. Carus's painting of the scene can be directly compared with that by Friedrich (134). Carus has given full rein in his picture to the glacier moving down from the mountain. Friedrich, by contrast, has cut this out altogether, concentrating the effect of the whole and making the soaring height of the mountain all the more inspiring. One might see in this an implicit criticism of Carus's more scientific approach. Whereas Carus wishes to explain as much as possible about the workings of nature, Friedrich selects, reducing information but heightening effects.

It would seem that such pictures were part of a public debate about nature and vision which Friedrich was conducting through exhibition. The culmination of this was his principal exhibit for 1825, *The Watzmann* (135). As with the *High Mountains*, this view of an alpine mountain was based on a sketch by a fellow artist – this time his own pupil, August Heinrich. It has been suggested by Börsch-Supan that the composition was a response to the much-praised view of the same mountain by Adrian Ludwig Richter that had dominated the Dresden show of the previous year (136). Richter – the artist who had complained of Friedrich chaining one to an 'abstract idea' – seems to have conceived his grand landscape as a kind of geological exposition. From the snow-capped mountain peak at the top of the picture, our eye

133
High Mountains, 1824. Oil on canvas; 132×167cm, 52×65¾in. Formerly Nationalgalerie, Berlin (destroyed)

134
Carl Gustav Carus, *View of Mont Blanc*, 1824. Oil on canvas; 93·5×119cm, 36⅞×46⅞in. Museum Georg Schäfer, Schweinfurt

135
The Watzmann,
1824–5.
Oil on canvas;
133×170cm,
52³⁄₈×68in.
Nationalgalerie,
Staatliche
Museen, Berlin

136
**Adrian Ludwig
Richter**,
The Watzmann,
1824.
Oil on canvas;
120·2×93cm,
47¹⁄₄×36⁵⁄₈in.
Neue
Pinakothek,
Munich

moves down through the varying terrain with its differing forms of life dependent upon the changing structure of the earth, to end with human habitation in the lower reaches. In this, Richter was following the example of Joseph Anton Koch (1768–1839), the leading German landscape painter in Rome, where he had recently been studying. Koch's hard-edged 'universal' pictures shared the commonly held German view that Werner's theory of Neptunism, or 'Geognosy' – that the earth's crust was shaped by flood waters that had receded at the beginning of time – provided the key to understanding the structure of the earth and its significance for all forms of life, including the differing types of human culture.

Friedrich was to dismiss the comprehensive overview offered by Koch's work as a 'boastful striving after abundance'. In his *Watzmann*, as in *High Mountains*, he cuts the image down to a central experience, of the upper part of the mountain towering above us, awesome and unreachable. However, it may be that these critiques by Friedrich do not altogether ignore the scientific knowledge of the day. In his book on *Art and Science in German Landscape Painting* (1993) during this period, Timothy F Mitchell has suggested that there are features in these alpine landscapes that make direct reference to Werner's theories. It is possible to see the *High Mountains* and *The Watzmann*, as Mitchell has, as pendant pictures demonstrating the two principal forms of mountain formation according to Werner, the crystalline (chemical = high mountains) and the sedimentary (mechanical = Watzmann). *High Mountains* features 'erratic' boulders believed to have been responsible for eroding crystalline mountains to their current shape. *The Watzmann* has a granite pile in it (taken from a study made in the Harz Mountains) which alludes to Werner's belief that granite was the 'original rock' on which other sedimentary mountains were overlaid.

As so often in Friedrich's work, we are left with nothing but circumstantial evidence on which to base this theory. If Friedrich did intend such reference, he seems as always to have been mediating this by focusing on the creation of overall impact and

effect. He does not dilute the effect of the mountains through the inclusion of other terrain, as Richter or Koch do, but concentrates on their essence. It seems highly likely that Friedrich was attempting to paint mountains in a 'modern' way. However, he was still insisting on the importance of individual experience, of the intensive and personal response to an overwhelming natural phenomenon which leads, as always for him, to a further perception of divine power in nature.

High Mountains had been bought by the faithful Reimer. However, if Friedrich had hoped to attract Reimer to *The Watzmann* which was similar in size and, as has been suggested, could almost be seen as a pendant to it, he was to be disappointed – though the Berlin publisher did purchase a topographical view of Eldena (see 111) from the exhibition, a work that would have had particular resonance for him as a Greifswalder.

It may be that it was the failure of *The Watzmann* to find a purchaser that persuaded Friedrich to abandon his attempts at a critique on naturalistic painting and scientific theory. Probably the main reason for this was personal. In 1825, at the age of fifty-one, he suffered a stroke and had to abandon large-scale painting for a while. When he did gradually recover his strength he moved in different directions, increasingly trying to regain territories previously lost.

This history of Friedrich's critique of naturalism might seem to be one of failure. Yet in a sense it is a triumph too. For it is Friedrich, rather than his naturalistic rivals, who attracts most attention as a landscape painter today. What seemed to them to be a new era proved more ephemeral than they had thought. Part of the reason for this in fact relates precisely to the scientific side of the movement. Science, unlike art, is constantly changing. Theories employed by us to account for the workings of the natural world today are not likely to survive indefinitely. Luke Howard's classification of clouds has so far endured, but almost all the geological theories that informed a 'scientific' view of landscape in the early nineteenth century have since been replaced.

Certainly Werner's 'Geognosy' was largely abandoned as a theory by the mid-1830s. Mitchell might well have been right when he interpreted the granite outcrop in *The Watzmann* and the boulders in *High Mountains* as signs of Friedrich incorporating Werner's ideas into his work. But the point surely is that such references would be unrecognizable to us without explanation, since the theory that supported them has been dead for the best part of two centuries. Fortunately these pictures do not rely on such details for their principal impact. Art based more on theory than experience is always liable to have a short shelf-life. From that point of view Friedrich was surely right and Goethe wrong in their dispute over the painting of clouds. However useful such classificatory studies might have been to science, they would not have helped Friedrich in the development of an art engaged with individual perception and feeling.

The Spiritual Eye Observations on Art and Artists

Äußerungen bei Betrachtung
einer Sammlung von Gemählden
von größtentheils noch lebenden
und unlängst verstorbenen Künstlern.

Es macht immer einen widrigen Eindruck
[...] in einem Saal oder Zimmer [...]
[handwritten German text, largely illegible]

'Close your bodily eye so that you see your picture first with your spiritual eye. Then bring what you saw in the dark into the light, so that it may have an effect on others, shining inwards from outside …'

This saying of Friedrich – like most of his best-known remarks – comes from a carefully written manuscript found in the artist's studio after his death (and now preserved in the Kupferstich-Kabinett, Dresden), entitled *Observations arising from the Contemplation of a Collection of Paintings, mostly by Living and Recently Dead Artists* (137). It consists of a series of brief commentaries on pictures by unnamed artists interspersed with aphoristic statements about artistic practice. The preamble to the text also suggests that Friedrich was recording his comments on request, though the supplicant's identity, like those of the artists being discussed, remains undisclosed.

137
Observations arising from the Contemplation of a Collection of Paintings, mostly by Living and Recently Dead Artists,
first page.
c.1828–30.
Pen;
36·2×21·5cm,
14¼×8½in.
Kupferstich-Kabinett,
Dresden

This document, which constitutes Friedrich's most extensive commentary on art, has great interest both for the insight it gives into his own practice and his views on those of his contemporaries. From the internal evidence provided by the manuscript, it would seem that it was largely written between 1828 and 1830. Many of the pictures mentioned are ones that were exhibited at the Dresden Academy during that period. Although it might refer, as the title suggests, to an actual collection of pictures, it seems more likely that this collection is an imagined one of pictures currently receiving attention. Friedrich was by this time well out of favour with the art establishment and this undoubtedly explains much of the sharpness in the comments that he makes.

It is generally believed that the person at whom the manuscript was aimed was the wealthy patron and aesthetician Quandt

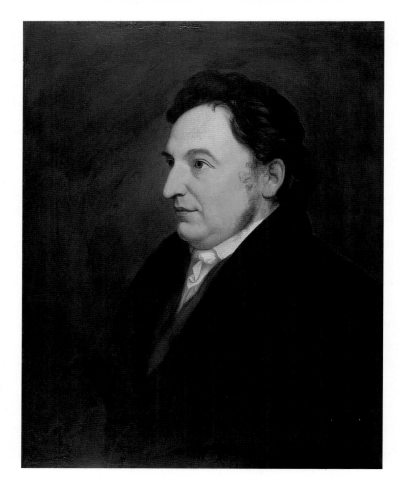

138
Carl Vogel
von Vogelstein,
*Johann Gottlob
von Quandt*,
1824.
Oil on wood;
63·5×53cm,
25×20⅞in.
Stadtmuseum,
Dresden

139
Julius Schnorr
von Carolsfeld,
*Frau Bianca
von Quandt*,
c.1820.
Oil on canvas;
37×26cm,
14½×10¼in.
Nationalgalerie,
Staatliche
Museen, Berlin

(138), who had commissioned Friedrich to paint the first
version of the theme represented in *Arctic Shipwreck* (see 129).
He is presumably the 'H.v.Q' (Herr von Quandt) referred to
somewhat critically in the last line of the document. There is,
furthermore, a marginal comment 'not yet for Q.' written against
one of the earlier sayings, significantly one that attacks the
'Gentleman aestheticians'. It would seem, in fact, that this
document may have started out as a commentary intended
to explain the artist's views to Quandt, as well as to be a major
statement of his artistic credo, but that it became too acerbic
in its view of the contemporary art world in Dresden (and, indeed,
of Quandt himself) to be made public.

It is perfectly understandable why Friedrich might have wished to present Quandt with his views on art at this point. Quandt had first come to Dresden around 1816 and was, by the end of the decade, one of the most influential figures on the local art scene. He used his considerable wealth to patronize contemporary artists. In 1818 Quandt had travelled to Rome and was a great enthusiast for the Nazarenes, particularly Julius Schnorr von Carolsfeld (1794–1872), with whom he maintained a lively correspondence and who portrayed his wife in the costume of a Renaissance court lady (139). Despite such personal preference, however, Quandt sought to be even-handed in his dealings with artists, and to cover as broad a range of contemporary art as possible in distributing his largess. He was also active as an antiquarian and published articles on aesthetics and art criticism. He was particularly influenced by the writings of Kant – to which he had been introduced by the Leipzig professor of philosophy Karl Friedrich Richter – and had assisted the philosopher Arthur Schopenhauer in the publication of his great work *Die Welt als Wille und Vorstellung* (*The World as Will and Idea*) in 1818. He was also deeply inspired by Goethe's views on art (despite disagreeing with him over the Nazarenes), and kept up a correspondence with the sage of Weimar. In 1828 Quandt had added to these activities a post of real power: he was made director of the recently established Saxon Art Union.

The Art Union (or *Kunstverein*) movement in Germany was the most significant innovation in art patronage in Germany after the Napoleonic Wars. By the time the Saxon Art Union was established, such institutions were already flourishing in Munich, Berlin and many other major cities. Later the system was much imitated abroad, particularly in Britain and the USA.

Essentially, Art Unions harnessed the purchasing power of largely bourgeois art enthusiasts to the acquisition of contemporary works of art. Membership was by annual subscription. The funds generated by this means were used by the Art Union to purchase works from current exhibitions. These were then either donated

to public collections and institutions, or distributed among members by means of a lottery. The Art Unions would also commission engravings of works thus selected, which would be distributed to the membership as a whole.

There is no doubt that this new source of patronage was greatly welcomed by artists. In his autobiography, Adrian Ludwig Richter cites the emergence of the Art Union as the single most important factor that enabled him to give up his post as an art supervisor at the Meissen porcelain factory to pursue his career as a full-time artist. Yet, important though such patronage was, it came at a price. In Germany (though not necessarily elsewhere) the choice of works to be purchased was made by the committee of the Art Union. The culturally aspiring, bourgeois members of the Art Union were in effect being instructed by these learned gentleman about the kind of art that was good for them. As an institution it perfectly fitted in with the ideology of Biedermeier Germany, in which those in authority sought to control and guide the emergent economic power of the bourgeoisie.

Friedrich had good reason, therefore, to wish to present his apologia for his art to the man in charge of such a powerful organization. As it happens, he did receive some patronage from the Art Union in the early 1830s, though this was limited and sometimes contained a critique of his work within it. As will be seen in the following chapter, it was the engraving (see 162) of *The Large Enclosure* (see 163), commissioned by the Saxon Art Union, that 'corrected' what were assumed to be mistakes in Friedrich's use of perspective. Quandt himself had mixed views about Friedrich. When commissioning a picture from him in 1820 he had subsequently expressed reservations in print about certain eccentric features in works exhibited by the artist. Friedrich must have known that he would have a difficult time persuading Quandt to see art from his point of view. Perhaps this is why, in the end, he gave up the attempt and settled instead for letting rip in his document with a full-blooded censure of current art practice.

In form, the commentary that Friedrich wrote copied those he was familiar with from his youth. One, mentioned earlier, was Schlegel's famous essay 'Die Gemälde', in which he set out his views on art in the form of a fictional visit to the Dresden picture gallery. Schlegel had used the form both to introduce a multiplicity of viewpoints and to base his discussion around the practical example of actual works of art. Friedrich, with his deep suspicion of abstract theorization, also wished to use pictures to make a detailed commentary. He himself had acted as a guide to the Gemäldegalerie in his first years in the town, and his comments on individual works were much prized by his admirers. Both Zhukovsky and Reimer recorded their pleasure in going round galleries in his company and listening to his observations. The form of the individual comments by Friedrich in his text also harked back to his youth. The aphorism – with its potential for pithy observation and use of wit and paradox – was a favoured form among the *philosophes* of the eighteenth century. Friedrich would surely have been familiar with the famous ones by the Swiss theologian Johann Kaspar Lavater and the German essayist Georg Christoph Lichtenberg. It had subsequently remained a popular form of expression, being much used in the art press of the day. Friedrich had himself harboured literary ambitions from early on in his career, frequently penning piquant verse in which a paradox is typically explored. He also mastered early on the aphoristic mode in his conversation and, like Lichtenberg, he made use of it to deflate the pretensions of more abstract theoretical positions. The collection of aphorisms in the *Observations* was to some extent a gathering together of such comments. His famous remark 'Art may be a game, but it is a serious game', for example, occurs in this collection, although much earlier he had used it in a letter to Philipp Otto Runge.

Opposition to theory does in fact seem to have been one of the main spurs behind Friedrich's lapidary remarks. 'If you wish to know what beauty is,' he comments, 'then ask the gentleman aestheticians. It could be useful to you at the tea table, but not before the easel. There you must feel what is beautiful.'

Much of the thinking behind Friedrich's remarks can, it is true, be traced back to the ideas of the writers and critics that he had encountered in his early years in Dresden. His very emphasis on feeling as 'the artist's law', and opposition to theory and academic rules, mirrored the rebellious mood of such celebrated texts as Wackenroder's *Outpourings of the Heart of an Art-Loving Monk*. In Friedrich's youth, many artists had subscribed to such a code. It had been the rallying call of the Brotherhood of St Luke when these medieval revivalists turned their back on the Vienna Academy in 1808 to form their own breakaway group, the Nazarenes. Yet much had changed since those days. By 1830 the Nazarenes were conformists, believing in the general forces of historical processes. Friedrich was unusual in maintaining the heady individualistic view of artistic practice promoted in the days of early Romanticism.

Friedrich's emphasis on feeling and individualism contrasts strongly with Quandt's views, which reflect the recent assertions of aesthetics and art history. In his three-volume work *Streifereien im Gebiete der Kunst auf einer Reise von Liepzig nach Italien* (*Excursions in the Territory of Art on a Journey from Leipzig to Italy in the Year 1813*, 1819) Quandt wrote:

The work of art is nothing other than an idea, which has been thought with such clarity that, by means of resemblance, it comes before us as the appearance of a reality.

It was not thought but feeling that lay at the heart of Friedrich's concept of art. The notion that a work of art was a concretion of thought represented precisely the intellectualized approach to art that he so opposed.

Friedrich's views on nature were also from an earlier age, being associated with nature philosophy, particularly as it had been developed by the German idealist philosopher Friedrich Schelling, one of the associates of Friedrich's acquaintance Gotthilf Heinrich von Schubert. But once again Friedrich differed from these writers in his opposition to establishing a system. The point at which he

3

Empfindung
Sentiment

D. Chodowiecki sculps.

4

Empfindung
Sentiment

D. Chodowiecki sculps.

parted company with his friend and admirer Carus was when the latter sought to reclassify landscape as 'earth-life' painting.

Throughout the *Observations* Friedrich expresses himself in oppositional terms, as though providing answers to points of view that must have been put to him by the more theoretically minded of his acquaintances. There are two main oppositions that emerge in the text. The first (as has already been suggested) is to theory – whether it be that of the traditional academic or of the modern aesthetician. The second is to materialism – both in the form of the new commercialism of post-Napoleonic society or in the naturalist's refusal to see beyond the surface appearance of phenomena.

140
Daniel Nicolas
Chodowiecki,
True Feeling
and *Affected
Feeling*,
engravings
from *Natürliche
und affectierte
Handlungen
des Lebens*,
1778

Friedrich seems to have felt the greatest need to defend direct perception, to give full weight to the effect and appearance of the visual, something that he saw being constantly undermined by theory. Yet he did at the same time recognize that the visual brought with it huge problems, particularly when it came to issues of spectatorship and meaning. One could, indeed, draw a distinction between true contemplativeness and superficial reaction – as the Berlin illustrator Daniel Chodowiecki had done a generation earlier (140). But once the contemplative mode had been achieved, there was no dictating its direction. He freely admitted that different people saw things in different ways, that what was inside governed what was perceived outside. This meant that when it came to interpreting the visual – whether in nature or before the canvas – there was no single right way of doing so. This was the paradox he had explored with his use of *Rückenfiguren* and ambiguous viewing points in his pictures (141). He could communicate a feeling well enough. But how could he communicate a meaning? 'For very well do those respected masters know that the ways that lead to art are infinitely different,' he wrote to Johannes Schultze on 8 February 1809; 'that art is actually the middle point of the world, the highest spiritual striving, and that artists stand in a circle around this point.'

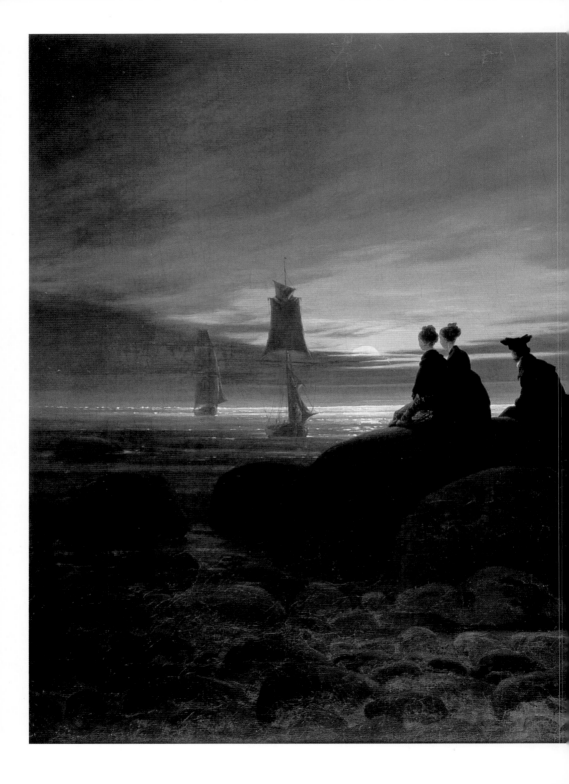

141
*Moonrise over
the Sea,*
1822.
Oil on canvas;
55×71cm,
21³⁄₈×28in.
Nationalgalerie,
Staatliche
Museen, Berlin

His own pictures certainly had meanings – what the art historian Werner Hofmann has referred to as 'open symbolism' – but they were nevertheless accessible to different readings. It was a problem that Friedrich recognized he could not resolve. Subsequently – as Hofmann's view suggests – this openness has been seen as one of his strengths in the eyes of modern commentators.

It was essentially their failure to appreciate the nature of individual vision that led Friedrich to condemn the Nazarenes, along with the Academicians and 'gentlemen aestheticians'. For they were proceeding not according to direct experience, but according to a theory of art. The theory, in his view, was

based on the misconception that one could enter into the minds of people who had lived at a very different time and under very different circumstances:

What pleases us about the older pictures is, above all, their pious simplicity. However, we do not want to become simple, as many have done, and ape their faults, but rather become pious and imitate their virtues.

This view on early art would have been particularly relevant to Quandt, who had a number of early German and Italian paintings in his collection – for example, *Four Scenes from the Life of St Zenobius* by Sandro Botticelli (1444/5–1510), now in the Gemäldegalerie at Dresden (142).

Similarly Friedrich condemned the naturalists for failing to obey their inner law and transcribing the outer appearance of things too literally.

The artist should not only paint what he sees before him, but also what he sees within him. If, however, he sees nothing within him, then he should also refrain from painting that which he sees before him. Otherwise his pictures will resemble those folding screens behind which one expects to find only the sick or even the dead.

The last sentence of this statement reveals a typical strain in Friedrich: the recourse to sarcastic remarks and ghoulish warnings. It also shows the anxiety about death that underlies his total dedication to the spiritual in nature – the desperate seeking for a redemption that will lift him from the material world.

142
Sandro
Botticelli,
*Four Scenes
from the Life
of St Zenobius*,
c.1500.
Tempera on
wood;
66×182cm,
26×74in.
Gemäldegalerie
Alte Meister,
Dresden

It was a symptom of the materialism that nurtured naturalism that all should become materialistic. Frequently in his observations Friedrich rails against the new materialism. It can be seen in the crowded exhibition room, where pictures are heaped up for sale as in a shop:

It always makes an adverse impression on me to see a mass of paintings exhibited or stored up like merchandise in a hall where the spectator is not able to contemplate each separately without having to see at the same time half of four other ones ... thus one picture, even without entirely suppressing the other, must still detract from it ...

This was a commonly expressed fear at the time. Like others, Friedrich had to live by exhibition. Yet the exhibition was a competitive commercial market that promoted flashy values. Similarly he remained sceptical of the effects of technological advance:

If you can, then build machines in which the spirit of man is kept and dispensed; but you must not make men that are like machines – without their own will and own energy.

He was particularly scathing about the new process of steel engraving – one that increased definition and made long print runs possible, though at the expense of the achievement of subtle effects.

This careful steel engraving is admirable for its beautifully treated tonality and has certainly been carried out either by an Englishman or a machine. A German, thank God, could never do such a thing, and the British are proud to be the only ones who can.

The reference to England is telling, since by this time most Continental observers felt that English art, briefly promising in the later eighteenth century, had been ruined by the rampant commercialism that was now threatening European cultures.

Friedrich's emphasis on feeling was based on the Rousseauian belief that it was feeling that made us at one with nature: 'Pure sensations can never be in contradiction to nature, but only in agreement with her.' He therefore attacks the use of formalist strategies in building up a picture:

Painters train themselves in inventing or, as they call it, composing. Doesn't that mean, in other words, they train themselves in patching and mending? A picture must not be invented but felt.

This assertion might seem to contradict Friedrich's use of the term 'own invention' to describe his own compositions. However, it was really the *training* he attacked, insisting that his own 'invention' came from his inner being, usually by means of a dream or vision. It was this that led to his classic remark concerning the spiritual or 'inner' eye, quoted at the head of this chapter. This vision of the inner eye had a particular singularity about it, to be distinguished from the 'multiplicity' of the constructed image.

Again, it might seem strange that in his *Observations* Friedrich should attack 'contradictions' when the dramatic effect of his own work depends so much on contrast: the use of the silhouette, for example, against a misty sky. As he wrote:

It is common amongst painters to want to speak in contradictions; they call it contrast. Crooked against straight, cold against warm, light against dark; these are the fine crutches on which mediocrity hobbles along.

However, it must be conceded that Friedrich does impose a greater uniformity on his designs than other artists and built up contrast to contribute to a central effect. As has already been seen, he was critical of the 'abundance' of the classically composed landscape. His outburst here might also be, as the art historian John Gage has suggested, a critique of the theory of the picturesque, as has been noted above (see page 25). Picturesque theory was popular in Germany at the time, much influenced by British writers, notably William Gilpin. Gilpin's *Three Essays* (1792), dealing with the 'rules' for picturesque composition, had been translated into German. Probably more influential were the images that he published with his texts, as in *Observations on the River Wye* (1782), which demonstrated correct ways for constructing a landscape (143). By comparison, Friedrich's compositions seem at times to be almost wilfully anti-picturesque. His *Village Landscape in Morning Light* (144), for example, has the distant vista of the mountains blocked by a tree, rather than having the foreground framing the distance as in Gilpin's examplar of picturesque mountain landscape.

Friedrich also warned against the 'strong hues' that were common in his day and that had come in as a result of naturalist painting techniques. For him, they detracted from the emotive impact of dominating tones, such as can be found in the blue of the *Monk* (see 72) or the brown of the *Abbey* (see 73). It is striking that Quandt should have expressed concern about the 'monotony' of the tone in the version of the *Arctic Shipwreck* he owned. Yet it is this which gives the subject its insistent mood. As with shapes, singularity for Friedrich meant directness of expression and feeling.

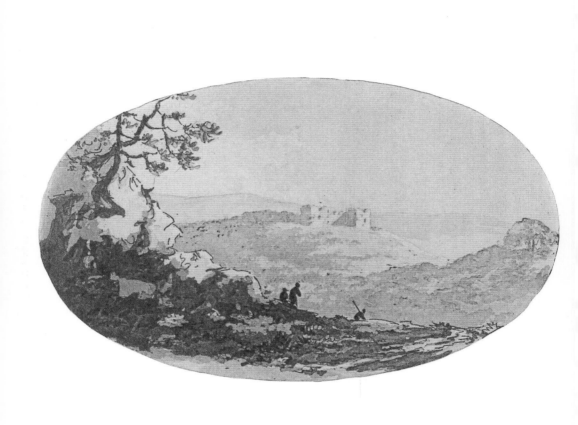

Friedrich's individualism can be seen as well in his attitude to the term 'sublime', which was frequently used by critics (including Quandt) about the most extreme of his works, such as *Arctic Shipwreck*. The sublime was a category enjoying much attention at this time in aesthetic discourse. Originally used in classical antiquity to indicate a higher kind of beauty, it came in the later eighteenth century to stand for a category on its own. As has been mentioned above (see page 128), the first person to drive a knife between it and beauty was Edmund Burke in his *Philosophical Inquiry into the Origin of Our Ideas of the Sublime and Beautiful*. Using a physiological rationale for aesthetic sensation, Burke claimed that beauty derived from feelings of attraction (in particular love) and the sublime from feelings of fear and repulsion. Although others were soon to find his physiological account over-materialistic, they retained the basic idea of a fundamental difference between a notion of beauty as pleasing and attractive and a notion of the sublime as an overwhelming state arising from more challenging experiences. From a historical point of view, one can see this need to find a separate term for the latter as a response to a world of growing change and uncertainty. The sublime has, indeed, been interpreted by some as the aestheticization of the dynamic entrepreneurial mood of imperialist capitalism that was so radically changing society. Be that as it may, the notion of the sublime and beauty as two separate categories was firmly established in the minds of most aestheticians by the 1790s.

It was at this point that the debate was taken up by Immanuel Kant, in his *Critique of Judgement*, building on earlier separate essays on the sublime (1764, 1771). While accepting the distinction between beauty and the sublime Kant wished, characteristically, to subsume them into one overarching system. Beauty for him becomes a lower, playful, category. The sublime is more elevated. But to be more elevated it has to be about more than the mere sensationalism that Burke appeared to ascribe to it. Kant therefore made a distinction between two kinds of sublime, the 'dynamic' sublime – which is stimulated by physical fear, as is

143
Wiliam Gilpin,
Plate from
*Observations
on the River
Wye,*
1782

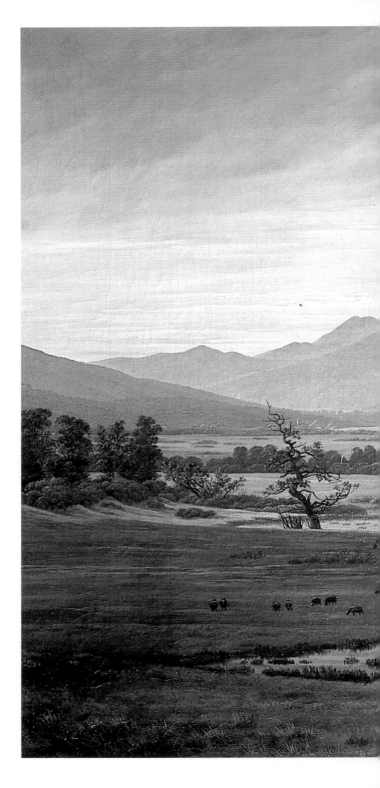

144
*Village
Landscape
in Morning
Light (The
Lonely Tree),*
1822.
Oil on canvas;
55 × 71 cm,
21³⁄₈ × 28 in.
Nationalgalerie,
Staatliche
Museen, Berlin

Burke's – and the 'mathematically' sublime, which is an intellectual response to immensity. In the 'mathematically' sublime, it is the concept of immeasurability that moves the spectator, rather than the physical response to uncertainty or danger. In giving examples, Kant related the 'dynamic' sublime to the contemplation of a stormy sea, and the 'mathematically' sublime to the contemplation of the endlessness of a tranquil sea. These categories were given wider currency at the time through the writings of Friedrich Schiller, both in his *Briefe über die aesthetische Erziehung des Menschen* (*Letters on the Aesthetic Education of Mankind*, 1795) and in subsequent studies on the sublime. While introducing his own modifications, Schiller kept essentially to Kant's categories. It was these that were adopted by the Dresden intellectuals in Friedrich's circle such as Gotthilf Heinrich von Schubert, C G Carus and Quandt himself.

It is not difficult to see why the concept of the sublime should occur to people looking at Friedrich's pictures. Indeed, the term was used habitually when considering any of the large pictures of danger or immensity that dominated exhibition halls of the period. Modern critics have also resorted frequently to the use of the word sublime when talking of Friedrich's work. Yet, attractive though the association is, there is a danger in assuming too easily that these are the terms in which the artist himself wished his work to be seen, or that it is the most illuminating way of exploring them.

It may well be true that Friedrich was encouraged by the current talk of the sublime and the beautiful to develop his pairs of contrasting pictures, such as that of 'beautiful' summer and 'sublime' winter seen in the pair of which the one in Munich is part (see 62 and 64). Yet even in these works there is more than the demonstration of aesthetic difference at stake and Friedrich was soon to take his pairing of forms in quite different directions. No one could seriously consider the *Monk* and the *Abbey* as constituting a contrast of the 'beautiful' and the 'sublime'. Certainly Friedrich's monk has a calm sea to contemplate,

as in Kant's example of the 'mathematically' sublime. Yet the melancholy and sense of alienation in this work bears no relation to the invigorating wonder that Kant expected such contemplation of divine power to elicit. As the literary theorist Terry Eagleton has pointed out in *The Ideology of the Aesthetic* (1990): 'Kant associates the sublime with the masculine and the military, useful antidotes against a peace which breeds cowardice and effeminacy.' There is no way that Friedrich's monk could be party to such thoughts (though it is interesting that when Brentano used the word 'sublime' in his satirical commentary on the picture, it was connected to military associations). Nor could any kind of case be made for either picture to stand for Kant's notion of the beautiful. Contrast is being used here by Friedrich for purposes quite alien to the debate about aesthetic categories being carried on around him by the 'gentlemen aestheticians' at their Dresden tea tables.

Friedrich did himself use the word sublime on occasion. Yet when he did so, as Johannes Grave has pointed out in his study on Friedrich and the sublime, it bore no relationship whatsoever to the way the term had been defined either by Kant or by Schiller. His most extended comment arises when he talks of the sublime effect of mists on the mountains:

When a landscape is covered in fog, it appears larger, more sublime, and heightens the strength of the imagination and excites expectation, rather like a veiled woman. The eye and fantasy feel themselves more attracted to the hazy distance than to that which lies near and distinct before us.

Such a sensual use of the term sublime – which seems to be exemplified by the diaphanously dressed woman set against a misty vista in *Morning in the Riesengebirge* (see 81) – is so contrary to anything being written by Kant or Schiller that Grave has concluded that Friedrich was unaware of their texts. This may well be true. The only contemporary philosopher he ever referred to was Hegel, whom he used to endorse the notion that art was an agent to spiritual enlightenment. His refusal to talk about the

sublime in Kantian terms suggests once again his opposition to the theorization of his age. He wished to retain the common-language use of the term as it had existed before the aestheticians got hold of it, when it simply referred to an intensely moving effect. That he should relate this intensity to an erotic experience was the final twist of the knife. For all the aestheticians of the time maintained that the erotic was the domain not of the sublime but of the beautiful.

There was a further reason why Friedrich should oppose the prevailing view of the sublime. For it had, by 1828, been used to pigeonhole him. As has already been said, Quandt used the term to characterize his *Arctic Shipwreck* in harsh contrast to the 'beautiful' view of the Italian South that he had commissioned Rohden to produce as a pendant. It is also interesting to note that, for Quandt, Friedrich's picture was too monotonous and negative in its effects – it failed to live up to the expectations of the Kantian sublime for him precisely because it provided no stimulus to invigorating response in the face of immensity and danger.

Friedrich therefore found himself in an impasse. By being called 'sublime' he was being reduced on the one hand to a mere sensationalist, and on the other to the agent of a particular kind of intellectualized response in the face of adversity. He was neither. He wanted art to be about the full experience of the tragedy of being. It was sensation, but sensation that was informed by thought, if not the comfortable kind of thought that Kant envisaged. In fact Friedrich's mood is closer to the sublime as conceived by deconstructionists in the twentieth century as a moment of fracture with the dominating ideology. But even if Friedrich does share a dimension of despair with the deconstructionists of a later age, his world view is radically different from theirs in almost every other respect.

This in the end was the kernel of the debate about aesthetics. For Friedrich, art was not about aesthetics. It was about life – and in particular the religious or spiritual experience of life. Aesthetic categorization, like scientific categorization, removed

the individual from this moment of direct experience. It was for this reason, ultimately, that he had no time for the 'gentlemen aestheticians at their Dresden tea tables'.

While expressing his views about art Friedrich does not discuss his own works in his *Observations*, with one exception. This is a reference to a work that he claimed to be the 'largest that I have ever made: 3 Ellen 12 Zoll high and 2 Ellen 12 Zoll broad' (approximately 200×144 cm, $78\frac{3}{4} \times 56\frac{3}{4}$ in). It showed the cathedral of Meissen in ruins with trees growing out of the rubble and an evangelical priest with 'eyes directed towards the blue sky, reflectively contemplating the little light bright clouds'. This picture remained unfinished – it was later in the possession of Dahl and has subsequently disappeared. The theme of the existing church being shown as a ruin being reclaimed by nature was used in other designs of the time, which suggests that it was an important one for the artist.

One can only speculate on why this particular theme was the one by which Friedrich wished his own art to be identified. It would seem that the underlying message was his understanding that all activities have their time and are then replaced. But there is as well perhaps the implication that Protestantism has become the successor of Catholicism and, unlike its predecessor, bases its faith on the experience of nature. Certainly the image of medieval churches in ruins would once again emphasize opposition to the medieval revivalism of his own day.

However, while this image might be taken as an affirmation of the Protestant position, Friedrich still sees this within the context of a greater fatalism. He realizes all too well the limits of his powers. 'Does man make the age, or the age man?' he asks in a concluding question. His own answer, made after reviewing a range of old and new works of art, is that 'Man is not as free to rise above time and place as many believe.'

This would appear to be yet one more parting dig at the aestheticians. For, following Schiller's *Letters on the Aesthetic*

Education of Mankind, many had warmed to the idea that the artist had a unique enlightening role for his age which involved him rising above it and then returning to chasten it.

'The artist is indeed the child of his time,' wrote Schiller, 'but woe to him if he is also its minion.' Schiller then went on to envisage the artists removed from his own times, nurtured in Grecian skies and then returning to cleanse his own world with their vision. More modestly, Friedrich believed that 'even those who want to fight against the main trends of the time have, nevertheless, to pay homage to it'.

There was only so much one person could do. Friedrich, experiencing increasing isolation, was faced with a choice. Either he had to conform, or hold his own view in silence. In the end he chose the latter course.

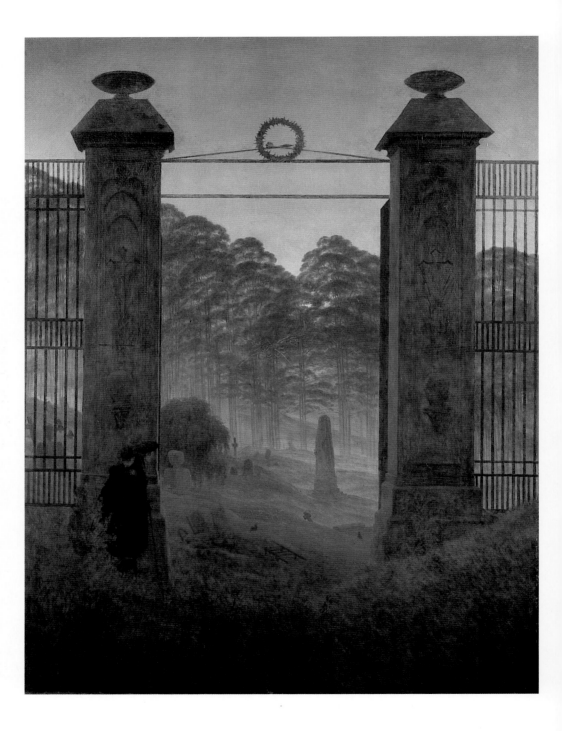

The last fifteen years of Friedrich's life told a sad story of declining powers and waning reputation. In 1825 he suffered the first of a series of strokes. By 1835 these had weakened him so much that he had to give up oil painting more or less completely. In the final five years of his life he could do little other than produce sepias and watercolours, largely reworking former compositions. As his physical powers ebbed, so he suffered increasing marginalization in the art world, where he came to be seen as a sombre and melancholy figure harking back to the eccentric days of early Romanticism. One by one his patrons dropped away, to leave no more than a handful of faithful friends and supporters.

145
The Cemetery Entrance,
1824–6.
Oil on canvas;
143×110cm,
56¼×43¼in.
Gemäldegalerie
Neue Meister,
Dresden

Friedrich's first stroke seems to have come as a shock. He had up to that time been physically healthy and active. His melancholy had to some extent abated under the influence of his new domestic life. He had three children by 1824, and much to live for. Even his art had been moving away from the gloom of earlier times to take on the brightness of fashionable naturalistic painting. However, almost as if by a premonition, the picture that he was working on at the time of his attack was sad indeed (145). Now called *The Cemetery Entrance*, it shows a tall portal in contemporary neoclassical style, designed with the rectilinear formality of the interiors that Friedrich had recently been painting. A couple peer round the left-hand column at the entrance to the cemetery, looking at a recently dug grave. There are figures lightly sketched in hovering above this, as though wafting a soul up to Heaven. From a description written by Zhukovsky, who saw the work in Friedrich's studio in 1826, we know that we are looking at the tomb of a child. It seems a strange subject for Friedrich to have undertaken so soon after having seen a healthy child of his own brought into the world. However, it was probably a commission. Karl Böttiger described the work as having been

ordered by a 'Leipzig art-lover'. The contemporary character of the cemetery, furthermore, would suggest a specific occasion. Perhaps the commissioner of the work was familiar with the painting that Friedrich had made of the grave of his friend Gerhard von Kügelgen, who had been murdered under shocking circumstances in 1820. Whatever the events that occasioned its origin, it remained uncompleted, eventually being taken off the artist's hands by Dahl.

It is a depressing subject and in its unfinished state it does not convey more than a hint of those carefully worked up atmospheric effects that give Friedrich's best finished work their absorbing beauty. Yet the mood is affecting. We can see how Friedrich has made the cemetery gateposts tower unnaturally high, giving the world beyond an awesome dignity. Typically he has also manipulated his viewpoint, setting this off-centre to the left at the level of the darkened middle-ground tree that rises behind the open grave. He has placed us, the viewers, in the space between the hovering angel, the watching parents and the child's grave beneath, implicitly making us share in the soulful moment. As so often with Friedrich, it is impossible to tell whether this is early morning or evening, whether we are witnessing the end of the earthly day or the beginning of the heavenly one to come. Of course we are in a sense doing both, the parents on this side of the gate in the closing world of evening, the child beyond in the opening world of dawn, lightened by a mist that rises through the fir trees, so often used by Friedrich as symbols of faith. It is, in the end, a picture that offers consolation.

There seems to be something of an irony in the fact that Friedrich was working on this graveyard scene when he experienced the stroke that hastened his own life and career towards its end. Twenty years earlier he had exhibited a sepia imagining his own burial. Now his painting of someone else's interment turned out to be the harbinger of his own. In immediate terms, his illness brought about a return to those forms of painting that he had long since abandoned for his large symbolic oils when he gained

fame. In 1825 Quandt reported that during his illness Friedrich had produced a series of watercolours of Rügen. Based on sketches, mostly made when a young man, they also harked back in composition to his 'pre-symbolic' phase. The technique, however, particularly in evidence in *The Chalk Cliffs on Rügen* (146), showed the effect of his recent paintings after nature (see 123). It would seem that Friedrich was relying here on hackwork. He also appears to have had hopes of turning the series into a set of engravings. With the growth of tourism and picturesque travel Rügen was becoming visited increasingly. It had also become a health resort. Indeed, Friedrich's own last visit to the island, in 1826, was for the purpose of taking a cure. It is ironic, too, that he should return as an invalid to an area that he had originally celebrated for its rugged wildness. It is not known why a publisher did not take up Friedrich's attempts to produce a set of picturesque views. Maybe his meticulous studies were not

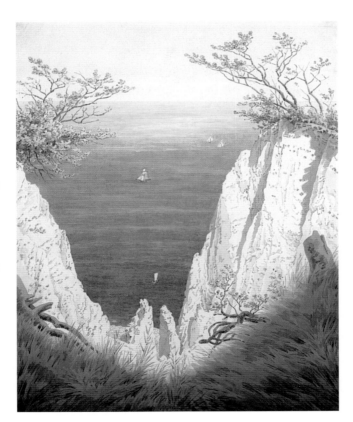

146
The Chalk Cliffs on Rügen, c.1825–6. Watercolour; 31·7×25·2cm, 12½×9⅞in. Museum der bildenden Künste, Leipzig

picturesque enough. It was left to other painters, such as Johann Friedrich Rosmäsler (1775–1858) and Robert Kummer (1810–89), to capture the Rügen tourist trade.

It is possible that the failure of this cycle of watercolours persuaded Friedrich finally that his essays in daylight painting were not likely to succeed commercially. His art lacked the brio that enabled Dahl to dominate the field with such panache. Instead Friedrich started reaching back into his own past, retracing the steps that had led him to become a painter of visions. He seems to have been attempting to return to his old sphere, the one that faithful supporters such as Reimer and Carus admired so much, and for which he was receiving renewed encouragement by new patrons such as Zhukovsky. The Russian poet had, indeed, returned to Dresden in 1826 and was once more recommending works to the Tsar and his family – though only such as were in the spiritual mode.

It was symptomatic of this regressive moment that Friedrich should have gone back to the cycle of the *Seasons*, which he had first designed in 1803. He reverted, too, to the use of sepia for painting these, displaying the results in the Dresden Academy exhibition of 1826. Friedrich augmented the cycle in the new version. He added a prelude to the life of man depicted in *The Times of Year* (see 42–45). This was a remarkably simple and direct image of life bubbling up out of the waters (147). It could be seen as a representation of the moment in the book of Genesis when the spirit of God moves above the waters. But it could also be construed as paying homage to the theories of earth history of Abraham Werner, which Friedrich had seemingly made reference to in his high-mountain pictures (see 133 and 135). As Friedrich's friend G H von Schubert had put it – following Werner's theory: 'The general waters, that we now know in their unequal narrow boundaries as seas, originally reached over the tops of the highest mountains.' The disturbance that we see in the waters in this picture could be the initial emergence of mountain tops as the waters begin to recede, that would eventually provide the

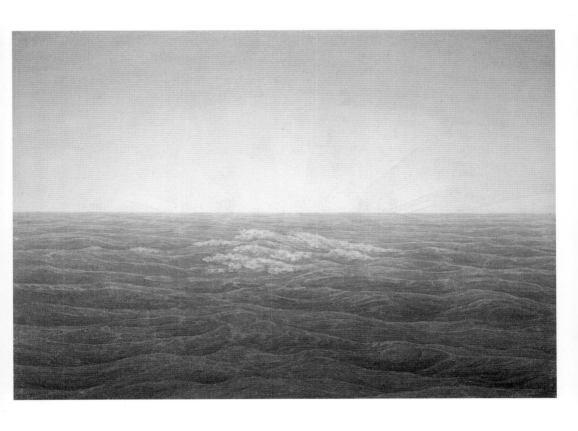

147
*Sunrise over the
Sea/The Waters
(The Seasons),*
c.1826.
Sepia;
18·7×26·5cm,
7¹⁸×10¹²in.
Kunsthalle,
Hamburg

148
*Skeletons
(The Seasons),*
c.1826.
Sepia;
18·8×27·5cm,
7³⁄₈×10³⁄₄in.
Kunsthalle,
Hamburg

149
*Angels in
Heaven
(The Seasons),*
c.1826.
Sepia;
18·5×26·7cm,
7¼×10½in.
Kunsthalle,
Hamburg

territory for the land creatures – including man – to develop. Such geological thinking also seems to guide the thinking in the second addition, which supplemented the end of the cycle. This image of skeletons in a cave (148), which follows the winter scene of the old man by the sea (see 45), appears to accept the integration of bodies into mountains (something that Werner also envisaged), while the separation of the physical and spiritual is indicated by the final picture in the cycle, showing angels hovering above the clouds in Heaven (149).

Friedrich also showed an interest in combining the old with the new in another venture that seems to have emerged during his time of illness. This was the designing of transparent paintings to be seen under specially controlled light effects. Most of these have not survived. However, there is one example extant of a mountain scene that changes character when viewed under different lights (150, 151), and there are outline designs of the compositions of a number of allegorical scenes (see 152).

The interest in transparency painting among fine artists had grown since the later eighteenth century. It ran in parallel with the popular development of peepshows, magic lanterns and finally of dioramas and panoramas. At first such works had been disparaged as 'illusion'. It was as examples of the 'spectres' that inhabited the unreflective mind that Kant talked of them in *Kritik der praktischen Vernunft* (*Critique of Practical Reason*, 1788). Their 'magical' properties recommended them in quite a different way to the Dresden Romantics, who celebrated them as objects of wonder. Many of Friedrich's early critics had felt that the weird effects achieved in his work were similar to what they regarded as a childish form of popular entertainment. When censuring Friedrich in 1810, the Duke of Sachsen-Gotha-Altenburg had dismissed his pictures of rainbows as 'peepshows purporting to be mystical allegories'. Friedrich may have known of the experiments of Philippe Jacques de Loutherbourg (1740–1812) and Gainsborough in England, who had both painted transparencies for display in lightboxes, thus demonstrating that this was a suitable field for

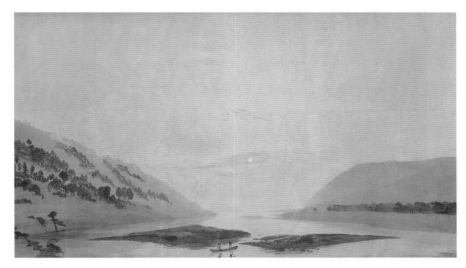

150
*Mountainous
River Landscape
(Day)*,
1830–5.
Watercolour
and tempera
on paper;
74×124cm,
29⅛×48⅞in.
Staatliche
Museen Neue
Galerie, Kassel

151
*Mountainous
River Landscape
(Night)*,
1830–5.
Watercolour
and tempera
on paper;
74×124cm,
29⅛×48⅞in.
Staatliche
Museen Neue
Galerie, Kassel

fine artists as well as for those working for a purely popular market. He was, of course, also well aware of the spectacular developments that had followed these experiments – the panoramas and dioramas that by the 1820s were drawing crowds throughout Europe with their theatrical illusionistic presentations of exotic, far-flung places and dramatic historical events. But he himself kept to the earlier, more intimate and domestic form of illuminated painting.

It is quite probable that Friedrich was encouraged to explore this kind of entertainment by the presence of children in his own house. When he described his transparencies to Zhukovsky in a letter of 9 February 1830 it was the 'young grand-duke' that he had in mind, supposing that they 'might well make an impression on a young childlike mind'. He mentioned four pictures and stipulated the way they should be lit and how they should be accompanied by music, envisaging various combinations of song, harp, guitar and glass harmonica for each.

This blend of words, music and light recalls in some ways the arrangements that Runge had conceived for his mystical cycle of *The Times of Day*, and can be seen to share with that project the Romantic interest in the *Gesamtkunstwerk* or 'total work of art'. While aimed at children, Friedrich's series of pictures were not simply designed to be illusionist fun. They also represented different forms of vision. One, showing a lady playing a harp on a balcony, looking at a Gothic cathedral, was intended to represent spiritual music; the other, depicting a slumbering lute-player (152), that of the world. In *The Musician's Dream* it is typical of Friedrich that even the player of earthly music received divine inspiration in a dream – evident in the organ-playing angels above his head. Yet such dreaming is to be distinguished from the clear sight of the lady as she plucks her harp directly in the presence of the Gothic image of the Divine.

The transparency of the mountainous landscape (see 150, 151) makes a different point; namely, how light can change appearances. Seen in normal ambient illumination, a daytime

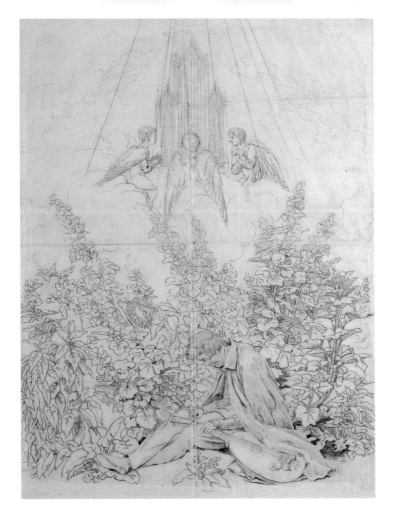

152
The Musician's Dream, c.1826–7.
Sepia;
72×51cm,
28⅜×20⅛in.
Kunsthalle, Hamburg

scene is visible. When lit from behind, however, the scene changes to night. It is both a trick of light and also an indication once again of the way in which things alter according to one's viewpoint. Like the allegories, there is a religious purpose behind such visions, which could make them appropriate as a form of childhood instruction.

Friedrich must have been pleased with his transparencies as he continued to paint them in the years to come. However, they remained something of a sideshow, particularly while he was trying to rebuild his career as an oil painter. In the years between 1827 and 1835 he attempted to maintain his presence as a serious

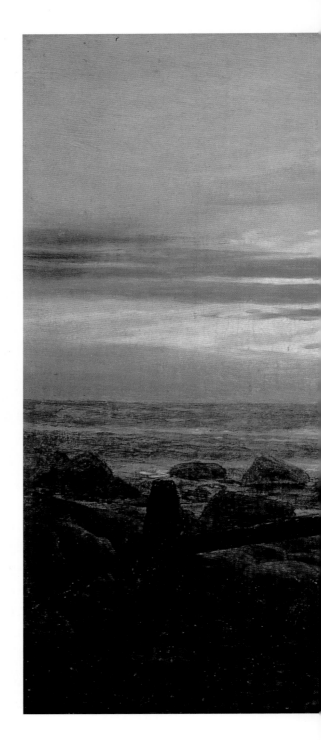

153
*Evening on
the Baltic,*
1826.
Oil on canvas;
25 × 31 cm,
9⅞ × 12¼ in.
Museum Georg
Schäfer,
Schweinfurt

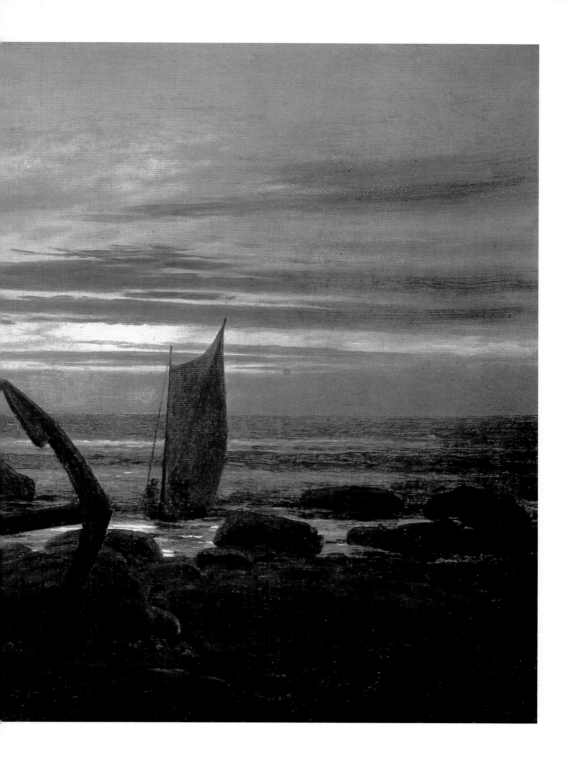

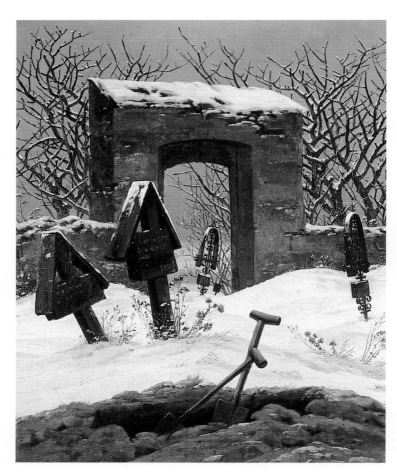

154
*Graveyard
under Snow*,
1826.
Oil on canvas;
30×26cm,
11¾×10¼in.
Museum der
bildenden
Künste, Leipzig

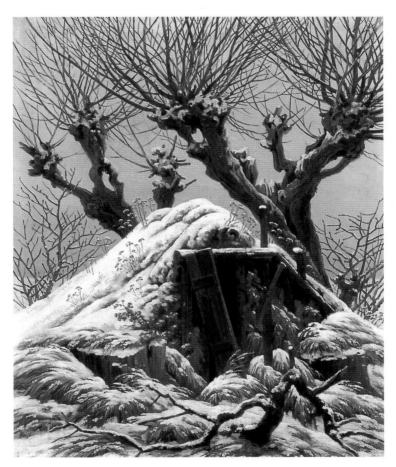

155
Hut under Snow,
c.1827.
Oil on canvas;
31×25cm,
12¼×9⅞in.
Nationalgalerie,
Staatliche
Museen, Berlin

artist, exhibiting regularly and keeping his studio open to visitors. He endeavoured to maintain production of large exhibition pieces that would attract critical attention and, hopefully, prestigious buyers. It is noticeable, however, that during this period he abandoned painting high mountains and distant polar regions, and returned to more familiar territories. His final visit to Rügen in 1826 seems to have reawakened his experience of the Baltic and sea scenes again become a dominating theme in his work. To a large extent he moved away from painting broad daylight to return to nocturnal scenes and twilights, such as *Evening on the Baltic* (153), a version of a large work exhibited in 1827. The anchor in the foreground seems once more to draw on the theme of faith, though in a less dramatic way than the earlier *Cross beside the Baltic* (see 74). While developing a greater poignancy of mood, he seems, in fact, to have kept his symbolic meanings in a low key.

156
*Trees and
Bushes in
the Snow*,
1828.
Oil on canvas;
31×25·5cm,
12¼×10in.
Gemäldegalerie
Neue Meister,
Dresden

The same patron bought a small *Graveyard under Snow* (154), in which similar melancholy thoughts are evoked. Friedrich also returned to small-scale snow scenes at this time – for secular as well as religious themes. These later ones, including *Hut under Snow* (c.1827; 155), have a new degree of observation about them – one that was developed from his *plein-air* studies, such as those of the ice blocks on the Elbe of 1820–1 (see 131). As elsewhere, he updates the naturalistic effects in his work, while stressing their essentially meditative character. It is a point brought out by the concentrated directness of the design. This can be seen perhaps most beautifully in the exquisite *Trees and Bushes in the Snow* (156). When exhibited at the Leipzig Easter Fair in 1828, the painting was praised for its truth to nature, in particular for the way in which the artist had stressed the individuality of each form. It is almost as though Friedrich was emulating those intensive watercolour studies by Dürer of clumps of grass, beetles and other tiny forms of life.

This was in fact the year commemorating the three-hundredth anniversary of Dürer's death. Celebrated by a massive festival

157
*The Heldstein
near Rathen
on the Elbe,*
1827–8.
Watercolour;
26·5×23·3cm,
10¼×9¼in.
Germanisches
National-
museum,
Nuremberg

in his native Nuremberg, the occasion provided an opportunity for
an auspicious celebration of the rebirth of German art. In Dresden,
as mentioned in the last chapter, the year 1828 was marked by the
founding of the Saxon Art Union. One might also see Friedrich's
trees and bushes, purified by snow and ready to spring once more
into life, as intimating hopes of a rebirth. Certainly Friedrich
himself was mindful of the festival in honour of Dürer and was
among the artists who contributed a picture to an album in
commemoration of the historical hero of German art. His offering
was a watercolour (157) based on a much earlier drawing of the
Heldstein in Saxon Switzerland. Börsch-Supan remarks in his
oeuvre catalogue that there is no discernible connection to be
made between this work and Dürer. However, we could reflect
that Dürer was the first German master of watercolour and that
he was noted for bringing together the most exacting observation

of nature and a sense of the spiritual. He was also one of the first to depict mountain scenery. Friedrich followed Dürer not by imitating his style (he was opposed to any artist modelling themselves on another, and censured the Nazarenes for imitation in this manner), but by responding to his spirit. He honoured Dürer by remaining, like his forebear, an explorer of nature, a religious man and, above all, a firm individualist.

While such works could be taken simply as perceptive studies of nature, they were viewed by the artist's most intimate supporters as full of spiritual allusion. Of one of the most breathtaking of the small snow scenes, the work now known as *Early Snow* (158), the faithful Reimer wrote: 'It is a picture full of meaning, even more satisfying in what it allows you to gain a presentiment of, than in what it shows.' Reimer, who owned the work, mentioned it as a pendant for a quite different scene that was also in his possession, *Easter Morning* (159), that shows the three Maries travelling along the road following the resurrection of Christ. Biblical scenes are extremely rare in Friedrich's work. This one, despite its subject, is in no sense a historical reconstruction. It shows three cloaked ladies wandering past trees very similar to those he had observed on the heathland outside Dresden and used in his *Trees and Bushes in the Snow* (see 156). Still less does the picture show any emulation of early art in its method. It could indeed be seen as a reproach to the Nazarenes, whose religious work Friedrich had attacked more or less contemporaneously in his *Observations*.

Since the style of *Easter Morning* is close to work executed in the 1830s, some modern scholars have doubted whether Friedrich actually intended it as a pendant for *Early Snow*. However, Reimer himself was quite certain about this, seeing the snow scene as representing the moment of purification of nature and *Easter Morning* as the celebration of rebirth.

These exquisite small snow scenes suggest that in the late 1820s Friedrich was going through a period of appreciating nature in a more optimistic mood. He may have experienced a new lease of life as he recovered something of his old powers after his illness.

158
Early Snow,
1828.
Oil on canvas;
43·8×34·5cm,
17¼×13½in.
Kunsthalle,
Hamburg

159
Easter Morning,
1828.
Oil on canvas;
43·7 × 34·4cm.
17¼ × 13½in.
Museo Thyssen-
Bornemisza, Madrid

Around this time he painted one or more larger works in which another of his familiar motifs – ruined Gothic churches – predominated. These were given a more positive interpretation than before. The ruin becoming overgrown by trees and bushes is now seen as an allegory of the triumph of Protestantism over Catholicism – the 'natural' vision of the former replacing the 'Gothic' image of the latter. One such picture showed the Greifswald Jacobikirche transformed in this manner, as has been described in Chapter 7.

There could, however, have been political reasons behind Friedrich's new-found optimism. In the late 1820s there was a sense that a change was imminent, one that might lead to some of the demands of the freedom fighters of 1813 finally being met. On an international level the cause of liberty seemed to be advancing at this time. In Greece, independence had finally been won, a position confirmed by the Treaty of Edirne between Russia and Turkey in 1829. In 1827 Friedrich had himself donated the payment received from a political picture, *Hutten's Tomb* (see 109), to the international fund set up to help the Greeks. One wonders whether his most unusual excursion into a classical scene – that showing a Greek building, *The Temple of Juno at Agrigento* (160) – was some kind of tribute to a nation on the point of rebirth. Friedrich based the scene on a topographical view by the artist Carl Ludwig Frommel (1789–1863). Characteristically he has reinterpreted the work in his own manner, removing foreground olive trees and casting the daylight scene into one of night. Yet it is a night made exciting and mysterious by the presence of the full moon. As in *Easter Morning* (see 159), the full moon presides over a scene of expectancy. Perhaps, like the compositions based on the imagined ruins of Meissen Cathedral and the Jakobikirche in Greifswald, Friedrich is suggesting here the new growing out of the old.

Hopes of rebirth and recovery seemed to be given even more substance on the night of 9 September 1830 when Dresden witnessed a popular uprising against the repressive Saxon regime.

This was one of a series of outbursts sparked off in Germany in the wake of the July Revolution in Paris. Just as that revolution seemed to herald a new, more liberal regime, the 'bourgeois monarchy' of Louis-Philippe, so it was hoped that concessions made to the insurgents would lead to a measure of liberalization and democracy in the German states.

Friedrich viewed these events with great excitement. His reactions were recorded in a long letter to his brother in Greifswald. 'I have lived now for almost thirty years in Dresden, yet I have never before seen so many cheerful faces as I did yesterday,' he wrote, recording the events that led to the storming of the police headquarters and the destruction of records kept against individuals (including Friedrich himself). Over the next few days Friedrich seems to have been constantly out and about in the city, following the crowd and observing the moves whereby a written constitution was offered by the King to the people. But Friedrich also expressed scepticism about the outcome, and rightly so. Once the crowd was dispersed, promises made in the heat of the moment were not followed up. Furthermore, the ringleaders of the uprising were gradually identified and rounded up. Principal among these was the lawyer Bernhard Mossdorf, who survived to create a *Bürgerverein* (Citizens' Union) in 1831, publishing illegally a 'Saxon Constitution' which demanded wide-ranging powers for an elected assembly. Mossdorf was arrested soon after this for sedition. Given a prison sentence of fifteen years, he was discovered dead in his cell in 1833. The authorities claimed that he had committed suicide.

With the return to an authoritarian regime, Friedrich again fell silent. We have no way of knowing how he felt following the suppression of this last moment of democratic fervour in his lifetime. We do not know how he viewed the 'young Germany' movement that grew up in his last years, or whether he had any intimation of the radical voices then beginning to be heard in the Rhineland, where the young Karl Marx was working as a campaigning journalist. The Revolution of 1848 – vigorously

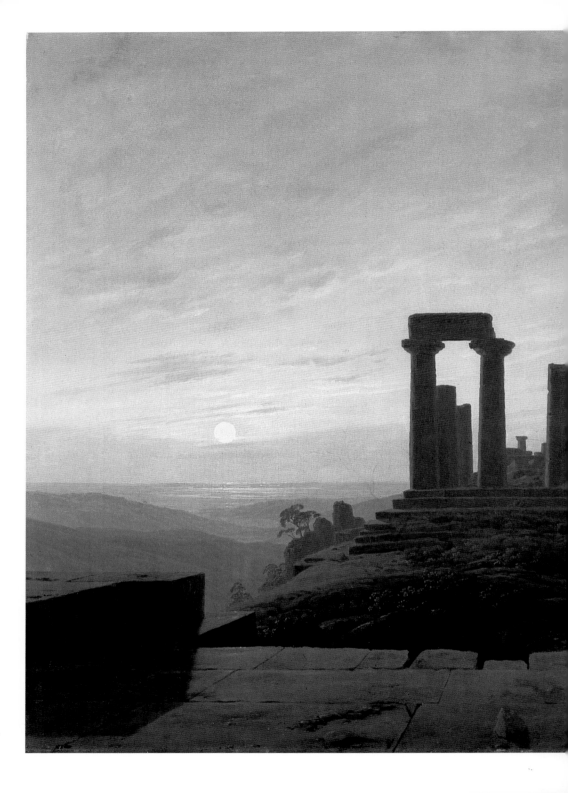

160
*The Temple
of Juno at
Agrigento,*
1828–30.
Oil on canvas;
54×72cm,
21¼×28⅜in.
Museum für
Kunst und
Kultur-
geschichte,
Dortmund

supported in Dresden as in the Rhineland – occurred well after the artist's death, and he may have had no sense of the possibility of such an event in the future. He might, in any case, have been thoroughly out of sympathy with the new milieu of the urban worker and its supporters. His world was that of the traditional craftsman, his democracy that of the burgher asserting ancient civic rights.

In all probability Friedrich, towards the end of his life, saw little to be enthusiastic about in a Germany in which authoritarian regimes had reasserted their power, in which the new superstate of Prussia was gaining increasing authority, and in which the sense of the spiritual seemed everywhere to be in retreat in the face of technological change and rampant commercialism.

It may be purely coincidental that Friedrich's art in the early 1830s becomes increasingly dark in mood. This change cannot be put down to ill health, since he was then still enjoying a degree of remission from the strokes he had suffered. During this period, in fact, Friedrich produced a series of works of poignant beauty that are among his finest achievements. There was even some degree of recognition of this at the time, for he experienced renewed success at exhibitions. The Saxon Art Union bought a number of works by him, their principal purchase in 1831 being *Evening on the Baltic* (161). In this picture Friedrich returned to exploiting the effect of a dark silhouette against a night sky – seen in particular with the ship sailing in the middle distance. He seemed to some extent to be looking back to the work of the French artist Claude-Joseph Vernet, particularly in the way in which he set the light of the fishermen's fire in the foreground against that of the moon. Similar effects could be seen in *Ruin at Twilight*, also bought by the Art Union, now in the Neue Pinakothek, Munich. A curious feature of both these works is the prominence that they give to local figures. These are not Friedrichian spectators, viewed from behind, they are fisherfolk and others going about their business. It is almost as though the artist is trying to grasp some image of the people, of the natural

161
Evening on the Baltic, c.1831.
Oil on canvas, 54×71·5cm, 21¼×28⅛in.
Gemäldegalerie Neue Meister, Dresden

figures who inhabit the environment he is depicting. Yet such figures are cast in darkness, as though occluded from their own world.

Friedrich must have been grateful for the financial support he received due to the Art Union's patronage, yet he may well have found their paternalistic approach irksome. In a review of the arts in Dresden in a city guide of 1833, the author (whose pseudonym was Janus) complained about the large notices which appeared beside the works they purchased in exhibitions, proclaiming 'Bought by the Art Union' as though this honoured the picture 'in the view of the World and of Heaven, giving their choice a certain infallibility and placing their judgement at the pinnacle of general taste'.

This arrogance is evident in the Art Union's treatment of the masterpiece of Friedrich's last years, *The Large Enclosure* (163). Exhibited in 1832, the picture shows a stretch of common land by the Elbe, just to the west of Dresden. There can be few more beautifully observed records of the moment when the sun sinks below clouds on the horizon and the earth is illuminated by the reflected light left in the sky. All is transformation, the water now shimmering brightly while the avenue of trees before it becomes menacingly dark. The poetry of this moment has never been better or more accurately caught. Yet what gives a strange urgency to this picture is the oddly distorted perspective, the 'fish-eye' view that the artist appears to have taken of the scene, so that, when standing before the actual canvas, we have to get very close indeed for it to fall into place. Friedrich had clear expressive reasons for wanting to draw us into the centre of the picture, where a sailing ship is being blown against a shore before dark trees, to a point of irredeemable darkness from which there is no escape. This is not just a poignant poetic moment on an evening walk. It is about the presence of death.

The officials of the Art Union can certainly be credited with perceptiveness when they selected such a remarkable work. Less to their credit was the way in which the image was treated

when they had it engraved – as was their wont – for distribution among their members. The engraving process ironed out the 'distortion' of the fish-eye perspective, regularizing the foreground (162). At the same time the original title – so redolent of a specific place – was replaced by the more general and conventionally poetic 'Evening on the Elbe'. This appears to be a sop to the naturalists, negating the individuality of observation and experience in the work as if these were romantic 'excesses' of an earlier generation. The result is an image that is harmless and bland.

There is no more telling way of seeing the difference between Friedrich and his contemporaries than in the changes wrought in this picture when it was made public and his 'game' was removed from it. Perhaps equally touching is the fact that the engraver who performed this task was not some indifferent jobbing copyist. J P Veit was an old acquaintance who had known the artist ever since he came to Dresden. As with Carus, friends were always setting out to excuse Friedrich, to try and make his work palatable to others. In this case, Veit no doubt thought he was saving Friedrich from the charge of eccentricity by smoothing out the 'peculiarities' of his picture. All manner of explanation has been offered as to why Friedrich should have hit upon this highly original device to heighten the effect of the reflected light – something that can be seen technically as a distortion and which appears to share more with modern ways of looking at landscape than with those of his own time. In the absence of evidence we cannot reach a conclusion; but we can surely recognize how well this intensely observed moment fits in with Friedrich's notion of the artist being guided by feeling rather than thinking.

It may be that the mood of melancholy that emerges so powerfully in this work can be read in terms of Friedrich's own growing sense of isolation. Yet that isolation might also be related to the abandonment of political hope. For people living in Dresden, this lonely view of a piece of common land just outside the city may have had a resonance of its own. The Large Enclosure

162
Johann Philipp
Veit after
Caspar David
Friedrich,
*Evening on
the Elbe*,
1832.
Engraving;
21·8×29·3cm,
8½×11½in

163
*The Large
Enclosure*,
c.1832.
Oil on canvas;
73·5×103cm,
29×40½in.
Gemäldegalerie
Neue Meister,
Dresden

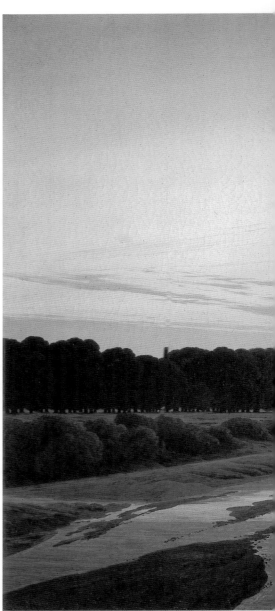

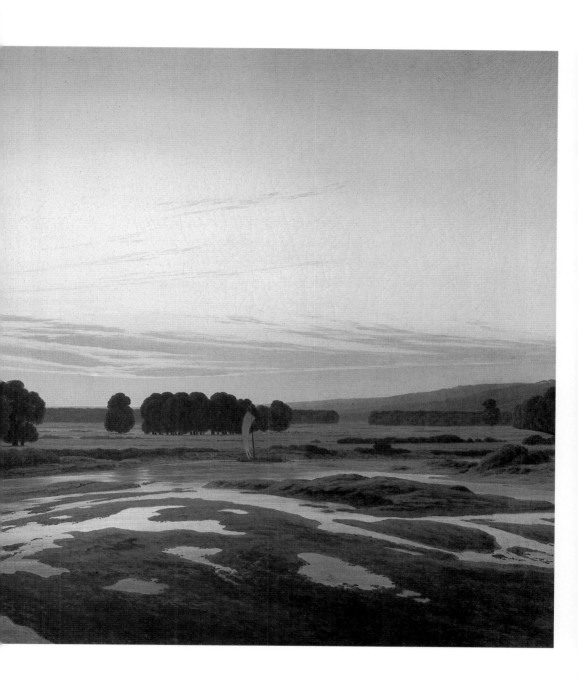

was a well-known area where citizens took their evening walks. The avenues of linden trees – seen as dark and menacing forms in Friedrich's picture – were particularly admired at the time for their magnificence and for their associations with the Germany of the past. Friedrich's portrayal of the pleasure resort as abandoned and threatening might well have been taken by some as a reference to the loss of hope so recently experienced by the populace. Perhaps it was for this reason that the Art Union took such pains to have this picture revised in the print made from it, turning its sense of gloom into one of gentle reverie.

While no other known work by Friedrich quite matches the mood of *The Large Enclosure*, there are many other pictures of the period that celebrate a touching moment of twilight. Some, like *Before Sunrise* (164), achieve their effect with great simplicity and directness. They have that integration of effect that fitted in so well with Friedrich's criteria for expressive landscape.

Yet, increasingly, there were those who did not understand these late works. 'Two lines and three colours – is that a landscape?' asked one reviewer. Whereas in the 1820s Friedrich had been able to hold his own against the naturalists by painting a kind of picture that they did not, in the 1830s he found himself outflanked by those such as the Düsseldorf painter Carl Friedrich Lessing

164
Before Sunrise,
1830/34.
Oil on canvas;
72×102cm,
28¼×40⅛in.
Nationalgalerie,
Staatliche
Museen, Berlin

165
Evening Walk at Dusk, 1830/35. Oil on canvas; 33×43cm, 13×17in. Private collection

(1808–80) who took over his 'Romantic' subject matter and invested it with a glossier naturalism (see 178).

Meanwhile, Friedrich's melancholy was being seen increasingly in terms of his own personal eccentricity. 'Here is a man who has discovered the tragedy of landscape,' proclaimed the French sculptor David d'Angers (1788–1856), according to Carus, when encountering Friedrich's work on a visit to Dresden in 1834. The phrase has since become a leitmotif for those who wish to link Friedrich's vision with that of twentieth-century existentialists. There is, indeed, a connection between the sense of loneliness and the fact that scenes whose beauty elicits such emotional engagement are at the same time the terrain of an indifferent and uncaring nature. What might seem curious about Friedrich's position is that someone so committed to the understanding of nature as a manifestation of divine creation and so full of the hope of eternal life should find more to mourn than to celebrate in the landscape. For most contemporaries – including David d'Angers – the explanation lay in the events of Friedrich's life, in the guilt emanating from witnessing the death of his brother at the age of thirteen. This story enabled them to isolate Friedrich's melancholy, to remove it from any more general application in relation to the human condition.

Towards the mid-1830s a series of pictures emerge in which Friedrich seems to return to observing himself. He can see himself as a man greatly changed. He is no longer the upright, supportive

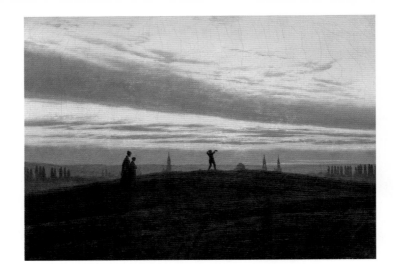

166
The Evening Star,
1830/35.
Oil on canvas;
32·5×45cm,
12¾×17¾in.
Freies
Deutsches
Hochstift,
Frankfurt

figure that appeared in *Two Men Contemplating the Moon* in 1819 (see 95). He is old and stiff. Shrouded in a long cloak, he moves with a stoop. In one such work, *Evening Walk at Dusk* (165), he approaches one of the mysterious dolmen on the island of Rügen as though it were his own grave. When he is with other people he seems to be left behind, as in the beautiful small work *The Evening Star* (166), another scene picture set in Dresden. This picture appears to show his own family on an evening walk with his son Gustav Adolf – now an impetuous young child – rushing forward in excitement, an excitement so rarely found in a Friedrich picture. Yet charming though this gesture is, it emphasizes the distance between the young figure and the artist, presumably watching from outside the picture. This was apparently the time when rifts began appear in his family, according to Carus, with Friedrich unfairly suspecting his wife of infidelity.

While such pictures may be based on actual individuals, one should not necessarily believe that they were intended to be private, any more than was the romantic *On the Sailing Boat* (see 116), painted during Friedrich's early married life. He drew his inspiration from his experiences, but the resultant pictures transcended the personal. Perhaps there is only one from this period in which a particular and individual message was intended.

This is the work now known as *The Stages of Life* (167). The picture appears to show Friedrich moving towards the shore, where there are two adults and two children greeting the ships as they come into harbour in the evening. The scene is of an actual place, Utkiek at the mouth of the river downstream from Greifswald harbour, where to this day people stroll to watch the boats. One can see an attempt at some kind of symbolic resonance between five people on land and the five ships at sea. It seems, too, that the 'end of day' motif applies most to the old man. Or perhaps one can say that only the old man – who stands furthest back and takes in the view most fully – can see it in terms that are abstract and reflective. The curious, almost menacing, gesture of the younger man – sometimes identified as Friedrich's nephew Heinrich who stayed with him during his illness of 1835 – could once again allude to jealousy – if we are to assume that the woman is Friedrich's wife. Some claim her to be Friedrich's eldest daughter, now in her mid-teens. But of course there is no way of proving such identifications, which must remain conjectural.

One feature is particularly striking: the children in the picture are waving a Swedish flag, although Pomerania had ceased to be Swedish for the best part of twenty years at the time of its painting. (It was for this reason that Von Einem and other earlier art historians assumed that *The Stages of Life* must have been painted before 1815; in fact it has been proved that it is based on studies made after that date.) This offers further evidence that Friedrich and his family – like so many Pomeranians – retained a sense of loyalty to the Swedish crown. In Julius Biesner's *Abriss der Geschichte Pommerns und Rügens* (1834), a book on the history of Pomerania (in which all three of Friedrich's brothers are listed as subscribers), the problem of residual leanings towards Sweden are acknowledged. Pomeranians are urged to overcome such feelings and make their peace with their new masters, the Prussians. Friedrich, however, had no wish to do this; perhaps all the more so since Prussian royal patronage had dried up. The Crown Prince had, it is true, visited Friedrich's studio in 1830 but no purchases had followed. It seems significant that *The Stages of Life* – despite

167
*The Stages
of Life*,
c.1835.
Oil on canvas;
72·5×94cm,
28×37in,
Museum der
bildenden
Künste, Leipzig

its scale and importance – was not exhibited and it may well be that the picture expressed an allegiance that had to be maintained in a clandestine manner. It was sent, apparently, straight up to Greifswald, where it remained in the Friedrich family until the early twentieth century.

It must have been very soon after painting *The Stages of Life* that the final catastrophe occurred: the massive stroke in 1835 that effectively ended Friedrich's career as an oil painter. As with *The Cemetery Entrance* (see 145) we are left with the evidence of unfinished work. One painting, *Rest during Haymaking* (168), now destroyed, seems uncharacteristically idyllic, yet even here a more melancholy reading is possible. Beyond the field in which peasant

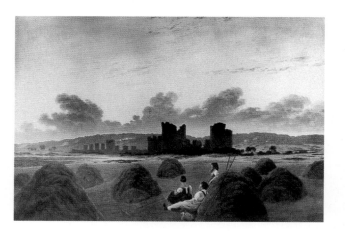

168
Rest during Haymaking,
1834–5.
Oil on canvas;
75·5×102cm,
29¼×40⅛in.
Formerly
Gemäldegalerie
Neue Meister,
Dresden
(destroyed)

women recline amid the haystacks is a ruin. It is near the end of the day. Furthermore, the ungathered hay in the middle of the field suggests that the women's work is uncompleted. According to Dahl, this was Friedrich's last full-sized oil painting. It seems to have evolved at the same time as an apocalyptic vision of Neubrandenburg (169), the home town of his parents, apparently going up in flames in the evening light. It is as though he is seeing the whole of his old world destroyed.

After his severest stroke the Russian royal family made purchases from Friedrich that gave him enough money to take a cure at Teplitz, but he never regained the full strength of his hand.

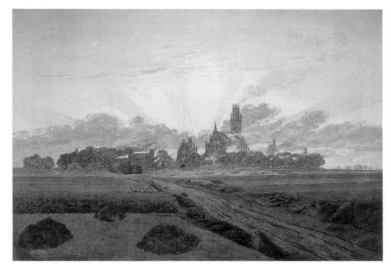

169
*Neubranden–
burg in Flames,*
1835.
Oil on canvas;
72·2×101·3cm,
28½×37⅞in.
Kunsthalle,
Hamburg

170
*Seashore by
Moonlight,*
1835–6.
Oil on canvas;
134×169cm,
52¾×66½in.
Kunsthalle,
Hamburg

His vision was still strong, however, and despite no longer being able to paint with his old vigour, he produced a remarkably moving 'black' painting, *Seashore by Moonlight* (170), the darkest of all his shorelines, in which richness of tonality compensates for the lack of his former finesse.

For the most part, Friedrich now worked in sepia. The Gothic themes of his earliest years now recurred, with a new level of ghoulishness about them, as in *Landscape with Grave, Coffin and Owl* (171), and *Owl on a Grave*. But there are also beautiful, calm, melancholy images of the shore and of figures staring out to sea (172).

Another theme that Friedrich returned to in these last years was that of the view through the window (173). Early in his career it had been the careful study of views through windows that had set Friedrich on the path of discovering his own particular way of representing landscape, of engaging in a dialogue between the inner and outer world (see 51, 52). Here, in this rigorous late painting, *Window and Garden*, there is no dialogue. The view is as impersonal as a blank wall. There is no way through. It is perhaps an indication of this that the window is closed.

The consummate technique of this window painting shows that Friedrich was somehow still able to control his hand when working on a small scale. The touch, though, is softer than before. In some

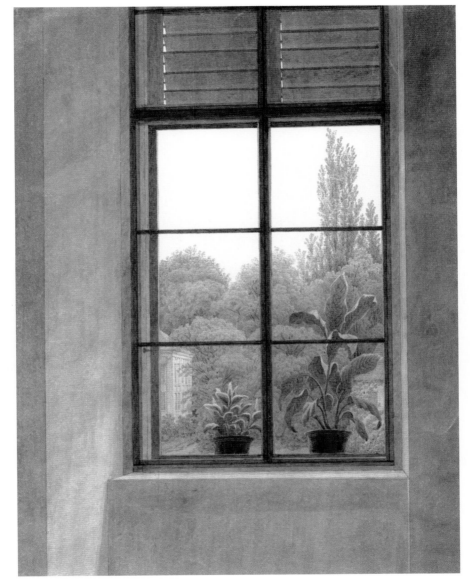

171
*Landscape
with Grave,
Coffin and Owl*,
*c.*1836–7.
Sepia;
48·5×38·5cm,
19×15¼in.
Kunsthalle,
Hamburg

172
*Two Men
at Moonrise*,
1835–7.
Sepia;
24·5×34·5cm,
9¾×13½in.
State
Hermitage
Museum,
St Petersburg

173
*Window
and Garden*,
*c.*1837.
Sepia;
39·8×30·5cm,
15⅜×12in.
State
Hermitage
Museum,
St Petersburg

ways this seems to have been an advantage in his watercolours, where lack of precision can lead to the exploration of more delicate effects. One of the finest of these last pictures is a view through a half-opened gate in a crumbling wall to a distant view of Dresden (174). It may be possible to read an allegory on the end of life into this work, too; but unlike the sepias of graves, owls and closed windows, there is an enchanting vision of the world beyond. Doubtless Friedrich himself moved between moods of despair, hope and resignation in his final years.

174
Landscape with Crumbling Wall, c.1837. Watercolour; 12·2×18·5cm, 4¾×7¼in. Kunsthalle, Hamburg

175
Caroline Bardua, *Friedrich in the Last Year of his Life,* 1839. Oil on canvas; 77×36cm, 30¼×14¼in. Anhaltische Gemäldegalerie, Dessau

In the last months of his life Friedrich was a broken figure, as can be seen in the portrait by his old acquaintance Caroline Bardua (175). The artist, seated, leans forward with an abstracted expression on his face, touching but not grasping his stick. Beyond him is a view of a bridge with a cross. This is just his kind of subject, but he does not bother to look towards it. He no longer holds the palette he had grasped so firmly in former portraits. It lies before him, unused. This is the Friedrich that Zhukovsky

encountered on his last visit on 19 March 1840. In his diary he wrote: 'To Friedrich's. A sorry ruin. He wept like a child.'

It was not the end of his involvement with Friedrich's affairs, however. The next day Zhukovsky selected further sepias to be acquired by the Russian royal family. He also successfully interceded for the artist to obtain a pension from them. Friedrich died on 7 May, before the first payment came through. When it did, it provided welcome relief for his family.

Friedrich's end was a melancholy one. Yet despite Zhukovsky's experience, the sense of resignation did not entirely desert him. At some point in these final months he produced an emblematic epitaph, a tailpiece to his life in the form of a palette resting beneath the reeds, with small birds, symbols of the soul, fluttering above. Artistically, if not personally, he ended his life in acquiescence, prepared to leave it to Fate to decide what would become of him afterwards.

I am not so weak as to submit to the demands of the age when they
go against my convictions. I spin a cocoon around myself; let others
do the same. I shall leave it to time to show what will come of it:
a brilliant butterfly or a maggot.

When Friedrich died in 1840, it was generally believed that his
art belonged to the past. He was, it is true, given a decent send-
off. Carus paid a fulsome tribute to him in a series of articles in
Schorn's Kunstblatt which were later printed as a book. But while
these made clear his merit as an artist, the articles mostly stressed
the way in which Friedrich had transformed the landscape practice

176
Ernst
Ferdinand
Oehme,
*Cathedral
in Winter*,
1819.
Oil on canvas;
127×100cm,
50×39⅜in.
Gemäldegalerie
Neue Meister,
Dresden

of his day, rather than seeing his art as a continuing inspiration.
By that time the two art forms that Friedrich had himself attacked
in his *Observations* – high-minded revivalism on the one hand
and sensationalist naturalism on the other – were engaged in
a dialectical struggle of their own, one that seemed to have an
added urgency as Germany moved towards modernization.
Neither side had much time for a fantastical dreamer from
a bygone age.

Friedrich's strongest impact on his artist contemporaries had been
in the decade following the successful exhibition of *The Monk
by the Sea* (see 72) and *The Abbey in the Oakwood* (see 73) in
Berlin in 1810. While having no official teaching position, he did
take private students, many of whom became deeply inspired
by his work.

One of the most remarkable of these was Ernst Ferdinand Oehme
(1797–1855), who in 1819 produced a *Cathedral in Winter* (176)
that seemed to extend the dramatic geometry of Friedrich's
architectural work of the time. Yet in the 1820s Oehme went
to study in Italy and his later work, while often containing a hint
of Friedrich's mood, turned away completely from his master's

stark and spare kind of composition. With the ascendancy of Dahl in Dresden, Friedrich's method was rejected on all sides in favour of more luxuriant forms of painting.

A similar story could be found elsewhere in Germany. In Berlin, Friedrich had been a challenge to local artists since 1810. As has been seen, the architect Schinkel adapted his work in this early period. In the 1820s he had still been sufficiently important for the leading landscapists of the city to respond to him. Perhaps the most interesting of them was Carl Blechen (1798–1840), who developed a pithy form of naturalistic observation. Blechen belonged, like the poet Heinrich Heine, to that generation who parodied the Romantics, admiring their imagination and sense of beauty, but unable to share their beliefs. While Friedrich was credited with having discovered the 'tragedy' of landscape, Blechen was described in the press of the day as showing nature in its 'irony'. This partly referred to his daring manner of recording light effects – in which the influence of Turner is evident. However, it also alluded to the manner in which he tended to undermine Romantic themes in his work. At first, while working in Berlin as a scene painter, Blechen produced scenes of ruins and mountains, the topics of Friedrich's northern landscapes. However, it was after a visit to Italy that the process developed to the full. One of his views, *The Park at Terni* (177), for example, shows an idyllic scene with nymphs bathing. Yet when we get closer to the canvas we see that the nymphs have spotted us and are turning away in fright. We have destroyed the idyll we are observing by our very presence. This is a playful inversion of the position of the figure in a Friedrich painting, which sets up the topic of the contemplative engagement of the spectator with the scene they perceive.

Blechen's playful ironies were not such a challenge to Friedrich's position as were works by those artists who popularized his themes, re-presenting them in a more attractive and less challenging package. This was achieved most successfully by artists working in Düsseldorf which, annexed to Prussia in 1815, became a thriving art centre. This was partly because of the re-

establishment of a teaching academy in the city; it was also due to the growth of a strong art market amongst the bourgeoisie – a section of society that was becoming increasingly powerful in the Rhineland as industrialization spread. This clientele had a distinct preference for sentimental and popular versions of romantic themes – very similar to that of Victorian society in Britain. The most successful adapter of Friedrichian subject matter was Carl Friedrich Lessing, who had an early success with *Cloister in Snow* (178) in 1829. Lessing's suave painting manner was far more accessible than Friedrich's stern, contemplative mood. While enjoying all the effects of snow, and the mystique of medieval ruins, we are also securely separated from too close an engagement with the themes painted by Lessing. For many contemporaries, Lessing represented a distinct advance on

177
Carl Blechen,
*The Park
at Terni,*
1836.
Oil on canvas;
105×78·5cm,
41³⁄₈×30⁷⁄₈in.
Museum Georg
Schäfer,
Schweinfurt

Friedrich. Indeed, one of the compliments paid to the latter in his obituaries was that he had paved the way for Lessing.

Friedrich's reputation in his lifetime had never been on an international scale. There are some records of sales to England and France and to parts of Scandinavia; but the only substantial purchasers of his works abroad were the Russian royal family who acted – as has been seen – on the advice of the poet Zhukovsky. These purchases do not seem to have had much circulation in Russia since they were largely confined to the private palaces of the monarchy.

In Scandinavia there was some artistic response to Friedrich's work. This came largely through personal contacts either with Friedrich himself or via his neighbour, J C C Dahl. In Danish painting there developed a tradition of sparsely painted landscapes and interiors – first by Christen Købke and later by Vilhelm Hammershøi (1864–1916) – that suggest a resonance with the work of the Dresden master. Yet it is difficult to say how much this is the result of direct contact and how much the consequence of a shared northern European practice. Such questions can be raised, too, about certain artists at work in Britain and North America. There has been speculation for years about possible associations between Friedrich's work and some of the more visionary British Romantic landscape painters such as Samuel Palmer (1805–81) and Francis Danby (1793–1861). Palmer almost certainly knew nothing of Friedrich's work. Danby lived on the Continent during the 1830s and had far more opportunities for coming into contact with Friedrich's pictures. He painted wild northern scenes as well as meditative calms. Such themes, however, were common among the Romantics and imitators such as Lessing. In all probability, connections between Danby and Friedrich are purely coincidental.

An even more intriguing possibility would be a connection with Turner, particularly in his later years when symbolic form became more important for him, as in such sea paintings as his commemorative picture for his friend David Wilkie,

178
Carl Friedrich
Lessing,
*Cloister
in Snow*,
1829.
Oil on canvas;
61 × 75 cm,
24 × 29½ in.
Wallraf-Richartz-
Museum,
Cologne

Peace – Burial at Sea (179). There seems more than a hint in this work of some of Friedrich's late, spectral ships (see 161). A parallel between the two artists did strike some contemporaries, though mostly on the grounds of shared eccentricity. The British traveller Anna Jameson, when in Dresden in 1834, recorded Friedrich in these terms: 'He is rather a mannerist in colour, like Turner, but in the opposite excess: His genius revels in gloom, as that of Turner revels in light.' As it happens, Turner travelled to Dresden in 1835. There is no record of him having visited Friedrich's studio. However, in his letters at this time Friedrich frequently reported foreign – including English – visitors to his studio, and one of them

179
J M W Turner,
*Peace –
Burial at Sea*,
1842.
Oil on canvas;
87 × 86·5cm,
34¼ × 34⅛in.
Tate, London

180
Fitz Hugh
Lane,
*Brace's Rock,
Brace's Cove*,
1864.
Oil on canvas;
26 × 38·7cm,
10¼ × 15¼in.
Terra
Foundation
for the Arts,
Daniel J Terra
Collection

may well have been a small rotund man looking (as Delacroix described Turner when the latter visited him in Paris) like a farmer. Turner might quite likely also have visited Quandt's collection of contemporary art in Dresden, where he would have seen a shipwreck by Friedrich similar to the celebrated *Arctic Shipwreck* (see 129). Be that as it may, it does seem that some of Turner's late sea pieces – perhaps particularly *Peace – Burial at Sea*, a work that does for once revel in gloom – contain more than a hint of Friedrich's direct method and use of silhouette.

Similar questions have been asked about possible connections between Friedrich's art and that of certain American landscape painters of the nineteenth century. There are greater possibilities of connection here, as cultural links between America and Germany were close at the time. Sometimes the pictorial affinities are so remarkable as to seem imperative. None suggests this more than the New England painter Fitz Hugh Lane (1804–65), whose contemplative Maine seascapes seem to have a clear resonance with Friedrich's Baltic coastal views (180). Yet all attempts to forge a link have failed and it may be that the best explanation lies in Lane's relationship to the 'transcendental' philosophy of Ralph Waldo Emerson, so influenced by German thought.

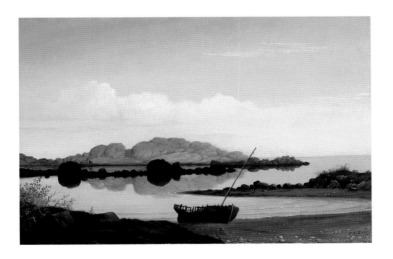

Elsewhere there were more direct artistic links with Germany. Many Americans, particularly those of German origin, studied at Düsseldorf. The painting there was a formative influence for Emanuel Leutze (1816–68), creator of the iconic image of *Washington Crossing the Delaware* (1851) now in the Metropolitan Museum of Art, New York. Artists such as Albert Bierstadt (1830–1902) drew similar inspiration from Düsseldorf landscape painting as practised by Lessing, Andreas Achenbach (1815–1910) and others. However, these artists were studying in Germany at a time when Friedrich was all but forgotten, and it is hard to know quite how they might have seen his pictures. In his

important exploration of landscape as a cultural phenomenon, *Landscape and Memory* (1995), Simon Schama suggests they saw Friedrich's *Cross in the Mountains* (see 86) in the Düsseldorf Kunstmuseum. 'Surely,' he comments, 'a half-century after it was painted, a group of young Americans, among them Worthington Whittredge, Albert Bierstadt, and Fitz Hugh Lane, stood stroking their chins and contemplating the mystery of the verdant cross.' It is an attractive notion, but as that particular work was not acquired by the museum until 1921, it is hardly likely that such an event could have taken place. In fact there were no Friedrich paintings on public view in Düsseldorf in this period and precious few elsewhere in Germany.

The truth of the matter is that almost all the links discussed above are probably 'false friends'. It has been a weakness in art historical studies in the past to assume that a visual affinity between two works implies some kind of direct connection. The links are probably of a much deeper and more complex kind, perhaps relating to a matrix of thought that pervaded the whole of northern European culture during the nineteenth century. This led to certain types of meditative landscape painting in the period in Scandinavia, Poland and Russia as well as in Germany and to some degree in Holland, Britain and the United States. Within that broad matrix Friedrich has his own distinctive place and practice – and those that appear to resemble him are probably coming from similarly individual positions.

Fascinating though such speculations are, they should not disguise for us the fact that there is a more tangible form of tradition from Friedrich that has played a central – and sometimes tragic – role in the history of German art. It is a role that has also had international ramifications from the 1920s onwards, ones that have, in recent decades, led to Friedrich actually achieving a degree of acclaim worldwide.

This tradition starts from a very low ebb in the mid-nineteenth century. As Friedrich's friends died out so the knowledge of him diminished, even if it was not totally extinguished. Occasionally

181
Arnold Böcklin,
*The Island
of the Dead*,
1880.
Oil on canvas;
111×155cm,
43¾×61in.
Kunstmuseum,
Basel

his work would surface and there would be the usual round of explanations and discussions about its curiosity. In 1859 a showing of Friedrich's work in Munich led to a moving plea by Reimer, his faithful collector, for his importance to be preserved. This seems to have fallen on deaf ears, and Reimer himself was silenced by death shortly afterwards. But by this time naturalistic landscape was also itself being brought into question. The hero in this area in the later nineteenth century was the Swiss painter Arnold Böcklin (1827–1901), whose doom-laden landscapes reasserted the power of the introspective vision of nature. Böcklin said of his most famous landscape, *The Island of the Dead* (181), that it was a 'picture for dreaming'. Again, it seems hard to imagine that this work could have been conceived without a knowledge of Friedrich's *Monk* (see 72) – not just because of the lonely isolation of the figure, but also because of the reflections on religion and death. Indeed, we should recall that Friedrich's *Monk* remained in a sense on public display in the Royal Palace in Berlin – if little commented on. There are of course important

psychological differences. Böcklin belongs to the age of Nietzsche, who turned his back on the fantasies of the romantics for a more 'earth-bound' image of the spiritual, one that proclaimed the death of God and saw the dynamics of being more in terms of the life force. Böcklin's picture looks forward to existential bleakness. But then so too does Friedrich, despite his religious beliefs.

We are on firmer ground in the 1890s, when the Symbolist movement was at its height. This was the time when Friedrich was rediscovered by the Norwegian art historian Andreas Aubert. Aubert's meticulously researched publications mark the beginning of modern Friedrich scholarship. He may also have been the

182
Edvard Munch,
*Two Human
Beings: The
Lonely Ones,*
1899.
Woodcut;
59×72cm,
23½×28½in.
Munch
Museum, Oslo

means whereby the great Norwegian Symbolist Edvard Munch (1863–1944) became aware of Friedrich, building this into his art when in Berlin in the 1890s. Such images as *Two Human Beings: The Lonely Ones* (182) seem like direct engagements with Friedrich's celebrated *Rückenfiguren*. Characteristically Munch has shifted the balance of the picture from the contemplation of the landscape to the sense of a lack of communication between his two pensive figures. Despite this distinction, Munch seems to have responded to the personal melancholy of Friedrich. Through him we might find a link that reaches forward to the present – and which has been explored by Robert Rosenblum in his challenging

work *Modern Painting and the Northern Romantic Tradition. From Friedrich to Rothko* (1975). But Friedrich was about to enter a very different kind of area, one which brought him perilously close to re-emerging as a maggot rather than as a butterfly.

In the period prior to World War I the artist became celebrated increasingly for his supposed 'German' character. Much the same process was taking place with Constable in Britain, where the East Anglian landscapist came to stand for the spirit of the nation. It was part of the ideology in both countries that their landscape painting tradition should be 'natural' and demonstrably dependent upon the indigenous terrain. Such considerations led to Friedrich enjoying a major showing in the great *Jahrhundertausstellung* in Berlin in 1906, the retrospective of German nineteenth-century art aimed at celebrating the national product. The anniversary of the Wars of Liberation in 1913 again drew attention to Friedrich's strong nationalist sentiments, and it was almost inevitable that, when Aubert's unfinished monograph on Friedrich was published in 1915, in the middle of World War I, it should have the subtitle *Gott, Freiheit, Vaterland* (God, Freedom, Fatherland).

Studies of Friedrich mushroomed in the 1920s, as did the interest of artists. The psychological intensity of his landscapes was much appreciated by the Expressionists, particularly by Emil Nolde. Nolde settled in the village of Seebüll, just south of the Danish border, and the elemental North Sea views that he painted there often seem to share an affinity with Friedrich's Baltic scenes. However, such enthusiasm was soon to be outpaced by a far more problematic admiration, that accorded by the National Socialists. Picking up on the pre-war veneration of Friedrich as the archetypal painter of the German landscape, the artist came to be seen as one of the key advocates of the new ideology. He was appropriated much in the same way as was the philosophy of Nietzsche. Reputedly Friedrich was one of Hitler's favourite artists. Many of the painters favoured by the Nazis drew on Friedrich's imagery, sometimes producing crude pastiches of it.

Yet at the same time, Friedrich was being celebrated quite differently by those progressive German voices participating in Surrealism and Existentialism. He was admired by Max Ernst (1891–1976), who frequently drew on his work, as in *Der Grosse Wald* (1927), and through whom he became widely known in Surrealist circles. He was the subject of an article by the critic Marie Landsberger in the Surrealist journal *Minotaur* in 1939. Long before that, his sparse mood had influenced the Belgian painter René Magritte (1898–1967), who seems to have taken his cue from the stark perceptual puzzles in Friedrich; Magritte's painting *The Human Condition* (183) not only has Friedrich's frontal exactitude but also re-poses the problem of vision. Friedrich, in his glimpses through windows, questions artistic conventions by stressing the position of the spectator. Magritte shows us in his picture a painting in front of a window that might or might not be the same as the landscape that it obscures, thus emphasizing the paradoxical nature of artistic representation. Even more surprising is the debt owed by the British Surrealist Paul Nash (1889–1946), whose wartime picture *Totes Meer* (184) seems almost certainly to have developed in dialogue with Friedrich's *Arctic Shipwreck* (see 129), then known as *The Wreck of the Hope*. Nash, unusually among the British, was a passionate admirer and supporter of Max Ernst and would undoubtedly have been familiar with the Landsberger article in which Friedrich's so-called 'Wreck of the Hope' was reproduced. The immediate inspiration for this picture was the sight of a dump of crashed German planes at Cowley, Oxford. Their jagged forms seem to have provoked in him some memory of Friedrich's scene of .disaster. Perhaps there was a deliberate intention to make ironic comment on his German predecessor's abandonment. But beyond this, there is, as in the work of Ernst and Magritte, a tribute to the tragic depths of Friedrich's vision.

Perhaps the most surprising and intriguing of connections of that time is that of Friedrich to the Irish existential playwright Samuel Beckett. Beckett toured Germany 1936, where he was greatly impressed with the works by Friedrich that he saw on view.

183
René Magritte,
The Human Condition,
1934.
Oil on canvas;
100·3×80cm,
39½×31½in.
Private
collection

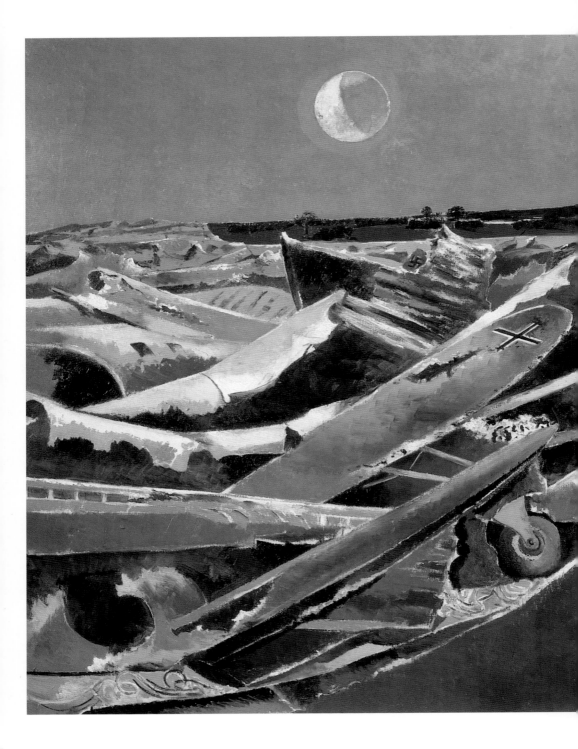

184
Paul Nash,
Totes Meer,
1940–1.
Oil on canvas;
101·6×512·4cm,
40×201¾in.
Tate, London

In a way this is ironic since the prominence of Friedrich in German galleries at this time was for the purpose of promoting Nazi ideology. But Beckett could respond – as Kleist had before him – to the searing loneliness conveyed by Friedrich, to the anxiety that lay behind all that staring into the distance. When in Dresden, Beckett was particularly struck by *Two Men Contemplating the Moon* (see 95). He confessed 'a pleasant predilection for two tiny languid men in his landscapes, as in the little moon landscape, that is the only kind of romantic still tolerable, the *bémolisé* [in a minor key]'. Later he made clear that it was this image that formed the visual source for his most famous play, *Waiting for Godot* (1952). He specifically drew attention to this fact when in Berlin in the 1950s, arranging for a performance of the work. The situation in Beckett's play, that of two tramps holding a half-despairing, half-slapstick dialogue in a barren landscape beneath a dead tree, can certainly be seen as having a parodic connection to Friedrich's pair of contemplative dissidents (185).

We know of this connection because of the intense documentation which Beckett's life has received. Other connections between

Friedrich and the artistic avant-garde of the 1930s are harder to recover. Yet they are important to bear in mind to counter the crude reduction of him to a nationalist artist by the Nazi propaganda machine.

Despite the championship of certain Surrealists and Existentialists, Friedrich had a rough time of it in the international art-critical world following World War II. This had probably less to do with any distaste brought about by Nazi associations than with his failure to conform to a narrowly defined concept of modernism then gaining the upper hand in critical circles. This saw modern art as a 'pure' painterly tradition traceable from the Impressionists to abstraction. The two black marks against Friedrich were his lack of painterly bravura and his reliance on symbol. Thus, in his magisterial book *Landscape into Art* (1949), Kenneth Clark dismissed the artist with the comment that he 'worked in the frigid technique of his times, which could hardly inspire a school of modern painting'. At much the same time Ernst Gombrich, in his influential survey *The Story of Art* (1950), commented that Friedrich's works 'reflect the mood of the Romantic lyrical poetry of his day' but that he fell short of the achievements of Constable who 'tried to explore the visible world rather than to conjure up poetic moods'.

185
Scene from
Samuel
Beckett's
*Waiting for
Godot* at the
Royal Court
Theatre,
London, 1964

Friedrich's case can hardly have been helped in such circles by the fact that, at a popular level, his imagery was used by many Hollywood directors for eerie effects in thrillers and fantasy films. They were building here on the work of such masters of German cinema as Fritz Lang and F W Murnau. In his 1924 epic *The Nibelungen*, for example, Lang had made particular use of Friedrichian motifs in his settings for the Germanic saga (186). The arrival of Lang and other German directors and designers as émigrés in Hollywood in the 1930s speeded up the assimilation of such features into American films. By the 1940s these were commonplace, even in the cartoons of Walt Disney.

If Friedrich made Hollywood easily enough, it took him longer to scale the heights of American high culture. After the war the main

obsession – promoted by Clement Greenberg and other high priests of modernism – was to show American abstract art to be the worthy successor of Parisian art and the international abstract movement. There was no room in this agenda for thinly painted imagistic work of the kind that Friedrich was associated with. It probably would not have helped if it had been known then that the one major American twentieth-century artist to take a serious interest in Friedrich was the figurative master Edward Hopper (1882–1967) – as the art historian David Anfam has suggested in pointedly comparing *Railroad Sunset* (1929) with *The Cross in the Mountains* (see 46). For Hopper represented precisely the tradition Greenberg was encouraging artists to move away from. It was not, in fact, until the supremacy of modernism began to be questioned seriously in the 1960s that the fortunes of Friedrich began to revive internationally.

Friedrich's rehabilitation took various forms. Serious scholarly investigation had continued, often completing work initiated in the 1930s but removing this from any of the political associations of the time. It was in the late 1950s that Werner Hofmann first created a context for Friedrich in terms of international Romanticism – something that was also confirmed by the artist's showing in the great Council of Europe exhibition on Romanticism held in London in 1959. Meanwhile Helmut Börsch-Supan and Sigrid Hinz were discovering the means for providing a sound chronology for Friedrich's work. While this might seem to be a technical matter, it was only with the establishment of a clear chronology that it became possible to relate Friedrich's products with any precision to the events of his day. From then on, it was no longer necessary to rely on airy abstractions when talking of the artist's work.

Equally significant was the repositioning of Friedrich's work within a German cultural tradition. To a large extent this was led by artists who re-engaged with areas where scholars and politicians feared to tread. Joseph Beuys (1921–86) – a former member of the Luftwaffe and teacher of sculpture at the Düsseldorf Academy

– became the conscience of this movement, creating installations and happenings that connected to a mystical concept of landscape encompassing Friedrich's visionary perception of nature. At a time when western Germany was trying to distance itself from a German past, Beuys was invoking Nordic images of rocks and forests, sometimes with an apocalyptic dimension that again seemed to draw on the devastation of Friedrich's *Arctic Shipwreck* (see 129). Beuys's *End of the Twentieth Century* (187) with its scattered basaltic blocks is like a giant three-dimensional reconstruction of the debris to be found in the foreground of his forebear's famous image. However, this has also been seen as an intimation of new beginnings. The archaic forms now laid low could become the basis for regeneration. In this way Beuys was perhaps trying to redeem the tragic vision of his Romantic predecessor.

Subsequently a younger generation dealt even more provocatively with the Nazi heritage. None has been more problematic from this point of view than the German painter Anselm Kiefer (b.1945) who embarked on a wholesale reworking of national iconography. His image of himself in Nazi uniform claiming territory as a *Rückenfigur* reminiscent of Friedrich's *Wanderer* played upon the role that had been assumed for Friedrich in the Third Reich. Yet it was also an acknowledgement that Friedrich's imagery was central to the national consciousness. Hardly

187
Josef Beuys,
*The End of
the Twentieth
Century*,
1983–5.
Basalt,
clay and felt.
Tate, London

188
Der Spiegel,
8 May 1995

surprising, therefore, that in an issue marking the fiftieth
anniversary of the ending of World War II in Europe, *Der Spiegel*
magazine used the image of *The Wanderer* yet again to confront
Germany's recent history (188).

If events since the 1960s have reconfirmed Friedrich's position
as an icon of German national identity, the artist has at the same
time been emerging as a figure of international importance.
This development was stimulated by the curiosity aroused by
Friedrich's presence in the 1959 Council of Europe Romanticism
exhibition. There were also signs of a new critical interest in
Friedrich, fired to some extent by the role that he had played
as an image of isolation for Beckett and other existentialists.
This interest, however, was more of an intellectual than an
aesthetic one and cut little ice with most art critics. The Tate
Gallery exhibition of 1972 – the first monographic showing of
the artist ever to have occurred outside Germany – finally began
to turn the tide of opinion. While the attitude of London critics to
the show was largely disparaging, it was enthusiastically received

by a number of artists. David Hockney (b.1937), in particular, claimed to have been bowled over by the works on display there, taking students to the exhibition on several occasions. Hockney's appreciation may have been related to changes already taking place in his own art. As early as 1970 he was painting contemplative landscapes drawing on the theme of spectatorship (189). Such works could themselves be a response, however, to remembered images of Friedrichs he might have seen when he was in Berlin in 1962.

The advocacy of artists such as Hockney gradually brought about a change of heart towards Friedrich in the British art establishment.

189
David
Hockney,
Le Parc des
Sources, Vichy,
1970.
Acrylic on
canvas;
213¼×305cm,
84×120in.
Private
collection

190
Sam Taylor-
Wood,
Self-Portrait
as a Tree,
2000.
C-type print;
75.6×91cm,
29¾×35¾in.
Private
collection

Unfortunately, this did not happen soon enough to persuade the National Gallery to acquire a Friedrich that surfaced from a collection in Britain as a result of the publicity generated by the Tate exhibition. When *Easter Morning* (see 159) was offered at a modest price to the National Gallery in 1973 it was rejected, one senior official reportedly making an unflattering comparison between Friedrich and a popular Victorian painter of moonlights: 'We might as well buy an Atkinson Grimshaw and pocket the difference.' Yet within a few years of this, Kenneth Clark was somewhat grudgingly qualifying his original rejection of Friedrich in a new edition of *Landscape into Art*.

Meanwhile the American scholar Robert Rosenblum boldly used Friedrich to redraw the map of modern art in his book *Modern Painting and the Northern Romantic Tradition*. Building on the existential interest in Friedrich as the painter of emptiness, Rosenblum proposed an alternative 'northern' tradition of spiritualized landscape that reached from Friedrich through the nineteenth century, incorporating Vincent van Gogh (1853–90) and Munch, and finally achieved an apotheosis in the lowering spaces of Rothko's great canvases. It was in a sense a 'virtual' tradition, born not of tangible historical contacts, but of a more

indefinite disposition that could be seen to emerge through largely philosophical continuities within northern Europe and North America. Although the dynamics of this proposed tradition are hard to grasp, the mere assertion of such a possibility did wonders in making Friedrich seem a viable proposition in the international art world. It put paid once and for all to the assertion of Clark, Gombrich and others that Friedrich had no place in the history of modern art. Nothing can demonstrate this change of heart more clearly than the fact that in 1987 the National Gallery in London paid a sum vastly in excess of what would have been

required to purchase *Easter Morning* in 1973 for the somewhat
less remarkable *Winter Landscape with a Church* (see 85).

Subsequently Friedrich's work has had major showings in New
York and Paris which have magnified his international reputation
even further. Meanwhile he has become accepted by artists
throughout the world as one of the more stimulating of the
'Old Masters'. One instance of this was provided in 2002 by
the British video artist Sam Taylor-Wood (b.1967) in her major
exhibition at the Hayward Gallery in London. Talking of her
photograph of a lone tree, entitled *Self-Portrait as a Tree* (190), she
mentioned how the image had grasped her inexplicably, and that
it was only after she had taken the picture that she realized why.

I came across those contact sheets and thought that that single
image summed up everything that I was feeling. It was only later that
I realized that it's great because the history of landscape painting is
there, that it looks somehow like a work by Caspar David Friedrich.
When you are making a photograph you have a memory bank of
images that work their way in subconsciously.

At the start of the twenty-first century Friedrich's international
reputation seems assured. The story is an unending one, and
tastes may easily change. Yet what is perhaps most reassuring
is the variety of support that he now receives. He is not simply the
hero of one particular clique or faction. Thus, while he remains a
national icon in Germany, he has become a focus for postmodern
chic in Paris, London and New York. There is every hope that
future artistic revolutions will not sink his reputation, but
instead will allow new aspects of his work to surface. Above all,
explorations over the past half-century have established Friedrich
as a figure of great psychological complexity, a believer who
struggled with doubt, a celebrator of beauty haunted by darkness.
In the end, he transcends interpretation, reaching across cultures
through the compelling appeal of his imagery. His art provides
an insight into the human condition. He truly has emerged
as a butterfly – hopefully one that will never again disappear
from our sight.

Glossary

Academy Used originally to describe meetings of scholars, the term became associated in the sixteenth century with groups of artists combining to study and establish artistic standards. In the seventeenth century practices became codified by the French Academy (founded 1648). This then set a standard imitated through Europe. In the Romantic period the values of academies became challenged on account of their rigidity, and they gradually began to lose authority in the art world.

Baroque The leading artistic style in Europe in the seventeenth century. Originating in Italy, it was associated with rich, convoluted forms and dramatic effects of lighting.

Classic Denotes a model of artistic excellence, usually hallowed by time. In the visual arts in Europe it has traditionally referred to the works of ancient Greece and Rome.

Engraving A process for reproducing images. It involves incising lines on a flat surface or 'plate'. A special form of ink is then applied to the plate and prints are taken from it.

Enlightenment The dominating intellectual movement of the eighteenth century. Originating in France and England, it spread throughout the Western world. Using reason as a touchstone, it questioned traditional values and practices in society and was a major stimulus to the scientific, social and political revolutions that marked the end of the century.

Etching A printing process in which acid is used to deepen lines scratched on a plate. It is capable of producing richer and more spontaneous effects than **engraving**, and for this reason it is often favoured to engraving as a reproduction method by fine artists.

Kunstverein (Art Union) A form of art organization innovated in the early nineteenth century in Germany and widely imitated elsewhere. Typically the Art Union would use funds raised by the subscriptions of its members to purchase works of art from exhibitions. These would then either be distributed by lottery to members or presented to art galleries and other institutions. Art Unions became an important form of middle-class patronage during the mid-nineteenth century.

Lithography A printing process innovated in Bavaria at the end of the eighteenth century which involved drawing on a stone with a special form of greasy chalk or pen using specially prepared ink. It became popular in the nineteenth century both because of the rapidity of the process and because of its ability to reproduce the effects of drawing and painting.

Nazarenes Group of German artists who sought to revive art by returning to the values of the Middle Ages. Established in 1808 as the *Lukasbund* (Brotherhood of St Luke) by a group of students of the Vienna Academy, they gained international fame after they moved to Rome in 1810. Their medievalizing style was in many ways a precursor to that of the English Pre-Raphaelite Brotherhood (est. 1848). They were strongly supported by political authorities in post-Napoleonic Germany because of the traditionalist ideals that they espoused.

Neoclassicism A movement to restore the artistic ideals of ancient Greece and Rome that originated in the mid-eighteenth century and became the dominant artistic form in Europe around 1800. Often seen as the artistic counterpart of the **Enlightenment**, it challenged the supposedly corrupt and superficial values of the **Baroque** and **Rococo**, aiming to promote serious subject matter and visual forms of noble simplicity.

Picturesque Literally meaning 'like a picture', the term came to be used in the later eighteenth century to describe a form of natural scenery that could stimulate aesthetic pleasure or interest. The taste for the picturesque stimulated a new form of tourism devoted to sampling the beauties of nature. The movement began in Britain, where the vogue led to the production of guidebooks to 'picturesque' sites – notably those by the Reverend William Gilpin. By 1800 the vogue for the Picturesque had spread throughout Europe. It was highly influential in landscape gardening and painting, and in the development of informal planning in architecture.

Rococo Originating in France in the early eighteenth century, this artistic movement favoured light colours and highly decorative and sensuous effects. A conscious reaction against the

heavier effects of the **Baroque**, it came to epitomize for later generations the more decadent aspects of the *ancien régime*. Many rococo artists, however, pioneered the interest in spontaneity and the contemporary that were to become keynotes for the development of modernity in art in the nineteenth century.

Romanticism The dominant cultural movement in Europe in the late eighteenth and early nineteenth centuries. It indicated more an attitude of mind than a specific style. The movement began as a reaction against the secular and materialistic nature of the **Enlightenment** and the formalism of **Neoclassicism**. It encouraged an interest in the exotic and the spiritual. In the visual arts it endowed landscape painting and the study of nature with new significance and led to a revaluation of the art of the Middle Ages.

Sepia A form of monochrome wash painting using the brown pigment secreted by the cuttlefish or squid. Known since classical antiquity, and much used for studies in the Renaissance, sepia became a popular medium for the production of finished pictures in the later eighteenth century.

Steel Engraving A form of **engraving** innovated in Britain in the early nineteenth century that used steel rather than the copper traditionally used for the printing plate. The material was harder to work and required special processes. However, it was capable of producing much longer runs of prints than copper and became highly popular for commercial publications in the mid-nineteenth century.

Sublime A term used to describe an overwhelming aesthetic sensation. Originally defined in classical antiquity – notably by Longinus – it came in the eighteenth century to be seen as distinct in nature from the gentler and more appealing sensation of beauty. A key publication that affected this change was Edmund Burke's *Philosophical Inquiry into the Origin of Our Ideas of the Sublime and Beautiful* (1757). Subsequent to this, opinions differed as to whether it was to be particularly associated with the *frisson* provided by the contemplation of frightening or horrific situations, or whether it was also (and more importantly) a means of intuiting a higher spiritual state of being.

Sturm und Drang (Storm and Stress) The name given to a group of young writers in Germany in the 1770s who opposed classical forms and the rationalism of the **Enlightenment**. The most famous member of the group was the poet **Goethe**, whose novel *The Sorrows of Young Werther* (1774) – concerning a young man who kills himself for love – brought their views to an international audience. Their violent emotionalism can be seen as an early form of **Romanticism**, though they have continued to have an independent influence on expressionist forms of art up to the present day.

Wood Engraving, Woodcut Printing processes that use lines cut or incised into a block of wood to reproduce an image. While often confused with each other, the two methods are distinct and produce different effects. Woodcuts – which have been common in Europe since the later Middle Ages – are made by cutting or gouging pieces out of the side of a plank of wood. Wood engraving – a late eighteenth-century innovation – involves incising lines in the end grain of some very hard wood (normally boxwood). Woodcuts excel in producing rich broad effects, wood engravings are suitable for more minute work. In the nineteenth century wood engraving was the preferred form for commercial publications.

Brief Biographies

Ernst Moritz Arndt (1769–1860) Poet, scholar and patriot. Born in Rügen, he knew Friedrich from the time that he became a lecturer in history at the University of Greifswald (1800). He was active as a writer of patriotic verse and as a political agitator during the Napoleonic Wars, a time when he was particularly close to Friedrich. He was subsequently imprisoned and barred from his teaching post at the University of Bonn (appointed 1818) on account of his criticism of the reactionary politics of the German powers. In 1840 he was reinstated and appointed Rector of the University.

Carl Gustav Carus (1789–1869) Doctor and amateur artist. Born in Leipzig he became court physician and professor of gynaecology at Dresden. He met Friedrich in 1817 and became a close supporter and friend. His own landscapes are heavily influenced by Friedrich, though he was in some senses critical of the older artist. His *Nine Letters on Landscape Painting* (1831) align landscape with scientific enquiry, leaning towards views on art and science held by **Goethe**.

Peter Cornelius (1783–1867) Leading member of the **Nazarene** group of painters in Rome. He first gained prominence for the gothicizing illustrations he made to the *Nibelungen* and to **Goethe**'s *Faust*. Returning to Germany in 1820 he was the leading figure behind the revival of mural painting in Munich and the reform of artistic education in Germany. Patronized first by the King of Bavaria and then by the King of Prussia he came to epitomize authoritarianism in art. Despite this, he was an artist of real imaginative power, as can be seen in his celebrated design, *The Four Horsemen of the Apocalypse.*

Johann Christian Clausen Dahl (1788–1857) Norwegian landscape painter who settled in Dresden in 1818 where he became a close friend of Friedrich's. While influenced by Friedrich's imagery, Dahl was more naturalistic in manner and enjoyed great success in the mid-nineteenth century. In 1824 he was made professor of landscape at the Dresden Academy. Dahl travelled widely, visiting Italy and returning to Norway on several occasions. He promoted his native scenery in a number of grand landscapes.

Frederick William IV, King of Prussia (1795–1861) During the War of Liberation against the Napoleonic occupation of Germany, Frederick William, then Crown Prince of Prussia, was an ardent patriot. He had previously shown his patriotic fervour by purchasing Friedrich's *Monk by the Sea* and *Abbey in the Oakwood* in 1810. He acquired several other works by Friedrich during the following decade. Strongly influenced by the revivalist ideals of certain German Romantics, he became increasingly reactionary after the Napoleonic Wars, a time when he ceased to patronize Friedrich. After he succeeded to the Prussian throne in 1840 he remained a resolute opponent of liberal tendencies, particularly after the failed revolution of 1848.

Johann Wolfgang von Goethe (1749–1832) The leading German poet of his age, he was also a major novelist, influential scientific investigator and keen amateur artist. He first came to prominence as a representative of the proto-romantic **Sturm und Drang** movement with his novel *The Sorrows of Young Werther* (1774). Later his interest in the medieval world and Shakespearean drama led to the production of his greatest work, the drama *Faust* (1808, 1832). His study of the emotive effects of colour led to insights that anticipated many romantic ideas. Despite this, he became increasingly critical of the Romantic movement. A privy councillor at the court in Weimar, he made that town the centre of a cultural milieu devoted to classical values. From 1799 to 1805 he ran an annual art competition at Weimar designed primarily to encourage German artists to develop as history painters. Friedrich won a half-prize in the last competition. While initially enthusiastic about Friedrich's skills as a landscape painter he later became critical of the artist's mystical tendencies.

Anton Graff (1736–1813) A Swiss portrait painter who was employed by the Saxon court and became a professor at the **Academy** at Dresden in 1766. Noted for the spirit and sensibility of his portraits, he was a supportive teacher and encouraged Friedrich in his early years.

Johann Gottfried von Herder (1744–1803) Writer and philosopher. A supporter of the ideals of the French Revolution,

he rejected the recourse to violence. He proposed a national regeneration through the revival of the German language and folk literature.

Heinrich von Kleist (1777–1811) The leading German dramatist of the early nineteenth century. His remarkable plays and short stories foresaw many of the problems of modern life and literature. He lived in Dresden between 1807 and 1809 where he was acquainted with Friedrich, who shared his patriotic and democratic views. In 1810, when living in Berlin, he published an important critique of Friedrich's *Monk by the Sea*. A year later he took his own life in a suicide pact with an incurably sick woman.

Theodore Körner (1791–1813) Patriotic poet of the War of Liberation against the Napoleonic occupation of Germany. His death in 1813 while fighting as a volunteer in the Lützower Corps made him a popular hero.

Gotthart Ludwig Theobul Kosegarten (1758–1818) Poet and pastor. Strongly influenced by English nature poets such as Edward Young and Thomas Gray, Kosegarten enjoyed fame in Germany for his emotive poetry in the early nineteenth century. A Pomeranian living in Rügen, he encouraged Friedrich and **Runge** in their development of spiritually inspired landscape painting.

August von Kotzebue (1761–1819) Prolific writer of melodramas who popularized the more emotive and sensationalist sides of **Romanticism**. In 1783 he moved to Russia, entering the service of the Tsar. After the Napoleonic Wars he became execrated by political radicals as a spy in the service of a reactionary power. This led to him being assassinated by a member of a radical student association when on a return visit to Germany.

Gerhard von Kügelgen (1772–1820) History painter who was active in Dresden from 1805. A close friend of Friedrich's and supporter of his art.

Nicholas I, Tsar of Russia (1796–1855) As Tsar (he ascended the throne in 1825), Nicholas is remembered as an autocratic reactionary opposed to movements towards liberalization and reform in Russia. Nicholas had strong links with Prussia, a country he greatly admired. He was married to **Frederick William IV**'s sister. He was stimulated in his interest in German culture by the poet **Zhukovsky**, who was a member of his entourage. An enthusiast for the work of Friedrich, Zhukovsky encouraged Nicholas to acquire works by the artist. Many of these form the basis of the collection of works by Friedrich in the Hermitage Museum, St Petersburg. This is the most important collection of works by Friedrich outside Germany.

Novalis (Friedrich von Hardenberg) (1772–1801) Leading Romantic poet and theorist. A member of the **Schlegel** circle, he wrote profoundly mystical works, notably the cycle *Hymns to the Night* (1800). His novel *Heinrich von Ofterdingen* (1802), set in the Middle Ages, described the mystical searchings of a young poet. He greatly influenced the thought of subsequent writers and painters, including **Runge**.

Ernst Ferdinand Oehme (1797–1855) A Dresden-born artist and a pupil of **Dahl**. His early work shows a strong influence of Friedrich's landscapes. He studied in Italy in the years 1822–5.

Johann Gottlob von Quandt (1787–1858) Dresden Maecenas who exerted great influence in the art world of that city in the early nineteenth century. He had a celebrated collection, which included works by Friedrich, notably the now destroyed celebrated arctic shipwreck scene *The Wreck of the Hope*.

Johann Gottfried Quistorp (1755–1835) Drawing master of the University of Greifswald and Friedrich's first teacher. A friend of **Kosegarten**, he seems to have been influential in the development of Friedrich's ideas on art.

Philipp Otto Runge (1777–1810) Painter, writer and theorist. Like Friedrich, he came from Pomerania and studied at Copenhagen before moving to Dresden. From 1802 he was close to **Tieck** and other Dresden Romantic writers. He is best known for his symbolic cycle *Times of Day* (1803–10) and for his theories on colour.

Karl Friedrich Schinkel (1781–1841) The leading German architect of his age. During the Napoleonic Wars he practised as a scene painter and landscapist, producing works that showed a strong influence of Friedrich's imagery. After the Napoleonic Wars he became chief architect to the Prussian government. He was responsible for the layout of central Berlin – including such famous buildings as the Schauspielhaus and the Altes Museum – and for the control of public buildings throughout Prussian territories.

August Wilhelm Schlegel (1767–1845) Critic and scholar, who became one of the most influential disseminators of the ideas of the German Romantic movement. Together with his brother **Friedrich Schegel** he founded the important magazine *Athenaeum* (1798), which became the organ of German **Romanticism**. In later life he was a professor of literature at the University of Bonn.

Friedrich Schlegel (1772–1829) Critic and writer who originated many of the ideas that inspired the German Romantic movement. Together with

his brother **August Wilhelm Schlegel** he founded the influential magazine *Athenaeum* (1798) in which he published his seminal definition of Romantic poetry. The Schlegel brothers formed the hub of a group of writers centred on Dresden, including **Novalis** and **Tieck** whose work brought the ideas of **Romanticism** before the public for the first time. After 1803 Friedrich Schlegel became more conservative in his views, focusing his interest on reviving the art and ideals of the Middle Ages. In 1808 he converted to Catholicism, becoming a strong supporter of the **Nazarenes**.

Daniel Friedrich Schleiermacher (1768–1834) Leading theologian of the early nineteenth century renowned for his ability to align traditional Protestant beliefs with contemporary sensibilities. A Pomeranian, he had friends in common with Friedrich. He visited the artist in Dresden on a number of occasions and appears to have had a strong influence on his thinking.

Ludwig Tieck (1773–1853) Writer. A close friend of Wackenroder he edited the latter's *Outpourings of the Heart of an Art-Loving Monk* (1797). He wrote novels and plays popularizing the ideas of the Romantics, notable *Franz Sternbald's Wanderings* (1798), a tale of the artistic education of a fictive pupil of Dürer.

Vasily Andreyevitch Zhukovsky (1783– 1852) Russian poet and translator, who was a key figure in introducing the literature and thought of German **Romanticism** into his native country. He visited Friedrich in Dresden in 1821 and became an enthusiast for the artist's work. A member of the entourage of Grand Duke Nicholas (later **Tsar Nicholas I**), and subsequently tutor to his son, he was instrumental in works by Friedrich being acquired by the Russian royal family.

Adrian Zingg (1734–1816) A Swiss painter who played a major role in the development of landscape in central Germany. He settled in Dresden in 1766, teaching at the **Academy**. His skilled **sepia** landscapes were a stimulus to Friedrich to execute works in the medium.

Key Dates

Numbers in square brackets refer to illustrations

The Life and Art of Friedrich

A Context of Events

	The Life and Art of Friedrich	A Context of Events
1774	Born 5 September in the Baltic harbour town of Greifswald, then in Swedish Pomerania	**1774** Goethe's *The Sorrows of Young Werther*
		1776 American Declaration of Independence
1781	7 March: Death of mother	
1782	12 February: Death of sister Elisabeth	
1787	8 December: Death of brother Johann Christoffer in skating accident	
		1789 Outbreak of French Revolution
1790	Enrolls as a private student of Johann Gottfried Quistorp, drawing master at the University of Greifswald	**1790** Immanuel Kant's *Critique of Judgement*
1791	27 May: Death of sister Maria	
1794	Begins study at the Danish Royal Academy in Copenhagen	
		1797 Wackenroder's *Outpourings of the Heart of an Art-Loving Monk*
1798	Leaves Copenhagen. After a brief period in Greifswald goes to Dresden, which becomes his principal place of residence and work for the rest of his life	**1798** The Schlegel brothers publish the Romantic periodical *Athenaeum*. Tieck's *Franz Sternbald's Wanderings*
1799	March: First exhibits at the Dresden Academy	
1801	January: Returns to Greifswald. Remains there until July, 1802. Meets Philipp Otto Runge. Twice visits the island of Rügen	
		1802 Novalis's *Heinrich von Ofterdingen*
1803	Exhibits sepias at the Dresden Academy. Creates *The Times of Year* [42–45]	
		1804 Napoleon proclaimed Emperor of France
1805	May–June: Visits Greifswald and Rügen. August: Shares the Weimarer Kunstfreunde prize awarded by Goethe [47, 48]	**1805** Battle of Trafalgar: British navy defeats French and Spanish. Battle of Austerlitz: Napoleon defeats Austria and Russia
1806	March–April: Suffers a severe illness. April–August: Visits Greifswald	**1806** Battle of Jena: Napoleon defeats Prussia. Beginning of French occupation of Germany
1807	Travels in Northern Bohemia	**1807** Inconclusive Battle of Eylau between France and Russia
1808	December: Exhibits *The Cross in the Mountains* [46] in his studio. 22 December: Death of sister Caroline in Breesen, near Neubrandenburg	**1808** Founding of Brotherhood of St Luke (the Nazarenes). Goethe's play *Faust* part 1. Kleist's *The Battle of Hermann*. G H von Schubert: *Views of the Dark Side of the Natural Sciences*

	The Life and Art of Friedrich	A Context of Events
1809	6 November: Death of father	1809 Napoleon defeats Austrians at Battle of Wagram and captures Vienna
1810	June: Tour of Riesengebirge with Georg Friedrich Kersting. 14 September: Visited by Schleiermacher. 18 September: Visited by Goethe. November: Exhibits *Monk by the Sea* [72] and *Abbey in the Oakwood* [73] at the Academy in Berlin. These works are bought by Frederick William, Crown Prince of Prussia. Elected a Member of the Prussian Academy of Arts	1810 Death of Runge
1811	Tour of the Harz Mountains. Visits Goethe in Jena	
1812	*Morning in the Riesengebirge* [81] bought by Frederick William III of Prussia. Exhibits *Tombs of Ancient Heroes* [88] in Berlin	1812 Napoleon invades Russia
1813	July: Retires to the Elbsandsteingebirge during the French occupation of Dresden	1813 October: Allies defeat Napoleon at the Battle of Leipzig
1814	March: Contributes *The Chasseur in the Woods* [71] and one other painting to the patriotic exhibition celebrating defeat of the French	1814 September: Beginning of Congress of Vienna (ends June 1815). Agrees redistribution of European territories following Napoleon. Swedish Pomerania becomes one of the areas ceded to Prussia
1815	August–September: Visits Greifswald and Rügen	1815 18 June: Final defeat of Napoleon at the Battle of Waterloo
1816	10 June: Applies for Saxon citizenship. 4 December: Elected member of the Dresden Academy	
1817	Beginning of friendship with doctor and amateur artist Carl Gustav Carus	1817 Wartburg Festival: Nationalist demonstration by students precipitates repressive measures against radicals. Constable exhibits his landscape paintings for the first time
1818	21 January: Marries Caroline Bommer. June–August: Visits his family in Greifswald with Caroline [8]. 28 September: J C C Dahl arrives in Dresden	
1819	12 July: Visit to Friedrich's studio by Prince Christian Frederic of Denmark. 30 August: Birth of first child, Emma. Exhibits *Monastery Graveyard in the Snow* [104]	1819 Time of *Demagogenverfolgung* – extreme repression of radicals – in German states. Géricault's *Raft of the Medusa* [132]
1820	19 April: Visit by Nazarene painter Peter Cornelius. August: Moves house to An der Elbe 33. December: Visit to Friedrich's studio by the future Tsar Nicholas I of Russia	
		1821 War of Independence begins in Greece. Death of Napoleon at St Helena. Constable exhibits the *Hay Wain* at the Royal Academy, London
1823	2 April J C C Dahl moves to an apartment in the same house as Friedrich. 2 September: Birth of daughter, Agnes	
1824	17 January: Appointed associate professor at the Dresden Academy. When the professor of landscape, Johann Christian	

Klengel dies on 19 December Friedrich
is not offered the post. It is given instead
to Dahl.
23 December: Birth of son, Gustav Adolf.
Completes *Arctic Shipwreck* [129]

1825 Exhibits *The Watzmann* [135] and *The Ruin
at Eldena* [111] at the Dresden Academy

1826 June: Curative visit to Rügen, following
an illness

1828 Visits Teplitz, in Bohemia. Becomes
a member of the newly founded Saxon
Art Union. Starts writing his *Observations*

1829 Treaty of Edirne confirms Greek
independence

1830 March: Visit to Friedrich's studio by Crown 1830 July Revolution in Paris. Uprisings
Prince Frederick Willliam of Prussia. in Germany, including Dresden
11–13 September: Witnesses and writes
a sympathetic account of the uprising
in Dresden

1831 Exhibits *Evening on the Baltic* [161] at the
Dresden Academy

1832 *The Large Enclosure* [163] acquired by the
Saxon Art Union

1834 7 November: Visit to Friedrich's studio by 1834 *Zollverein* (German Customs Union)
French sculptor David d'Angers established under the leadership of Prussia

1835 26 June: Suffers a stroke.
August–September: Takes six weeks cure in
Teplitz, enabled by purchase of works by
Nicholas I of Russia. Owing to ill health now
works mainly in sepia and watercolour

1837 Queen Victoria succeeds to the
British throne

1838 23 June: Death of brother Adolf in
Greifswald.
13 November: Friedrich's daughter Emma
marries Robert Krüger, a fisherman on the
Elbe.
Last works exhibited at Dresden Academy

1839 Visited by the artist Caroline Bardua who
paints his portrait [175]

1840 7 May: Dies in Dresden 1840 Queen Victoria marries Albert of Saxe-
10 May: Buried in Trinity Cemetery, Dresden Coburg-Gotha.
Claude Monet born

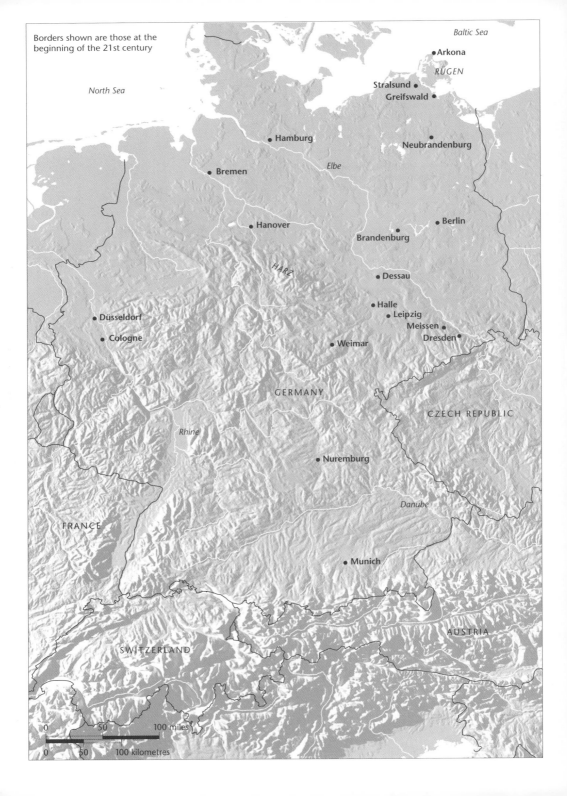

Borders shown are those at the
beginning of the 21st century

Baltic Sea

• Arkona

RÜGEN

North Sea

Stralsund •
Greifswald •

• Hamburg

Elbe

• Neubrandenburg

• Bremen

• Hanover

• Berlin

Brandenburg •

HARZ

• Dessau

• Halle
• Leipzig
Meissen •
Dresden •

• Weimar

GERMANY

CZECH REPUBLIC

Rhine

• Nuremburg

Danube

FRANCE

• Munich

AUSTRIA

SWITZERLAND

0 50 100 miles

0 50 100 kilometres

Further Reading

Works on Friedrich

The literature on Friedrich is vast – but it is mostly in German. Although there have been some excellent critical studies relating to Friedrich in both English and French, most detailed academic scholarship is still conducted within the German-speaking community. As this book is aimed at an English-reading public, I have listed just the most important German publications. These contain bibliographies to guide the curious further. Where important German publications have been translated into English, I refer to the English edition.

Helmut Börsch-Supan, *Caspar David Friedrich* (London, 1974)

Helmut Börsch-Supan and Karl Wilhelm Jähnig, *Caspar David Friedrich; Gemälde, Druckgraphik und bildmäßige Zeichnungen* (catalogue raisonné, Munich, 1973)

Werner Busch, *Caspar David Friedrich. Ästhetik und Religion* (Munich, 2003)

Françoise Forster-Hahn et al., *Spirit of an Age. Nineteenth-Century Paintings from the Nationalgalerie, Berlin* (exh. cat., National Gallery, London, 2001)

Caspar David Friedrich, *Äußerungen bei Betrachtung einer Sammlung von Gemählden von größtentheils noch lebenden oder unlängst verstorbenen Künstlern*, eds Gerhard Eimer and Günther Rath (Kritische Edition der Schriften des Künstlers und seiner Zeitzeugen I, Frankfurt am Main, 1999)

Johannes Grave, *Caspar David Friedrich und die Theorie des Erhabenen* (Weimar, 2001)

Sigrid Hinz, *Caspar David Friedrich in Briefen und Bekenntnissen* (Munich, 1974)

Karl-Ludwig Hoch, *Caspar David Friedrich – unbekannte Dokumente seines Lebens* (Dresden, 1985)

Werner Hofmann, *Caspar David Friedrich* (London, 2000)

Werner Hofmann (ed.), *Caspar David Friedrich* (exh. cat., Kunsthalle, Hamburg, 1974)

Jens Christian Jensen, *Caspar David Friedrich: Life and Works* (Woodbury, NJ, 1981)

John Leighton and Colin J Bailey, *Caspar David Friedrich: Winter Landscape* (exh. cat., National Gallery, London, 1990)

Joseph Leo Koerner, *Caspar David Friedrich and the Subject of Landscape* (London, 1990)

Sabine Rewald (ed.), *The Romantic Vision of Caspar David Friedrich. Paintings and Drawings from the USSR* (exh. cat., Metropolitan Museum of Art, New York, 1991)

Sabine Rewald and Kaspar Monrad, *Caspar David Friedrich. Moonwatchers* (exh. cat., Metropolitan Museum of Art, New York, 2002)

Charles Sala, *Caspar David Friedrich and Romantic Painting* (Paris, 1997)

Linda Siegel, *Caspar David Friedrich and the Age of German Romanticism* (Boston, 1978)

Werner Sumowski, *Caspar David Friedrich Studien* (Wiesbaden, 1970)

William Vaughan et al., *Caspar David Friedrich 1774–1840. Romantic Landscape Painting in Dresden* (exh. cat., Tate Gallery, London, 1972)

Historical and Cultural Background

Malcolm Andrews, *Landscape and Western Art* (Oxford, 1999)

Hans Belting, *The Germans and their Art. A Troublesome Relationship* (New Haven and London, 1998)

David Blayney Brown, *Romanticism* (London 2001)

Roger Cardinal, *German Romanticism in Context* (London, 1975)

Lorenz Eitner, *Neoclassicism and Romanticism 1750–1850*, 2 vols (Englewood Cliffs, NJ, 1970)

G Eley and David Blackbourne, *The Peculiarities of German History; Bourgeois Society and Politics in Nineteenth-Century Germany* (New York, 1984)

Keith Hartley et al., *The Romantic Spirit in German Art 1790–1990* (exh. cat., Royal Scottish Academy, Edinburgh, Hayward Gallery, London and Haus der Kunst, Munich, 1994–5)

Andrew Hemingway and William Vaughan (eds), *Art in Bourgeois Society 1750–1850* (Cambridge, 1998)

Hugh Honour, *Romanticism* (London, 1979)

Timothy F Mitchell, *Art and Science in German Landscape Painting, 1770–1840* (Oxford, 1993)

Peter Paret, *Art and History: Episodes in the Culture and Politics of Nineteenth-Century Germany* (Princeton, 1988)

Robert Rosenblum, *Modern Painting and the Northern Romantic Tradition. From Friedrich to Rothko* (London, 1975)

Simon Schama, *Landscape and Memory* (London, 1995)

William Vaughan, *German Romantic Painting* (New Haven and London, 1980)

–, *Romanticism and Art* (London, 1994)

Theodore Ziolkowski, *German Romanticism and its Institutions* (Princeton, 1990)

Books about Friedrich's contemporaries and subsequent admirers

Keith Andrews, *The Nazarenes. A Brotherhood of German Painters in Rome* (Oxford, 1964)

Andrew Causey, *Paul Nash* (Oxford, 1980)

Ingrid Ehrhardt and Simon Reynolds (eds), *Kingdom of the Soul; Symbolist Art in Germany 1870–1920* (exh. cat., City Art Gallery, Birmingham, 2000)

James Knowlson, *Damned to Fame. The Life of Samuel Beckett* (London, 1996)

Robin Lenman, *Artists and Society in Germany, 1850–1914* (Manchester, 1997)

Marco Livingstone, *David Hockney* (London, 1987)

Michael Snodin (ed.), *Karl Friedrich Schinkel: A Universal Man* (exh. cat., Victoria and Albert Museum, London, 1991)

Sam Taylor-Wood *et al.*, *Sam Taylor-Wood* (exh. cat., Hayward Gallery, London, 2002)

Caroline Tisdall, *Joseph Beuys* (London, 1979)

Sheena Wagstaff (ed.), *Edward Hopper* (exh. cat., Tate, London, 2004)

Andrew Wilton and Tim Barringer, *American Sublime. Landscape Painting in the United States 1820–1880* (London, 2002)

Index

Numbers in **bold** refer to illustrations

Acknowledgements

Over the decades I have been enlightened by
very many people in the consideration of the
art of Caspar David Friedrich; too many, alas,
to thank individually here, but I would like to
mention especially Keith Andrews, David
Bindman, Werner Busch, Helmut Börsch-
Supan, John Gage, Andrew Hemingway,
Werner Hofmann, Michael Kitson, Joseph
Koerner, John Leighton, Timothy Mitchell,
Hans Joachim Neidhardt, Alex Potts, Robert
Rosenblum, Helen Weston and Richard
Wollheim. In the case of this book I owe a
special debt to Keith Hartley who read
through the whole manuscript, providing
much appreciated encouragement and
making invaluable suggestions. I am grateful
to the Gemeinde of the St Nikolai-Kirche,
Greifswald for their permission to reproduce a
panel from the Corswandtschen Chapel and to
Andreas Reuter for his photograph of this and
of the Abbey of Eldena. I would also like to
thank the staff at Phaidon for all their help; in
particular David Anfam, who first approached
me with the offer of writing this book and who
has maintained a stimulating interest in it
throughout, Jane Lambert for her assiduous
picture researching and Julia MacKenzie, who
as editor has been a constant support, and
done such a fine job in preparing my text
for publication.

W V

Photographic Credits

akg-images: 1, 2, 4, 21, 22, 24, 31, 33, 50, 58, 62, 69, 71, 72, 78, 80, 84, 86, 89, 90, 91, 94, 95, 99, 101, 103, 106, 108, 109, 114, 123, 124, 125, 126, 127, 134, 136, 140, 142, 144, 145, 153, 155, 156, 160, 161, 169, 173, 175, 176, 177, photo Erich Lessing 163; Artothek: 46, 63; Bildarchiv Preußischer Kulturbesitz: photo Joerg Anders/Kupferstich- kabinett, Staatliche Museum, Berlin 18, 25, 41, 55, 77, photo Elke Walford and Christoph Irrgang/Kunsthalle Hamburg 76, 92, photo Joerg P Anders/Nationalgalerie, Staatliche Museen, Berlin 81, 93, 111, 135, 139, 164; www.bridgeman.co.uk: 5, 10, 11, 19, 23, 32, 39, 40, 57, 67, 88, 110, 115, 116, 120, 122, 128, 129, 132, 147, 148, 149, 152, 154, 158, 167, 170, 171, 172, 183, photo Bildarchiv Steffens 83, photo Christie's Images 85, photo Interfoto 166, photo Peter Willi 181; British Museum, Department of Prints & Drawings: 37; Ny Carlsberg Glyptotek, Copenhagen: 17; © Christie's Images/Corbis: 165; Zoë Dominic: 185; Drammens Museum: 121; Ronald Grant Archive: 186; Herzog August Bibliothek, Wolfenbüttel (Graph. A1: 747n): 29; HM The Queen's Reference Library, Copenhagen: 14; © David Hockney: 189; Kunsthalle Mannheim: 27, 28, 98, 119, photo Margita Wickenhäuser 113; Ian Bavington Jones: 3; Kunstsammlungen Chemnitz (Inv. Nr 815): photo Lászlo Tóth, Chemnitz 100; Kupferstich-Kabinett, Dresden: photo Herbert Boswank 26, 30, 35, 137, 162; Library of Art Academy, Copenhagen: 15; Mountain High Maps © 1995 Digital Wisdom Inc: p.342; © Munch Museum (photo Andersen/de Jong): 182; © Museo Thyssen-Bornemisza, Madrid: 159; Museum der bildenden Künste Leipzig: 146; Museum Georg Schäfer, Schweinfurt am Main: 65, 87, 102; Museum Oskar Reinhart am Stadtgarten, Winterthur: 7, 118; © 2003 National Gallery, Norway, photo K Ø Nerdrum 54, © 2004 National Gallery, Norway, photo K Ø Nerdrum 68, 117, © 2002 National Gallery, Norway, photo J Lathion 112; National Museum of Fine Arts, Stockholm: 16; Pommersches Landesmuseum, Greifswald: 8, 12, 13; Andreas Reuter: 6, 9; Rheinisches Bildarchiv Koln: 178; Der Spiegel: 188; Staatliche Kunstsammlungen Dresden: 59; Städelsches Kunstinstitut, Frankfurt an Main: photo © Ursula Edelmann 96, 130; Städtische Galerie Dresden, Kunstsammlung: 138; Statens Museum for Kunst, Copenhagen: SMK Foto 20; Stiftung Weimar Klassik und Kunstsammlungen (Inv. Nr. G 689): photo Eberhard und Stefan Renno, Fotoatelier Held Weimar 79; © Tate, London 2004: 179, 184, 187; © Sam Taylor-Wood, courtesy Jay Jopling/White Cube (London): 190; Photography courtesy of Terra Foundation for the Arts: 180

Phaidon Press Limited
Regent's Wharf
All Saints Street
London N1 9PA

Phaidon Press Inc.
180 Varick Street
New York, NY 10014

www.phaidon.com

First published 2004

© 2004 Phaidon Press Limited

ISBN 0 7148 4060 2

A CIP catalogue record for this book
is available from the British Library.

Typeset in Stone Sans

Printed in Singapore

Cover illustration *The Chalk Cliffs on Rügen,*
after 1818 (see pp.202–3)